POST BLITZ
PLYMOUTH
FROM THE AIR
then & now

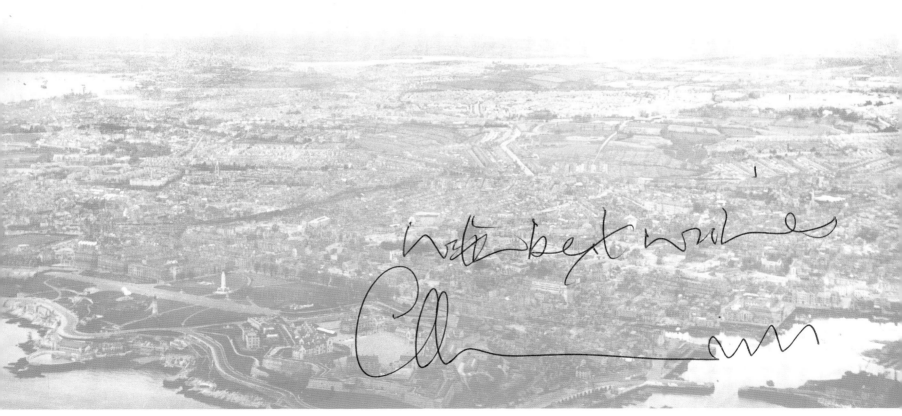

Chris Robinson

British Library Cataloguing in Publication Data

Chris Robinson
Post-Bltiz Plymouth
From the Air Then & Now

A catalogue record for this book is available from the British Library
ISBN 978-1-7384266-0-7

Written and illustrated by Chris Robinson
Layout Chris Robinson
© Chris Robinson 2023

First published November 2023

Also available:
Victorian Plymouth
Plymouth's Great War
Plymouth in the Twenties & Thirties
Plymouth in the Forties & Fifties
Plymouth in the Fifties & Sixties (out of print)
Plymouth in the Seventies
The Story of the Hoe, Barbican and City Centre
Plymouth in the Age of the Petrol Driven Motor Car
Plymouth Before the War From the Air Then & Now

Published by
Pen & Ink Publishing
34 New Street, Barbican
Plymouth PL1 2NA
Tel: 01752 705337
www.chrisrobinson.co.uk

Printed and bound in Great Britain by Short Run Press
Bittern Road, Sowton Industrial Estate
Exeter EX2 7LW

CONTENTS

INTRODUCTION

The first volume of Plymouth from the Air Then & Now provided a fascinating insight into what Plymouth looked like and how it functioned before the wartime bombardment reduced so much of it to rubble. This book picks up at that point and charts the replanning, the rebuilding and the ever evolving changes that discovery, innovation and 'progress' throw in the path of 'best laid plans.'

Map makers have been attempting to represent our world in two dimensions for hundreds of years, some, in the past, more successfully than others, but, in recent years, extremely accurately. In 1858 the French photographer, Gaspard-Félix Tournachon, or Nadar as he was professionally known, became the first person to photograph anywhere from the air – 260ft above the valley of the Bièvre. In the 1870s a couple of quite accurate engravings were produced of Plymouth from the air, which may or may not have been helped by observation from a hot air balloon, but the earliest photograph of the city that I've found, to date, is certainly post Wright brothers and into the second decade of the twentieth century at least.

For the current volume, however, our source material is exclusively from the 20 year period following the Blitz attacks of 1941, with most of the Then photographs dating from 1945-1955. The scale of the devastation, particularly in the centres of Plymouth and Devonport is dramatic but for the most part orderly. For a generation that has grown up with death and destruction from foreign wars on our screens almost as it happens such scenes may seem tame, but nonetheless horrific because as Pat Twyford put it in his account of the Second World War in Plymouth – *It Came To Our Door*. And let us not forget although the devastation inflicted by the Luftwaffe was awful, it was not nearly as bad as that visited upon a number of German cities by the RAF. Nevertheless, Plymouth was, per capita, the worst bombed city in Britain, with over 2,000 slightly injured, 1000 seriously injured and over 1100 killed. Over 70,000 homes were damaged, almost 4,000 of which were so bad that they had to be demolished. Schools, churches, clubs, pubs, offices and other public buildings were lost to the bombing and many more were lost to the Plan.

While many were disappointed that the decision was taken to start from scratch rather than mix and match, or rebuild what had been lost, there was a certain logic to it. Plymouth had grown massively during the course of the nineteenth century. Its dominance over the other two towns was irrefutable as was the need to bring the city centre in line with the cultural changes that were impacting on an area that was ill-equipped to cope with the modern world. Spooner's Corner was said to be the busiest junction outside of London, as car ownership was taking place faster than anyone could have anticipated. Here was an opportunity to future-proof the city and to provide housing for all those displaced by war. *The Plan for Plymouth*, produced in 1943 while the war was still raging, was a visionary document. That Plymouth should have been able to enlist the services of Patrick Abercombie, that the city (and remember city status only arrived in 1928) should have been blessed with a forward thinking city engineer/surveyor, as James Paton Watson, was due in no small measure to the man who served essentially as an a-political Lord Mayor for most of the war, Waldorf Astor.

Lord Astor, as he had become in 1918 when he renounced his seat in the Commons to inherit his father's title, was not only one of the wealthiest men in the western world, he was also a very keen student of town planning and the war gave him and those around him the opportunity to put their ideas into practice.

For those who have never seen the *Plan*, it is a thoroughly detailed document, a 150-page hard back tome, replete with drawings, maps, charts, photographs and fizzing with ideas on how to build a better city. The division of the centre into areas, civic, retail, educational, cultural; the creation of a grid system for the shops, a grand highway for the major retailers – Royal Parade; the creation of a central backbone running north south through the whole development to give structure and shape to the modern city and to give all comers a direct path to city's jewel in the crown, the massive public open space that is Plymouth Hoe and mighty and largely unspoilt amphitheatre that overlooks the harbour from the east and west – the magnificent Plymouth Sound. Today this backbone is very much a back bone of contention and proposals for its future are the subject of public consultation as I write and sadly it is in desperate danger of being misunderstood. Plymouth currently has far more post-war listed buildings than any other British town or city. This is something we should be celebrating and actively promoting. We not only have thousands of years of history here, including that which celebrates our local Elizabethan seafarers – hence Armada Way – but we also have a special twentieth century history and it needs the key that is Armada Way to unlock it, to guide tourists, students and locals alike around that post-war landscape. Because it was an ambitious gesture to drive a boulevard from North Cross to the Hoe it took longer than most elements to put in place. By the time the mile-long stretch had been cleared and thoughts were given over to how it might be 'finished' with the predestrianisation plans of the mid-1980s, the original vision had been almost forgotten and we ended up with a cluttered and cobbled affair the overall integrity of which was hardly apparent at any point along its length apart from – from the air. That needs to change, as this

has enormous potential to put post war Plymouth firmly on the map. The *1943 Plan* contains no vision based on whim, it was based on the foremost planning notions of the day and within its pages were plans for the Parkway – a vision that made sense then but took 40 years to realise – and Derriford Hospital – which took a similar amount of time.

Of course no one can accurately predict the future. Who could have anticipated just how fast the growth in car ownership would have been, facilitating a situation whereby shoppers no longer needed to rely on buses, and retailers would be able to forsake the high city centre rental costs by moving to 'out of town' retail parts, with free parking?

Time was when all city centre department stores – Dingles, Debenhams, the Co-op, Littlewoods, British Home Stores etc – all sold white goods, furniture, food, and so many more staples of the modern retail park. And who would have thought that there would be a mass move to online ordering? Even those firms with delivery vans in the forties and fifties, would not have seen this large-scale, cardboard-covered revolution coming. As the city's high street struggles one is minded of the smaller high streets, or 'fore' streets that we see around the city as Fore Streets still thrive in satellite towns like Saltash, Torpoint and Ivybridge, essentially one-road shopping offers with little to the side. The Ridgeway, the Broadway and Mutley Plain too are similarly still in relatively reasonable health. Admittedly the Plymouth city centre retail footprint was probably a little too big in the first place but it was exciting at first because, doubtless thanks to the Astor influence Plymouth was able to be ahead of others in the rebuilding stakes. Questions have also been asked of the decisions underpinning the layout of the city's new housing estates. Post war the population remained much the same, but the acreage of the city doubled as communities were cast out of their often cramped and inadequate accommodation and into great sprawling estates with little in the way of basic community infrastructure and where corner shops and corner pubs were replaced by large central shopping precincts and big brewery-owned, characterless estate pubs, many of which have long since closed. There were also very few corners as streets were long, concentric and curved.

It is an intriguing story of post-war evolution. It starts with the Hoe and Barbican but then chronicles the gradual realisation of the Plan for the city centre, before taking us on a tour of the city, area by area, out to the Tamar and back across to Marsh Mills and the Plym (Plympton and Plymstock did not become part of the city until 1967!).

Here is perhaps the most comprehensive collection of aerial images of the hundreds of prefabs that populated Plymouth in the immediate aftermath of the war: some of the streets they were placed on survive today, but many don't.

But it really doesn't matter what you're looking for here, the reality is simple: here's a wonderful spot the difference book for grown-ups and children alike, guaranteed to fascinate anyone, even those with little or no connection to the city! And if you want to take the comparisons even further back then I can't recommend more highly the National Library of Scotland's Georeferencing facilities. They have a labelled version of the RAF top-down Then photographs which you can cross-fade in and out of a contemporary visual, or you can toggle back to the middle of the nineteenth century with a marvellous collection of detailed maps.

Inside you will note how the lack of cars makes the street lines easier to read

ACKNOWLEDGEMENTS

Grateful thanks to all those Herald readers who, over the years, have been an invaluable source of images for all of the Pen & Ink projects we've produced over the last 40 years. Specifically for this volume thanks to Robin Hoskin, Tim Charlesworth, Ted Luscombe, Peter Waterhouse, Andy Endacott, Graham Brooks, Barbara Hampshire, Daryl Jago, Mr & Mrs WP Squire, and Steve Johnson for imagery. To Terry Willson and Anne Corry for research assistance and to Google Earth for the facility to fly to a particular point in the sky and capture a similar scene to those taken by anonymous airmen in the 1940s and 1950s. Thanks too to Clare Robinson, Gloria Dixon, Patricia Greathead and Beverley Kinsella for their patience and proof reading and to the team at Short Run Press for turning the printing around to meet exacting deadlines!

Chris Robinson MBE
November 2023

PLYMOUTH PANORAMA 1944

This fabulous panorama of Plymouth was taken some three years after the Blitz, sometime in 1944 before the war had ended. It was captured by a photographer on a Sunderland flying boat, like the one we see here. There are so many features to look out for, from the Royal Citadel and the Hoe, around through parts of Stonehouse and Devonport, across to Torpoint and the other side of the Tamar as it snakes its way across the top of the vista and back on to Plymouth where Alma Road, Central Park and the pedestrian walkway across the top, all stand out then as now.

Note off the Hoe we can still see the iron foundations of the Victorian Plymouth Pier, while on the Hoe itself the white blob that is a barrage balloon, flies above Smeaton's Tower, but, from this perspective, not that high.

Other notable features in the earlier image include: the dark line that is the railway running into Millbay Station, above and to the right of Millbay Park; the massive structure with the white facade that is the old Regent (Odeon) cinema, to the left and above the Guildhall tower and Public Secondary School, now dwarfed by the neighbouring Roland Levinsky Building.

Below the latter today we the modern Drake Circus and below that the Barcode, the largest city centre cinema in the heart of today's retail offer. Curiously enough Beckley Point does not appear as conspicuous

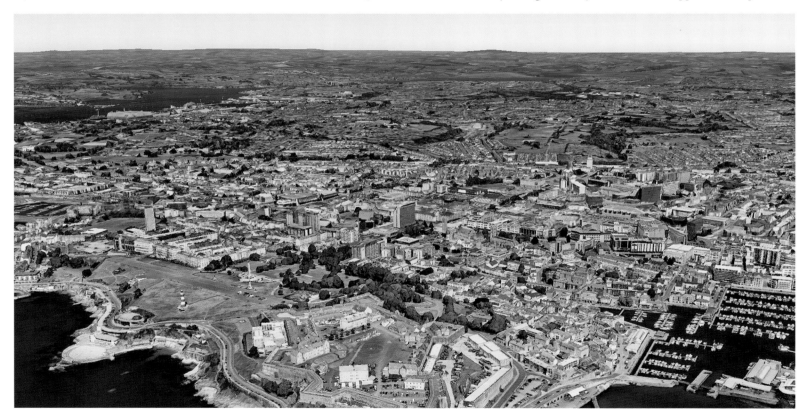

here as the Civic Centre, further down Armada Way, while at the southern end of that thoroughfare note how the Naval War Memorial has been extended on the ground to include the names of those lost at sea in the Second World War.

Meanwhile, still on the sea, one of the most conspicuous changes here once again is in the number of leisure craft we see in what was then still very much a working Sutton Harbour.

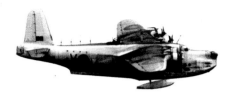

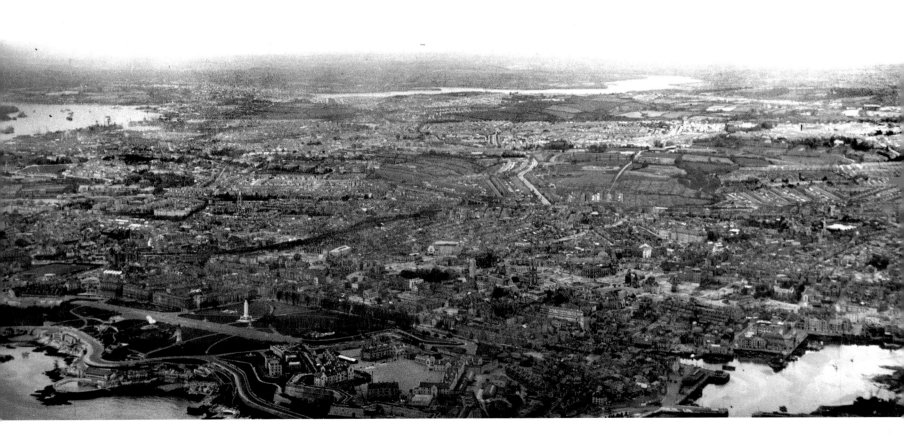

PLYMOUTH HOE PIER c1948

The postmark on a postcard version of the earlier view is dated 1949 and certainly the year can't be far out as we know that the former Second World War aircraft hangar from the RAF base at Harrowbeer (Yelverton) arrived on the Hoe, on the site of the bombed 1920's Hoe Cafe, in 1947.

The aerial bombardment of the city also accounted for a substantial section of Osborne Place at the top of Lockyer Street as we see here just west of the Hoe Bowling Green. The Naval War Memorial has

yet to be extended for those sailors lost in the Second World War and, although difficult to discern here, the grain silo at Millbay is still sporting its painted wartime camouflage.

Alongside the Grand Hotel we see the cleared site formerly occupied by the Royal Western Yacht Club and now sporting the Azure block of apartments.

The burnt out shell of the modest properties at the top of Cliff Road are still standing as are the houses at the southern end of Leigham

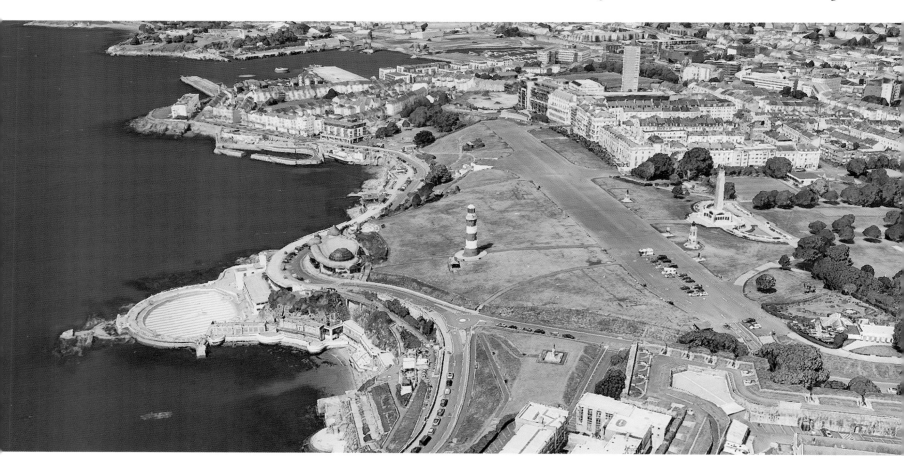

Street. It would be another 20 years or so before the Mayflower Hotel would be built on this site and another 44 years on top of that before that facility would close. That was in 2014: three years later indications were that work was about to start on a new development, but as we can see here, nothing, so far, has materialised.

Meanwhile there has been plenty of development along the landward side of Grand Parade, as the former tennis court sites have all been redeveloped.

Another conspicuous feature in the earlier view is what was left of the Promenade Pier. The original superstructure was mainly made of wood, and after falling prey to wartime incendiary devices only a scarred metal skelton survived. Most of what remained above water was cut away fairly promptly but what you see here around the waterline remained until its removal in 1953 by the Eglington Brothers who needed to use explosives to completely free the remains of the cast iron columns from the sea bed.

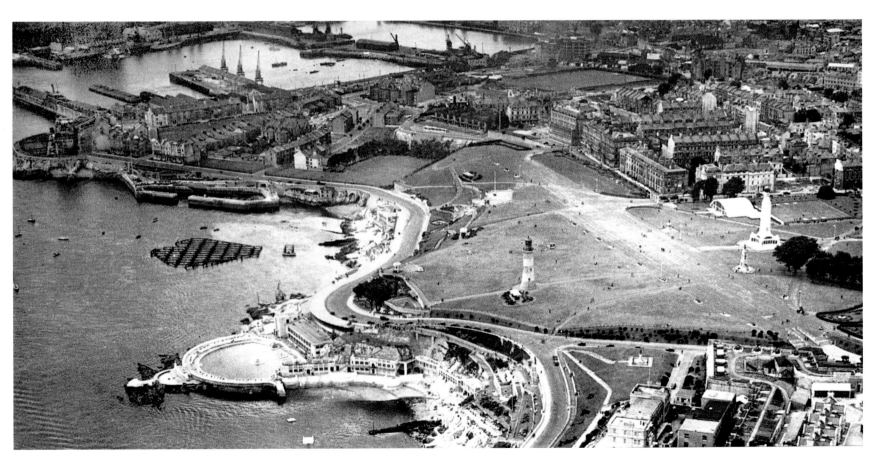

PLYMOUTH HOE c1948

Based on the blimp, the former aircraft hangar used as a Lyons Maid cafe on the Hoe from 1947 until the late-1970s, and the fact that although Royal Parade appears to have been laid out but there has yet to be any evidence of Dingles rising from the ashes, then a late 1940s date would appear right for our earlier image. The tide is quite high and therefore seems to be covering most of the surviving ironwork of the Promenade Pier that we see in the previous spread, but we can see markers. The slightly longer shadow suggests that although both photographs look as through they were taken around the same time of day, it clearly wasn't quite at the same time of year.

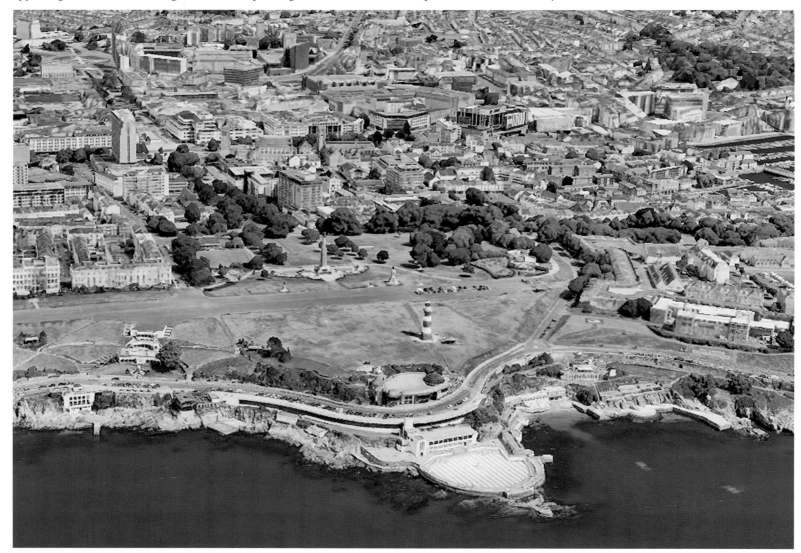

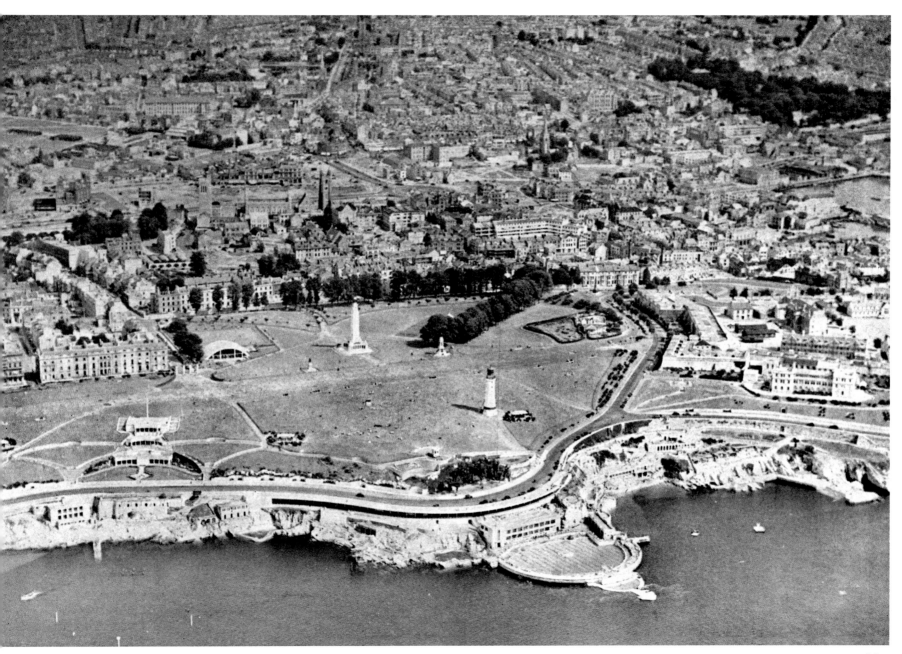

HOE & BARBICAN 1948

Life is always full of 'what if' moments and this particular pairing makes me think of what might have happened to Plymouth had it not been a major target during the Second World War. Would there have been a much slower exodus from the crowded city centre and from Stonehouse and Devonport to the new estates beyond the pre-war boundaries? Would a greater or lesser number of Tudor and Jacobean buildings around the heart of old Plymouth still be standing today? And would the bold 1938 plans from the City Engineer and Surveyor, James Paton-Watson have been fulfilled.

Forget the 1943 wartime *Plan for Plymouth* produced in the aftermath of the aerial bombardment of the city, which facilitated a more radical proposal, this 1938 proposal put forward the notion of creating a new boulevard from the centre of the city to the Hoe: 'I am of the opinion that the best general line for such a road would be from the city centre at St. Andrew's Cross to Tinside, via Hoe-street, crossing the Hoe east of the South African War Memorial. This could be made a most attractive direct route, if carried out in boulevard form.'

Paton Watson, a Scot, who took up his post in 1935, clearly valued the Hoe and suggested that it had not had the maintenance that it justified: 'I suggest that you give priority to any scheme for the improvement of its amenities, and insist upon a high standard of maintenance in the future. It is undoubtedly one of the finest promenades, and a viewpoint of unequalled merit, and for that reason the citizens should have pride in seeing that it is properly and efficiently maintained.'

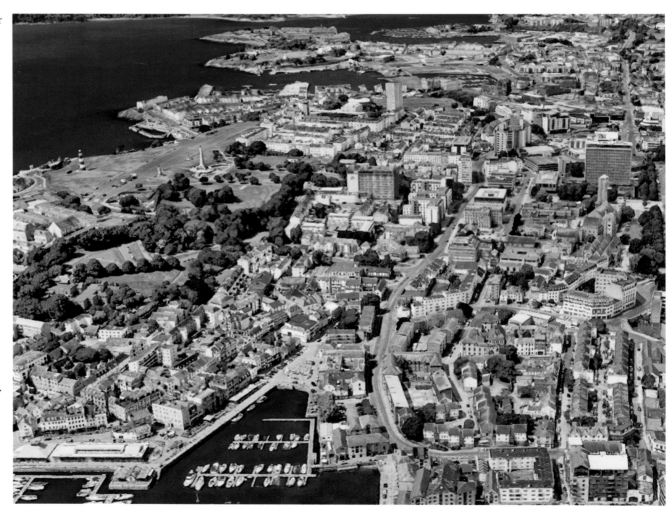

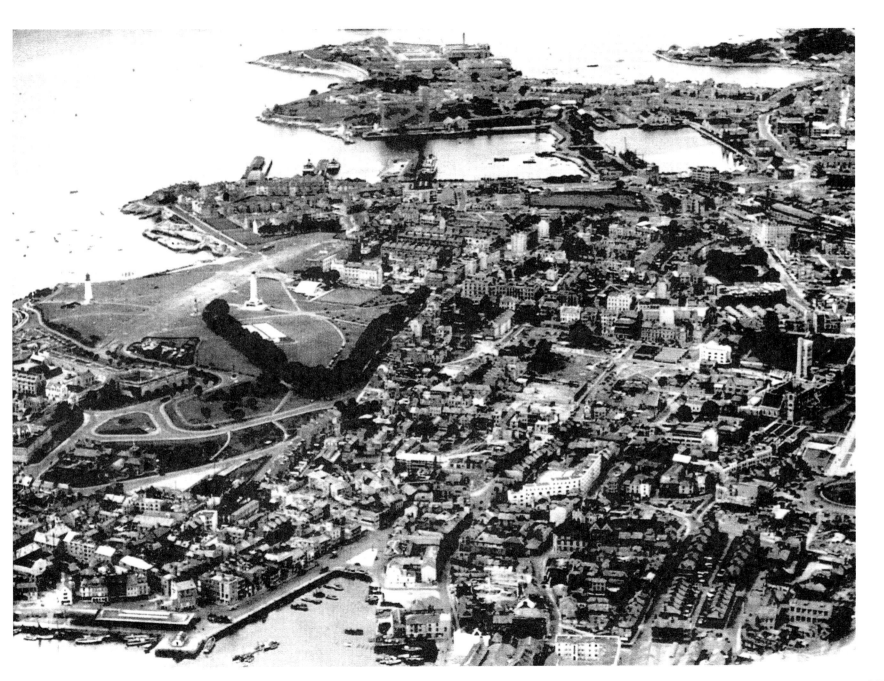

QUAY ROAD, BARBICAN 1948

There are a few bomb sites evident in our earlier image: notably to the left of the Island House, one of the few that subsequently remained clear and open as a seating area; to the right of the old Custom House, which did get rebuilt; and the great scar that ran from the Parade up to Citadel Road. Before the war this site housed various commercial buildings, the Queen's Arms (which was rebuilt in the mid-1960s) and Trinity Church and school, neither of which were reconstructed. Substantially however this area was deemed to be of little strategic importance and survived the war reasonably well. Post war planning restrictions have not allowed for any tall buildings in this part of the historic quarter and gradually it has been transformed from being part of a working harbour into a largely residential, retail and leisure area. The original licensed premises have survived and many more have appeared, the fish market has moved to the other side of the harbour and the distinctive 'White House' on the pier by the old fish market, which for decades served as the base for the Barbican bobby has become the 'world famous' Cap'n Jasper's eatery.

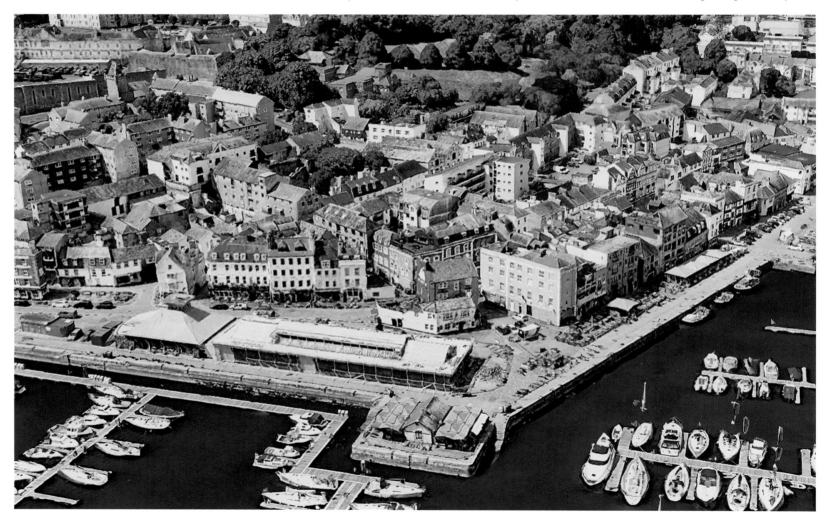

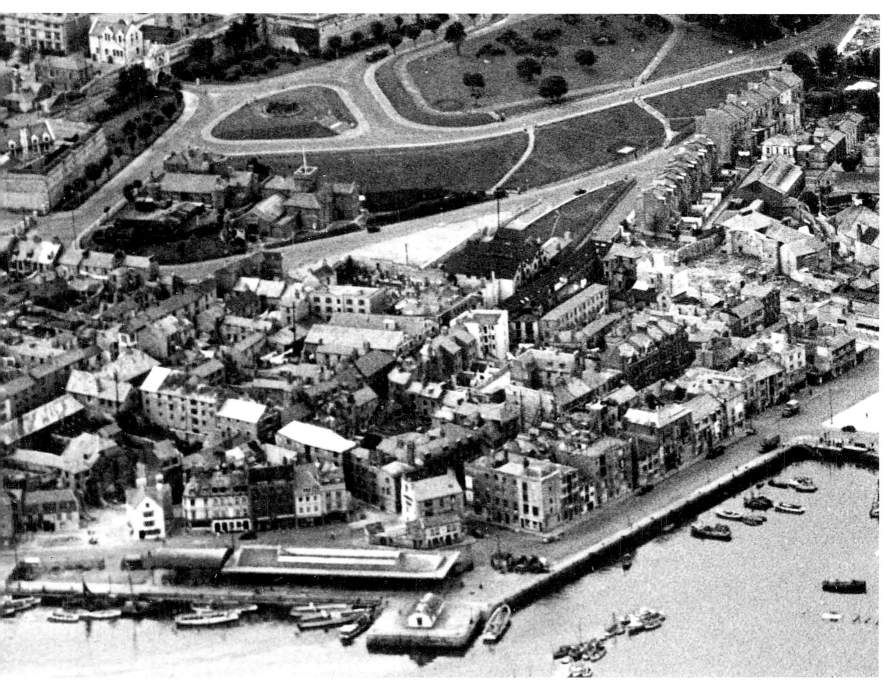

ROYAL PARADE & SUTTON POOL 1948

In pre-war Plymouth the towers of the ancient church of St Andrew and the Victorian Guildhall were two of the tallest structures in the city. Today we see the insidious move towards the sky that is taking place across the modern world and perhaps, because Plymouth has so many post-war listed buildings, the lack of tall buildings within the

Royal Parade, Old Town Street, Mayflower Street, Western Approach perimenter, this could be another feature that keeps this city so special. Clearly the historic quarter nestled around the western fringes of Sutton Pool which is also thankfully devoid of disproportionate ambience-affecting monsters helps nurture this aspect of the open sunny city while some of the new arrivals, on the north and eastern banks of Sutton Pool and in other parts of the city centre, cast dark shadows behind them.

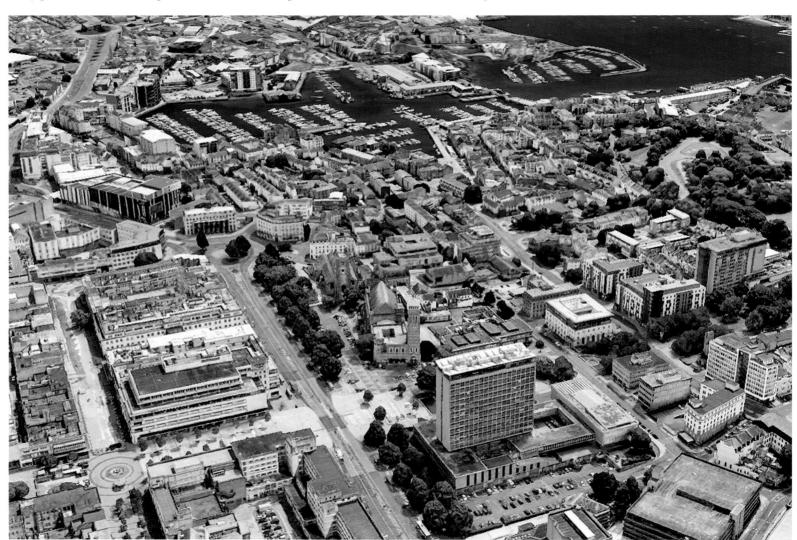

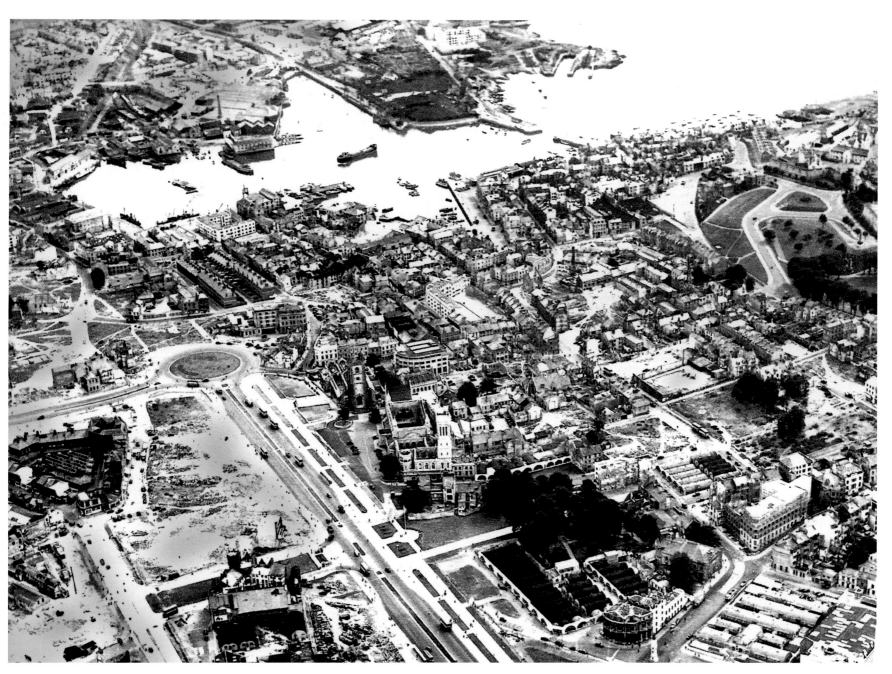

COXSIDE c1959

Sutton Pool is an ever-evolving, ever-shrinking harbour. Land reclamation has been going on here since at least the sixteenth century. In the 1890s a substantial amount of land was 'won' in order to create the space for Plymouth's first covered fish market – the amount of land added at that time is delineated by a row of bollards from Smart's Quay

by the Navy Hotel, down to West Pier, itself reclaimed from the sea a century earlier. Then, in the 1990s, the need to build a more hygienic fish market prompted the land grab that saw the old coal yard site extended for the 1990s fish market and the approach road to it. Utilising part of the fabric of East Pier there was also enough space to

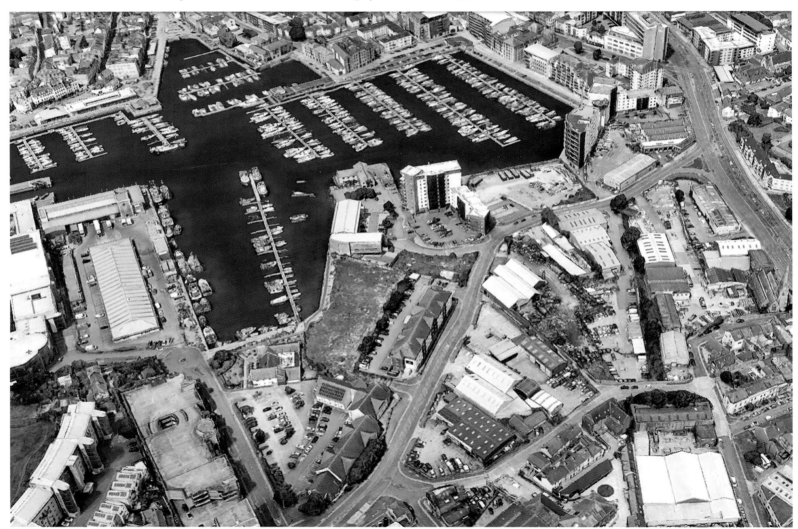

create the National Marine Aquarium, part of which we see here. In the same process, which followed the introduction of lock gates so that the water levels in the harbour could be controlled – for the time being at least – the decision was taken to infill part of Coxside Creek such that Lockyer's Quay became land-locked and a pub bearing the same name was erected on the new space. Other changes here have been even more dramatic and there are already plans for development on the now vacant plots on Shepherd's Wharf, north of Coxside Creek and west of Salt Quay House. All of these and those already constructed on North Quay will be higher than anything seen around the harbour before, as it morphs from being a working harbour, with a rail link, to one dominated by leisure craft, posh offices and residential accommodation.

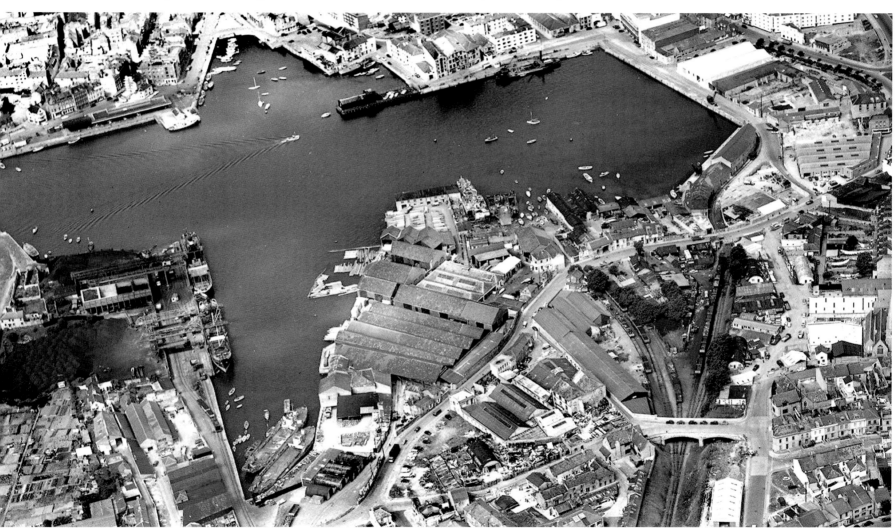

19

THE BARBICAN & NOTTE STREET c1945

Post Blitz but undated, this c1945 image shows most of the rubble cleared from the badly bombed city centre but we still see the shells and the scars of a number of significant structures. Foremost among them, at the top of the image, are the Guildhall and St Andrew's Church, both of which were rebuilt, not so though the Municipal Building on the northern side of the Guildhall. Another notable ruin is that of St Saviour's Church, towards the middle of the image at the bottom: the tower still stands today and the structure to the west of the tower, but long gone is the main body of the church.

Directly opposite the church, casting a shadow in the afternoon sun, is the terrace of married quarter buildings that disappeared in the 1960s. Quite a few other conspicuous structures survived the war but not the rebuilding, like the later-1930s Humm car showroom in the top left corner catching the sun on what was left of Princess Square. The Corn Exchange above and to the right of St Andrew's, was older and was not long for this world, while the 1935 Telephone Exchange to the east of Old Town Street, still stands today, framed by modern buildings and the latest incarnation of Drake Circus.

Meanwhile look out for the section of Notte Street, west of St Andrew Street, again destined for demolition, and the massive Mumford building in St Andrew Street itself. Damaged during the war, but not destroyed, it survived until the 1970s when it was cleared to make way for the Magistrates' Court.

There are countless changes here, but note particularly how many more mature trees there are now dotted around the place.

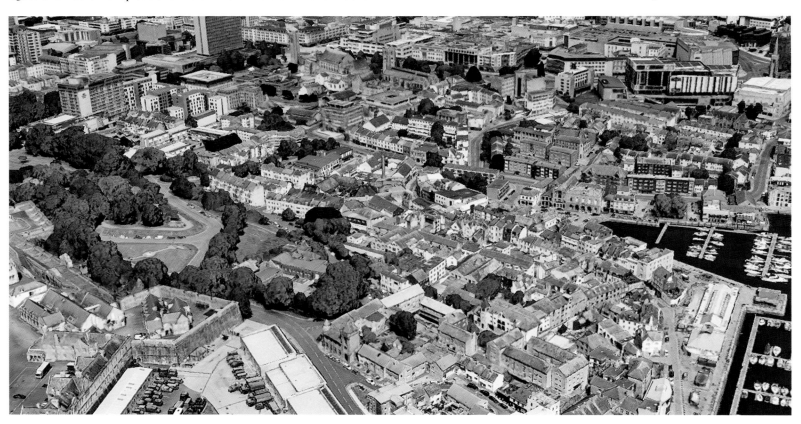

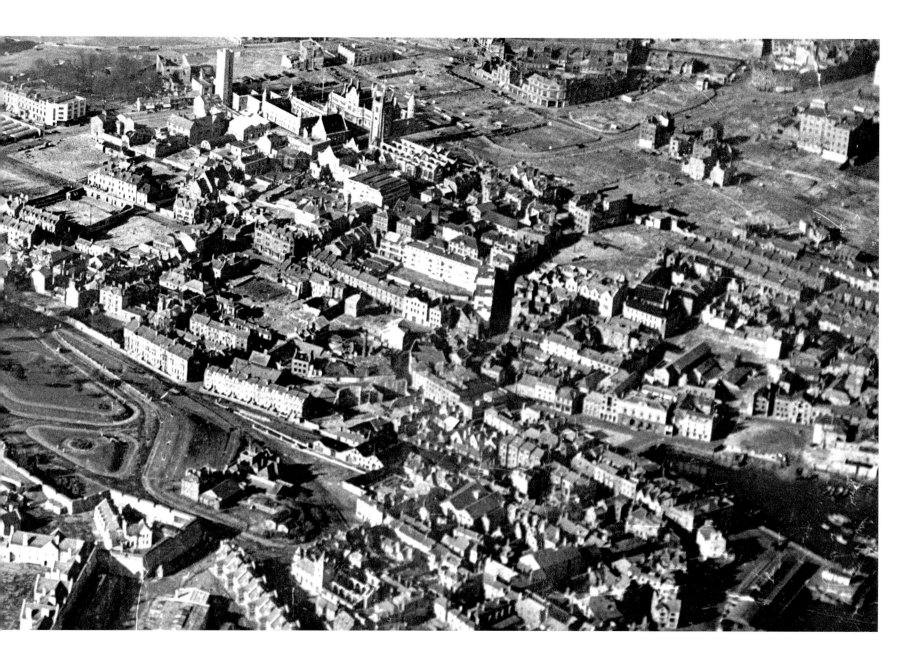

21

CITADEL ROAD & LOCKYER STREET 1947

Clockwise from the top the area is bounded substantially by: George Street (then), Royal Parade, St Andrew Street, the Hoe Approach Road, Citadel Road, and Lockyer Street. Like the rest of the city centre this was one of the most heavily blitzed parts of Plymouth as the many bomb sites either side of Notte Street and the many shelled structures bear witness, not to mention those sites that had been razed to the ground and repopulated with Nissen huts by April 1947. What this pairing of images also provides is an enhanced understanding of how: the tree-lined Armada Way now feeds into the Hoe Park; how the Theatre Royal car park now occupies the temporary site of the NAAFI as we see it here, on the space previously occupied (since the early nineteenth century) by the Foulston-designed Theatre Royal Hotel and how some of the trees below the bombed out George Street Chapel in Westwell Street Gardens have survived through to the present day. The heart of Princess Square, incidentally, was also then occupied by Nissen huts, and is now where we find the water feature in San Sebastian Square.

It's also worth noting that the red-brick NAAFI building, opened by Princess Margaret in July 1952, has been replaced by student flats while a residential development also now sits on the site of the shell of Hoe Grammar School on the corner of Lockyer Street and Citadel Road.

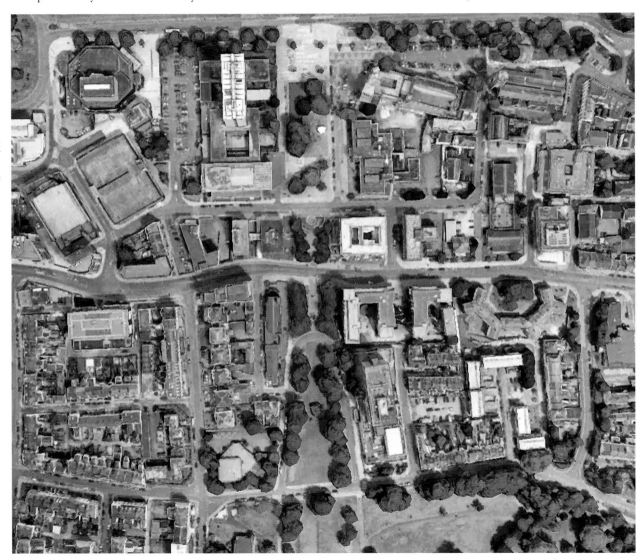

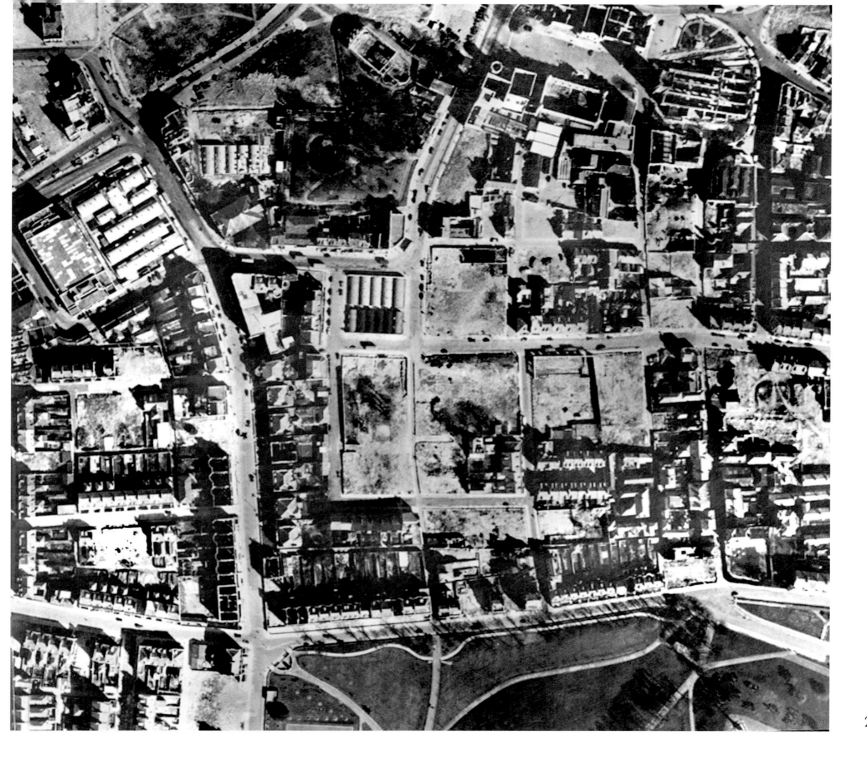

23

CITY CENTRE c1945

Aerial perspectives taken directly overhead offer a different and more map-like take on the Then & Now format. Here we see the stark contrast between the pre-war street plan of Plymouth city centre and the post-war version of today. Before the war this area had evolved over a period of centuries, post-war it has been over decades with only minor changes effected to that plan in the last 50 years.

The clearest link between the two is in the bottom left corner where what is now Buckwell Street (previously known as High Street) bends northwards from Notte Street. Palace Street and Stillman Street still branch west and east off it respectively and Looe Street and How Street are still readily identifiable to the far left.

One can quite clearly see why this was called the High Street, linking the Old Town Street with the harbourside.

Our earlier view gives us a doll's house overhead angle of the shells of St Andrew's Church, the Guildhall, Municipal Building and, just above the trees of Westwell Gardens, George Street Baptist Church – the last two of which were destined not to be reconstructed, but replaced with other structures on other footprints.

All in all it is a graphic reminder of just how much damage was done to the city centre fabric during the war, and just how many buildings, like the old market and Corn Exchange, survived the war, but not the re-planning.

So too are St Andrew Street, Finewell Street and Catherine Street as they spur northwards of Notte Street heading west. Since 1979 however the Magistrates' Court has cut St Andrew Street in half, thereby frustrating a principal link between the city centre and the Barbican.

Note too how clear the link between the two was before Plymouth's original guildhall site was redeveloped at the eastern end of Whimple Street, the southern side of which still stands today.

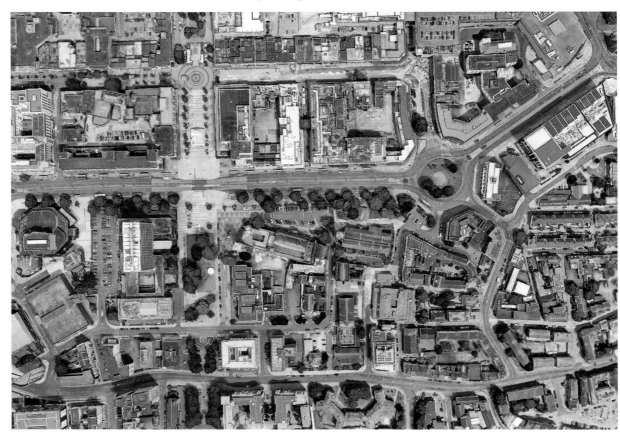

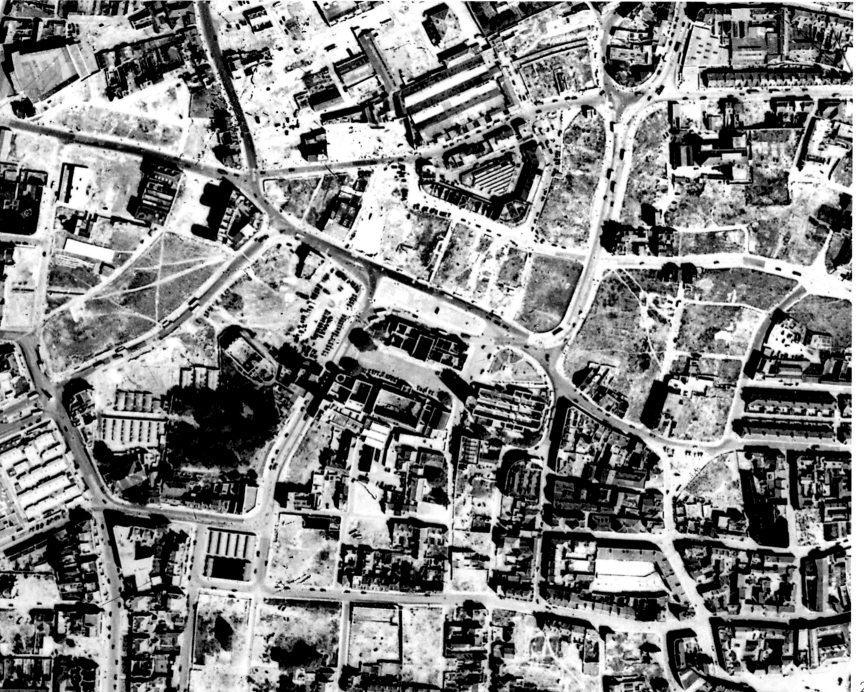

CITY CENTRE LOOKING WEST c1945

This mid-1940s aerial view of Plymouth city centre shows just how much was left ... and how much was lost in the wartime bombing raids on the city. So many buildings have been cleared and so many more, mainly houses, were destined to be cleared by the City Council. In other words, in order to realise the vision established in the *1943 Plan for Plymouth* there were still many sacrifices to be made. Not everyone was happy at the time, not everyone was happy with the benefit of hindsight, but what Plymouth was left with was a city centre that was unique in Britain.

During the fifties and sixties the city enjoyed a shopping precinct that was the most modern in England. Picture postcard sales of scenes of the wonderful new boulevard that was Royal Parade surpassed those of the Hoe and Barbican. Royal Parade became Royal when the King and

Queen arrived in October 1947 and personally conferred the right to use the royal epithet. There was then little further development of the city centre until the majority of the bombed out and displaced residents had been rehoused. After that the emphasis was on getting the retailers back into the centre. Thus Armada Way, although the major key to the post-war street layout, took longer to fully bring to life. This was unfortunate as by the time it was 'finished' it fell some way short of the original vision. A generation had passed since the Blitz and the new generation just wanted to get on with life, they had a different agenda. Now, however, we stand on the brink of realising a truer version of that vision and there can be little doubt that when it is at last realised people will come to thank those who dreamt it up in the first place and those who made it happen in the end.

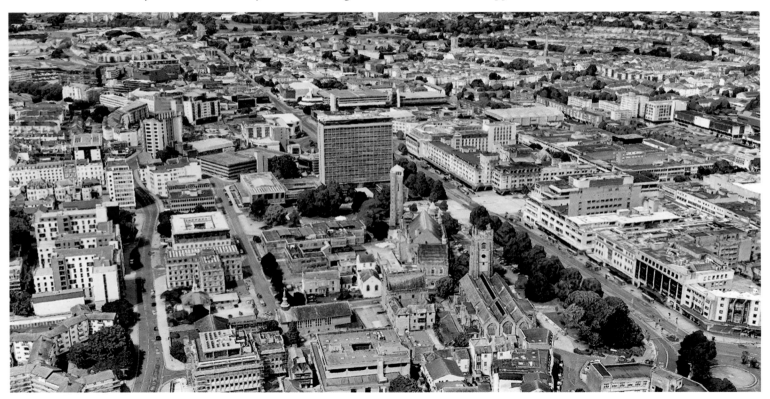

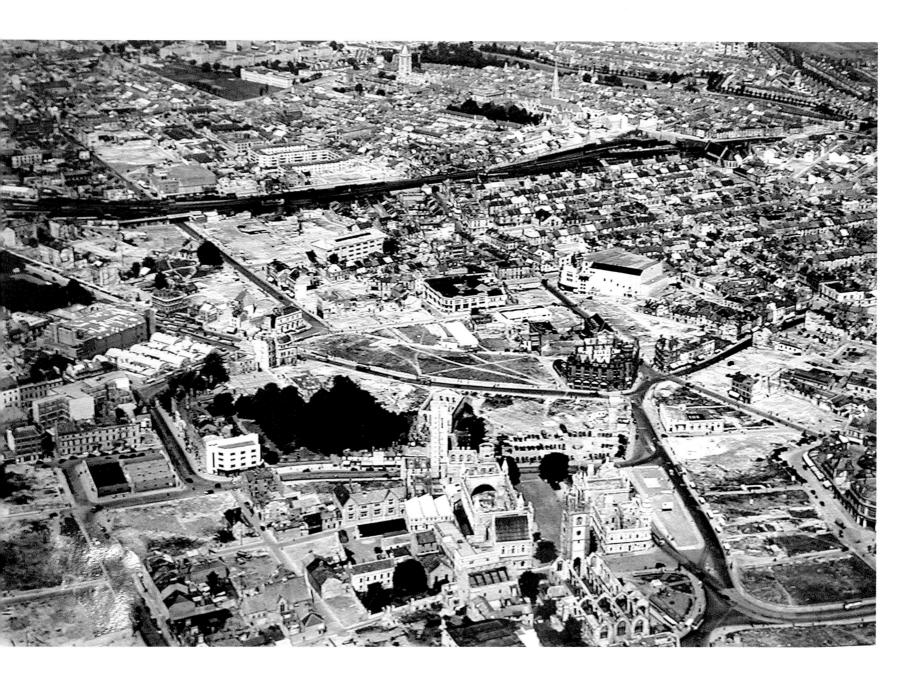

CITY CENTRE STREETS VIEW c1945

Notte Street, Buckwell Street (formerly High Street), Looe Street and Howe Street provide consistent framing for the lower section of both images while St Andrew's Church and the Guildhall are key landmarks connecting the two along with the Telephone Exchange (completed in 1935 and now tucked in behind Drake Circus) and the slightly earlier Public Secondary Schools. Our earlier view here is undated but is clearly post-Blitz clean up as there is little or no sign of rubble and the only obvious ruins are the aforementioned church and guildhall. Work has yet to begin on the reconstruction of the city centre however and there is, as yet, no sign of markers delineating what would become, in 1947, Royal Parade. What the early 1940s view does clearly afford us however is a wonderful insight into the streets, lanes and alleyways of pre-war Plymouth. If we follow the line of Old Town Street we see it running down from the original Drake Circus towards the eastern end of St Andrew's with Whimple Street, then as now curving down towards the Barbican and joining Looe Street. At the junction of the two we see the triangular site that had housed Plymouth's two earlier guildhalls with Palace Street running parallel to Notte Street – note the old Board School now occupied by Arts University Plymouth.

The line of Treville Street, running east of Old Town Street and below the Telephone Exchange is clear as is East Street on the western side of Old Town Street running up to and beyond the Corn Exchange. Meanwhile running west from St Andrew's Cross is Bedford Street, heading off to the old Prudential Building where it breaks up with George Street to the left, Frankfort Street heading straight down to the Regent/Odeon cinema, Russell Street to the right and, coming back eastwards but in a more northerly direction, the original Cornwall Street.

All in all it's a fascinating photograph in the light of the post-war transformation, giving us a very clear idea of what survived the war, but not the re-planning – it's quite amazing just how much was sacrificed, with a comparative minimum of fuss.

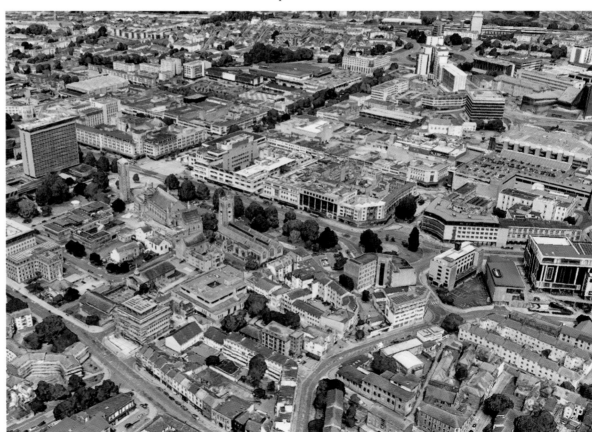

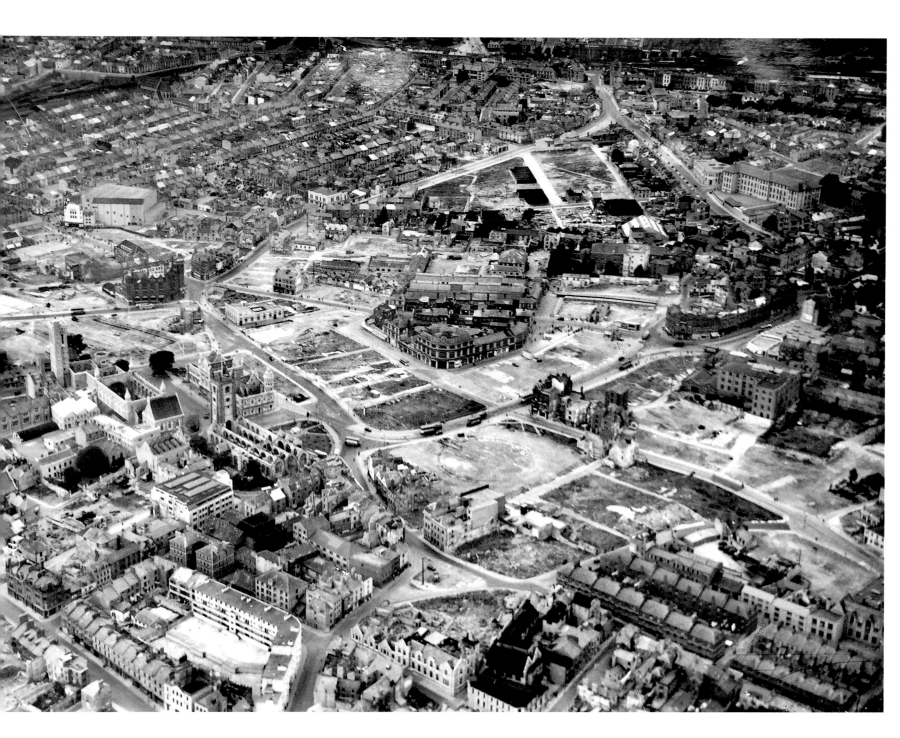

CITY CENTRE RE-PLANNING c1946

Our Then image bears the stamp of J Paton Watson, City Engineer and Surveyor on the back and was sent with a personal note from Paton Watson dated November 1948. The photo shows a crudely imagined Royal Parade, a roughly redrawn Old Town Street, and a hint of Armada Way in the middle of Royal Parade. It also offers an excellent appraisal of what was still standing in the city centre some five years after the Blitz, including the Corn Exchange and parts of the market, just west of Old Town Street, the early twentieth century red-brick Prudential building and the massive Odeon cinema (opened as the Regent in 1930). St Andrew's Church, like the Guildhall, is still a shell, while the stone fabric of the Municipal Building, most of which survived the war, has now been demolished. Humm's garage, newly opened in the late 1930s, the Co-operative Society's two-storey 1932 furniture store and the Civil Defence HQ on the site of the current Theatre Royal are among those wartime survivors destined to be cleared away in the reconstruction process. Meanwhile the 1935 Telephone Exchange, the late-30s Car Sales building and the New Continental Hotel are among those conspicuous pre-war structures still standing today.

Note how the traditional routes from the city centre to Sutton Harbour via Whimple Street and St Andrew Street were both compromised after the war: the former with the construction of an electricity substation where the road curves around into Buckwell Street, and the latter with the erection of the Magistrates' Court, right across the street line. Note too the dark line across the top of the earlier image that is the erstwhile railway route into Millbay.

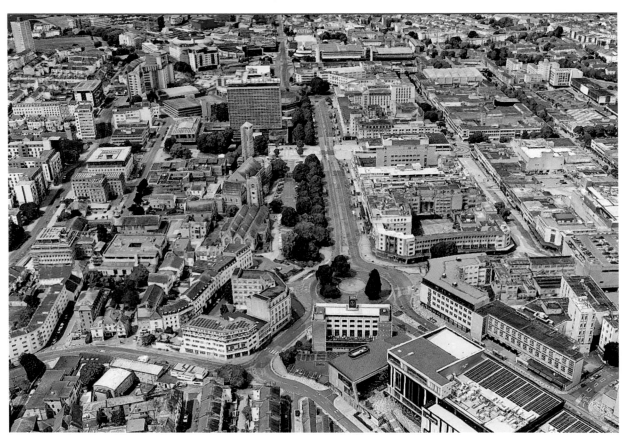

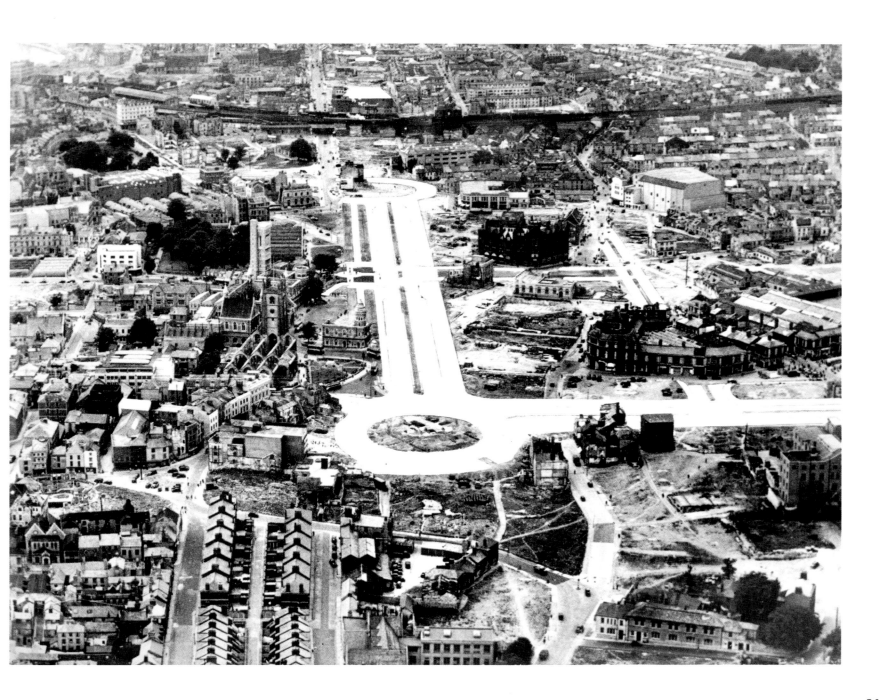

31

BRETONSIDE c1946

We're looking down Looe Street and How Street, the clean lines of the late-nineteenth century Corporation Dwellings, then barely 50 years old, dominating the middle section at the bottom of the earlier image. The street pattern south of this stretch has changed little although Looe Street with primarily Tudor and Jacobean buildings lining the left side as we see it here, was lucky not to have been destroyed soon after this. That it was

saved and still stands today is thanks almost entirely to the endeavours of the charitable organisation that is the Plymouth Barbican Association (Trust). Today the abundance of trees in the neighbourhood impact on the readability of the street pattern, as do the number of parked cars. North of Looe Street there were fewer survivors as the bomb sites lining either side of Treville Street, winding down from Old Town Street bear witness. The Spread Eagle (demolished in the late-1950s) stands isolated at the top, while the King's Head, at the bottom here, still stands today.

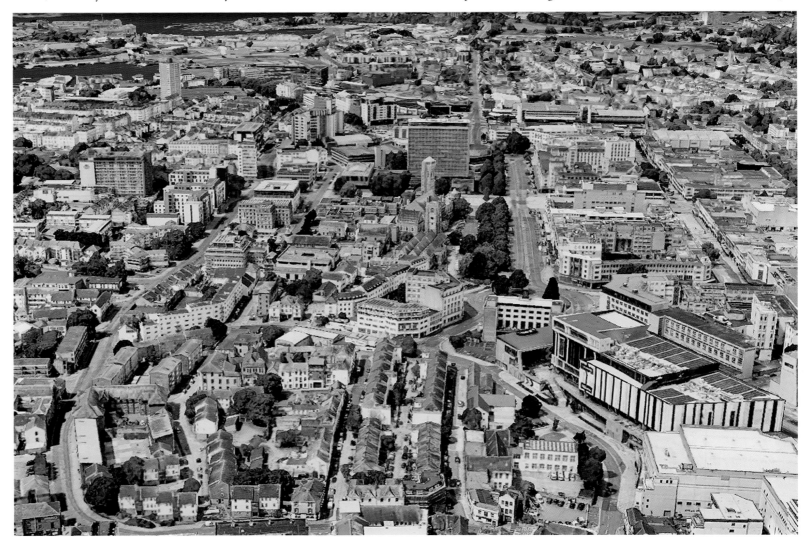

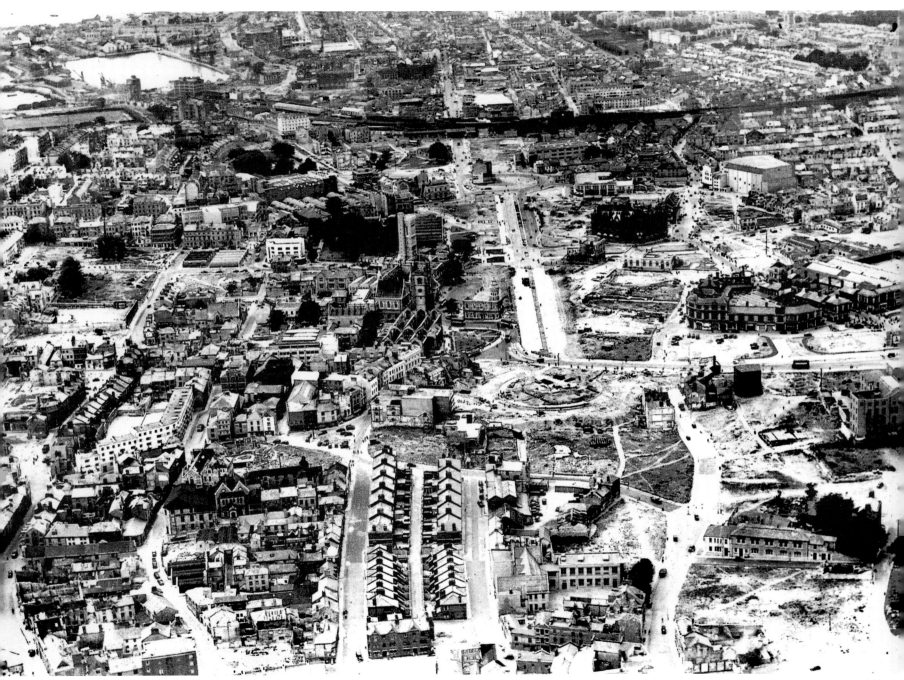

CITY CENTRE SEPTEMBER 1949

We have a date – 21 September 1949 – and clearly Plymouth's new city centre is well under way. It is almost two years since King George VI and Queen Elizabeth were here to confer royal status on the new east-west thoroughfare. Elsewhere a lot of much needed housing has appeared on newly acquired sites beyond the pre-war city boundaries and now some effort can be channelled into rebuilding the shopping centre.

The Woolworth building in New George Street is almost finished and work is progressing on what will become the first post-war department store to be built in England – Dingles. The Prudential building is still standing, as is the Corn Exchange, most of the western side of Russell Street, part of Westwell Street, the late-thirties car showroom, Humm's in Princess Square, St Andrew's School to the left of the Guildhall and the massive Regent (Odeon) cinema at the end of King Street – all of them destined to come down at some point over the next 15 years. There were plenty of other casualties here too and very few survivors – among them: the Car Sales showroom in what is now Colin Campbell Court, the ABC (Royal cinema – now Reel) and, of course, the Guildhall itself and St Andrew's Church, then in an advanced state of reconstruction.

We can clearly see the beginnings of New George Street and the first steps towards what was to become Armada Way, but note the many properties that would be sacrificed to make way for Western Approach and the dark lines of railway track that were still carrying goods traffic in and out of Millbay Docks. The station itself had closed to pedestrian traffic during the war but the hotels to service that facility – the Albion (subsequently extended and subsumed within the Continental) and the Duke of Cornwall (out of picture to the left) all continue to operate.

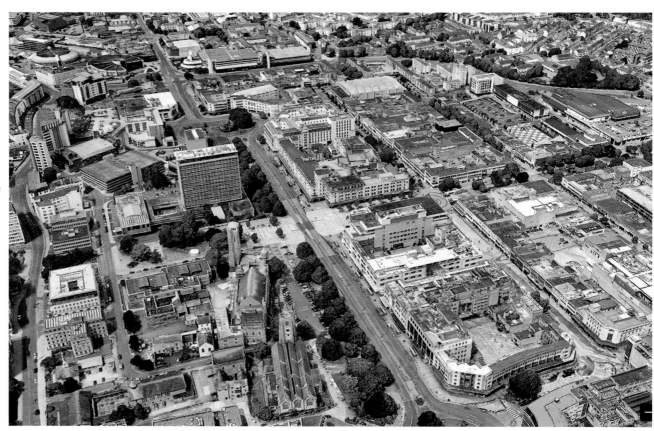

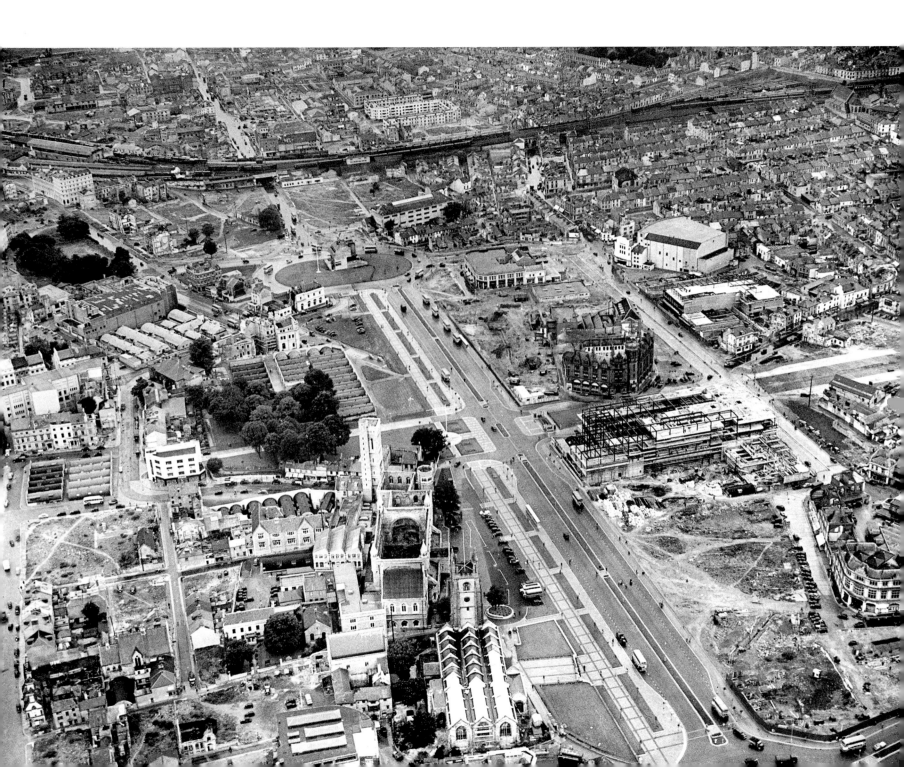

DINGLES 1951

We have a date of March 1951 for our Then image: the hoardings are still up around the Dingles building, the steelwork for the first phase of the Pearl Assurance building is on its way up, while the further along Royal Parade structural elements are being added to the framework of the Norwich Union House. The Corn Exchange is still open for business but the familiar redbrick Prudential Building, across from Dingles on the other side of what will become Armada Way, has almost disappeared. Above it, in the rapidly emerging New George Street, we see the completed Woolworth building – a few months earlier, back in

November, it had earned the distinction of being the first new store to open the post-war city centre.

Taking the silver medal as the second store to open was Dolcis shoe shop, the back of which we see here. It opened in August 1951, just a week or two before Dingles opened their doors – on 1 September.

The Odeon cinema basks in sunlight at the bottom of Cambridge Street, which like so many of its neighbours, Well Street, Tracy Street, King Gardens, Morley Place – and Morley Street which cuts through the middle of them all – survived the war, pretty much intact.

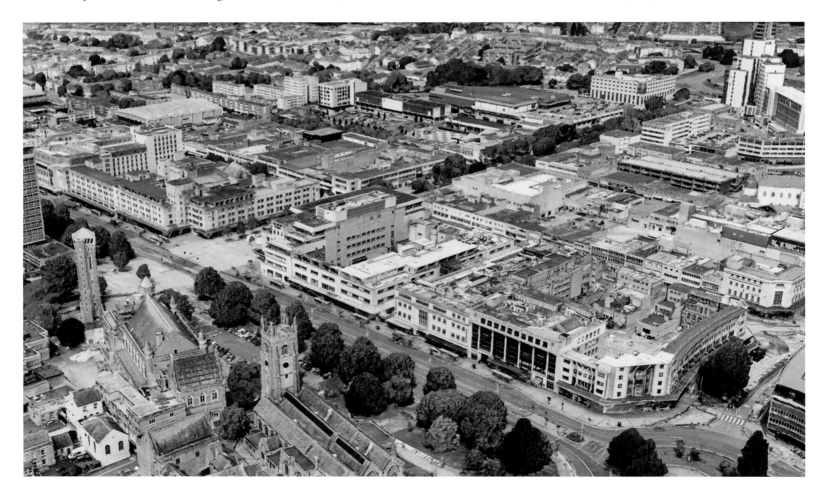

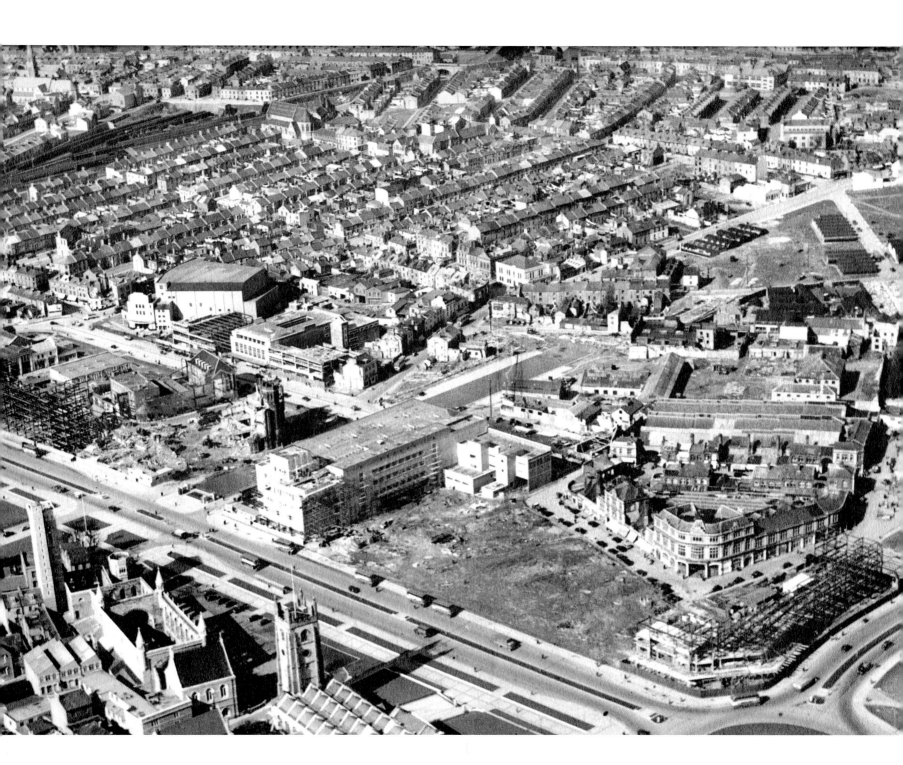

CHARLES CHURCH 1951

We have no exact date for our Then picture but the hoardings are down on Norwich Union House but still up on the Marks & Spencer store, which suggests somewhere in the middle of 1951. Early that month the contractors for the former, Dudley Coles, put an ad in the Herald: 'Ten months ago today if you had looked at the site of Norwich Union House you would have seen nothing showing above ground level. Since that time this major building project has been carried to completion and is today officially opened.' The then neighbourless Marks & Spencer store opened a few weeks later on 29 November. We also see here the original Drake Circus development, the Telephone Exchange, still visible today behind the 2006 Drake Circus, the former western end of Ebrington Street, and, of course, Charles Church. Left as a memorial to the civilian war dead of Plymouth, the city's second parish church sits today in the middle of a large multi-laned roundabout.

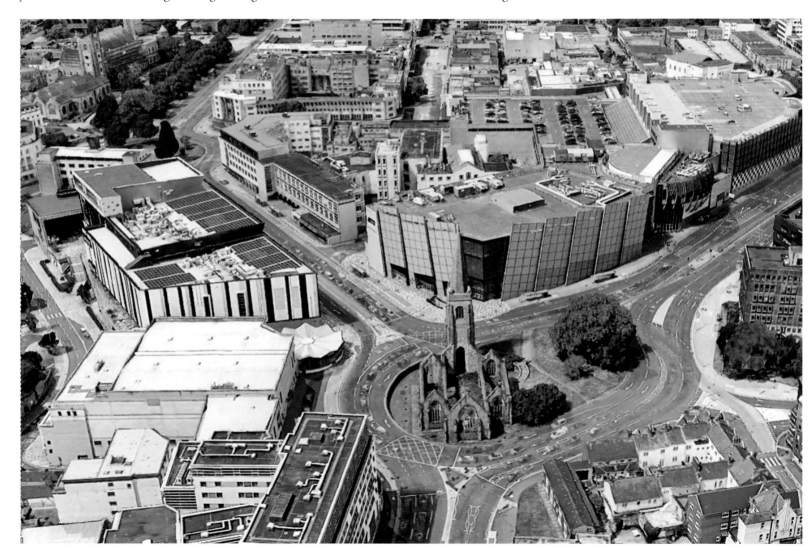

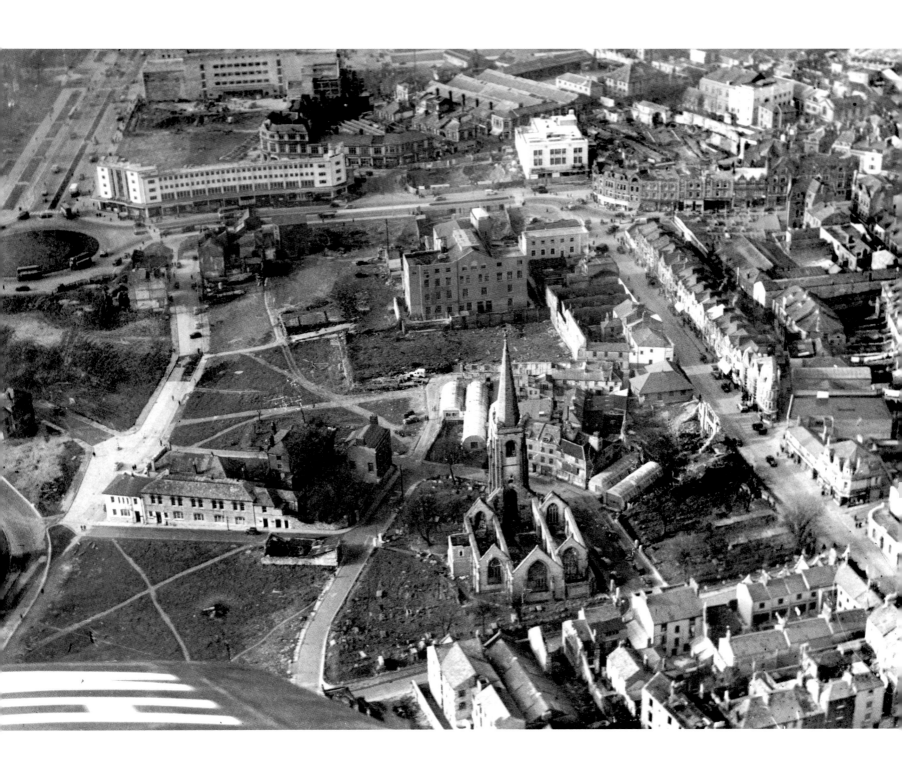

OLD TOWN STREET 1954

March 1954 is the date we have for our Then image: Marks & Spencer have Truform and Boots on their southern flank and Timothy Whites to the north on the corner of Cornwall Street. The distinctive form of Central Methodist Hall, where many a wartime council meeting was held, sits across from the well-known pharmacists who already have another outlet in New George Street, down by Woolworths. Clearly the grid pattern of the new city centre is starting to impose itself on the Plymouth psyche ... and before long will be confusing many! Armada Way (although not yet named as such), is also starting to take shape, but its gestation will be the longest of all. Many of the pre-war survivors are now not long for this world, although Drake Circus will enjoy another decade at least.

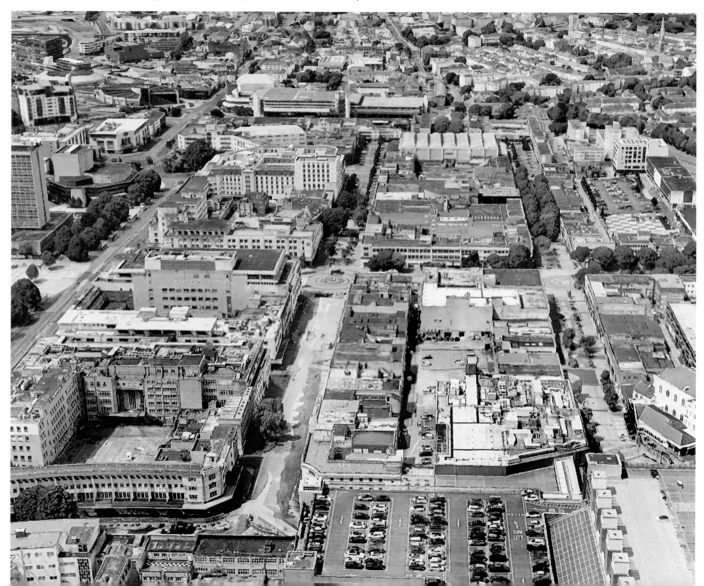

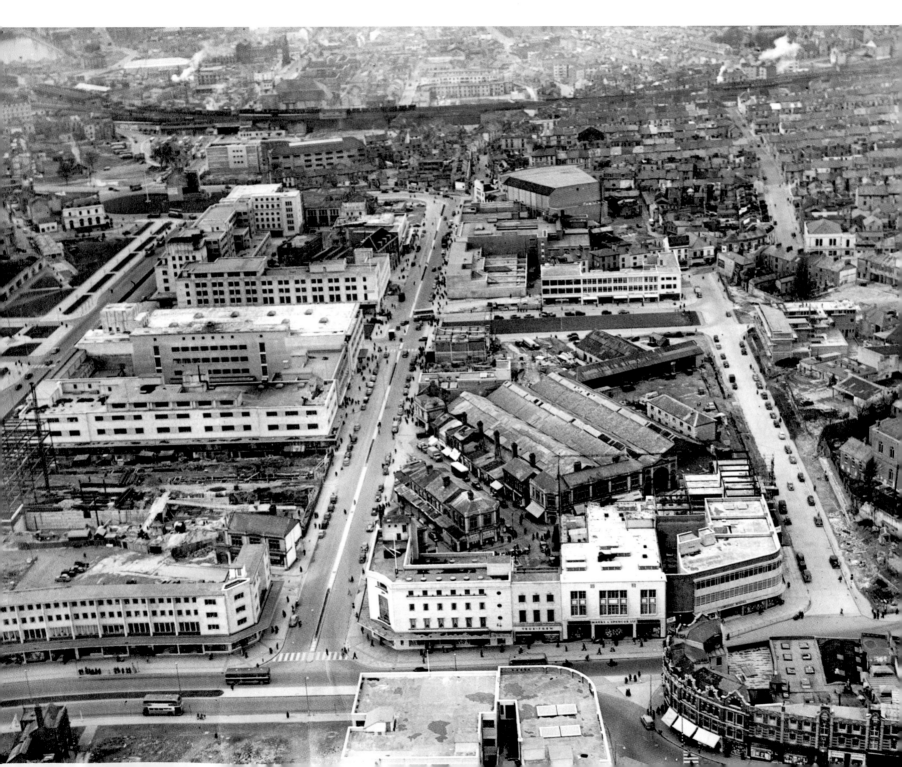

ROYAL PARADE 1953

The north side of Royal Parade is almost complete, although Spooner's (later part of Debenhams) is still an ongoing project and work has yet to begin on the Lloyds Bank/Pophams building. The western end of New George Street is well under way, although the pre-war Odeon (Regent) cinema, opposite the original Barley Sheaf at the bottom of Cambridge Street, still has another few years to go, as does what is left of Plymouth Market tucked in behind the west side of the work in progress that is the 'new' Old Town Street. At the top of that thoroughfare we can still see the original c1900 Drake Circus while to the east of Old Town Street, the 1935 premises of Plymouth's Telephone Exchange stands proud, as it does now, albeit surrounded now on three fronts by the present iteration of Drake Circus.

There are a few new properties in the newly laid out Cornwall Street but to date only a hint of what is to become Mayflower Street. Work on Royal Parade has also begun but it will be a long time before that boulevard will be anything like finished! A large part of the area south of Cobourg Street has been cleared, much of it by the Luftwaffe and the site is peppered with Nissen huts, while Cobourg Street survives largely untouched by the bombing but is soon to be devastated by the developers. Note too how North Road East and West still meet in the middle.

The Royal Insurance building still has scaffolding on its back elevation, while the National Westminster Bank, at the eastern end of Royal Parade, has yet to be lifted off the drawing board of their staff architect BC Sherren. St Andrew's Church has a new roof, but the Guildhall doesn't – yet. All of this points to a likely date of 1953 for our earlier aerial image.

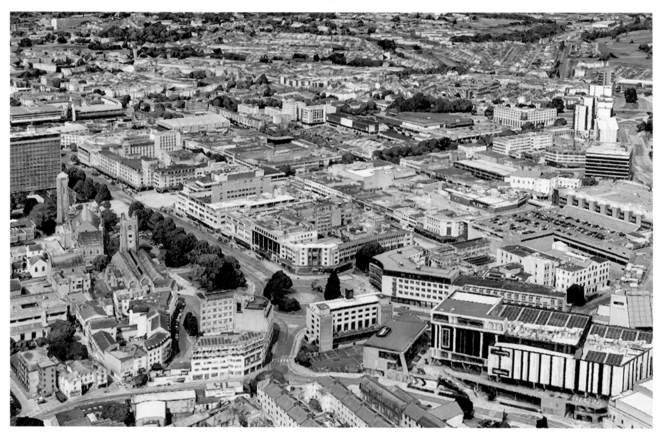

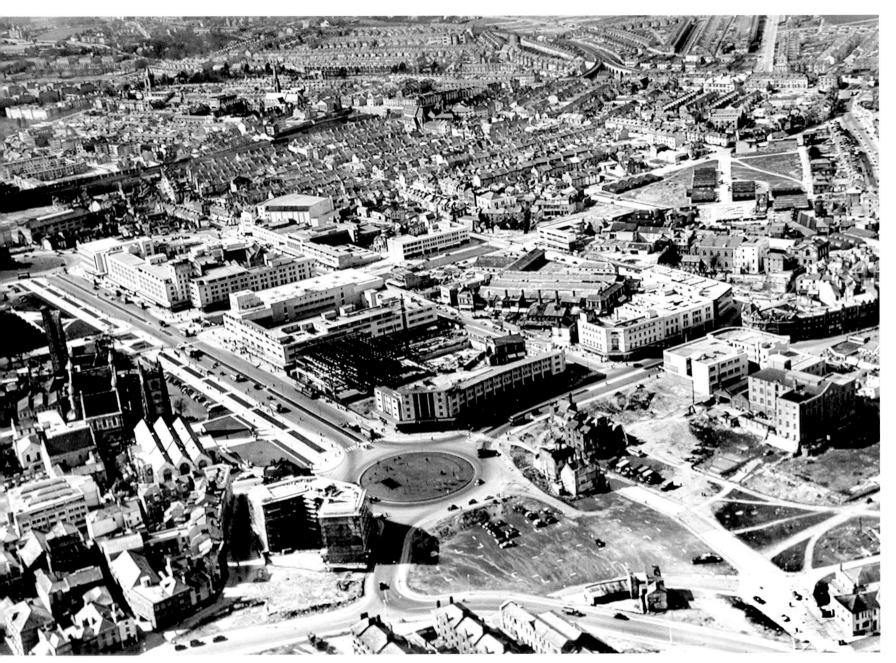

43

ROYAL PARADE LOOKING EAST c1947

Some of the major features appearing in both images provide the obvious links between the two. Armada Way has just been laid out and despite the changes all around it, instantly gives us a fixed reference point. Sutton Pool too, these days awash with yachts and moorings, makes a big impact. However moving down from the top right corner we can see St Andrew's Church and the Guildhall, both as shells in the earlier picture; Derry's Clock with the Bank behind it sits just above the old Royal cinema, which like the distinctive art deco building in what is now Colin Campbell Court, just managed to pre-date the war. A century earlier and still standing, the Crescent in the bottom right hand corner gives us another clear reference point, but thereafter the overlaps are few and far between. The distinctive rebuilt roof of the late-1930s offices of the Western Morning News and Evening Herald at least covers the same footprint although the structure beneath is very different today.

Other 1930s structures that were still around in the late-1940s included the massive Regent/Odeon cinema which was to survive another 15 years or so, the Co-operative furniture building, which wasn't, and the imposing Mumford's garage and car showroom in St Andrew Street which stood until it was demolished in the late-1970s to make way for the new Magistrates' Court.

As with other immediately post-war aerial images one of the most striking features here is the visibility of the pre-war street layout, especially the small back alleys and little lanes and the charming little park that formerly occupied the site across from the Crescent. Close examination of the earlier image also reveals a large number of Nissen huts dotted around the city centre, most notably those that were serving as the NAAFI alongside the ABC Royal cinema.

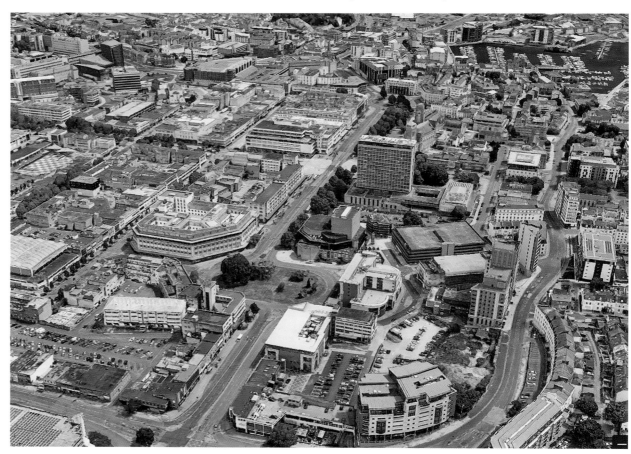

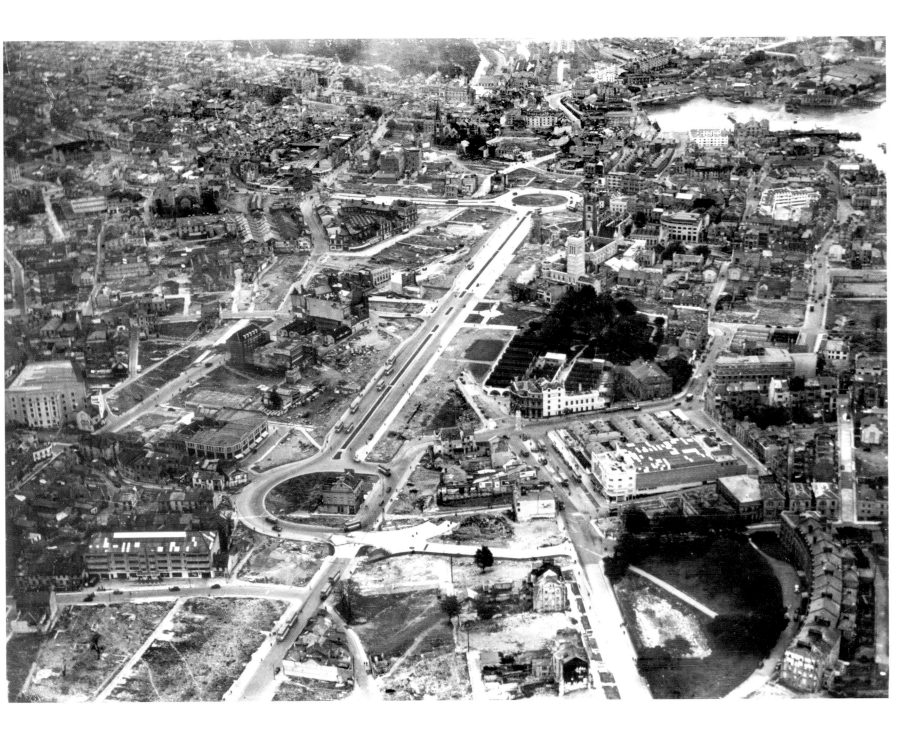

NEW GEORGE STREET 1950

The familiar landmark, erected as a water fountain but never evidently working as such, Derry's Clock tower stands proud at the end of Lockyer Street alongside the former bank building now serving as a public house – the Bank. Further up on the southern side of Royal Parade, which looks strangely exposed without its now fully mature double line of trees, we see the two other familiar landmarks, St Andrew's Church and the Guildhall.

With the exception of the reconstructed Leicester Harmsworth House in New George Street, nothing else survives from the pre-Blitz era. Disappearing even faster than the wartime survivors was the pre-war street plan, although at the end of the developing New George Street we can quite clearly see Market Avenue and East Street making a 'v' shape at the top of the photograph. Mill Street too is discernible running down across Russell Street to the Odeon. There is also the original Raleigh Street curving around the Co-operative furniture store at the bottom of the image, into the pre-war Courtenay Street.

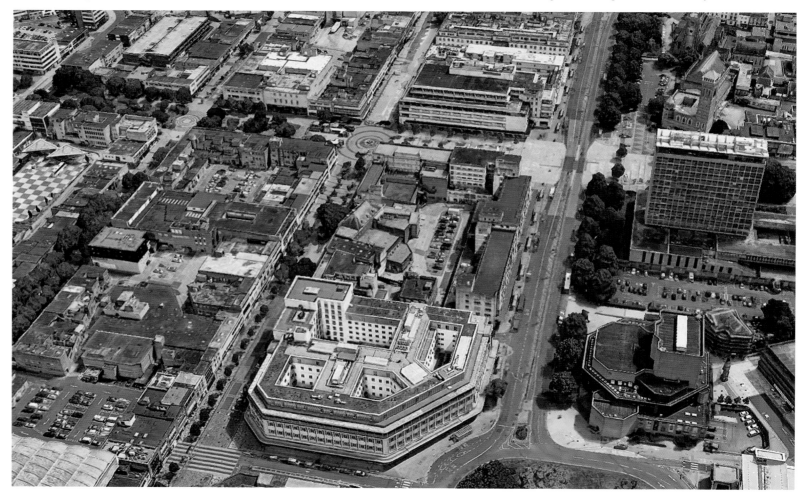

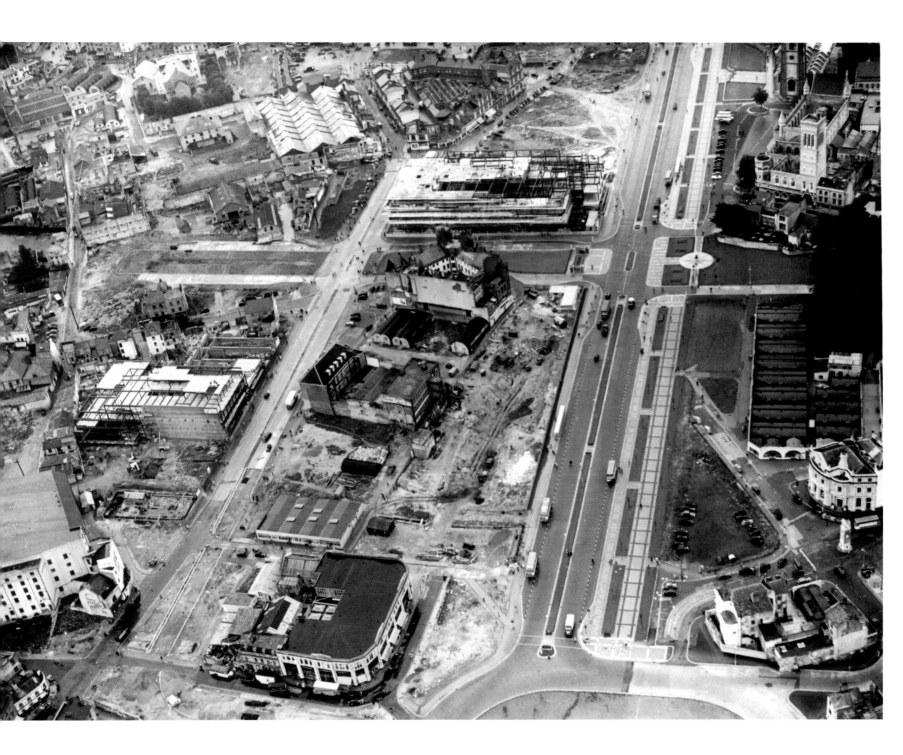

ST ANDREW'S CROSS 1952

The redevelopment of Plymouth city centre was sufficiently advanced for the similarities between these two images to be obvious, and yet there have been a good many comings and goings in the meantime. St Andrew's Cross roundabout provides an easy reference point, with Royal Parade and Old Town Street already radiating off it – the link to Charles Church, however, is yet to become apparent. On the south eastern corner of the roundabout the Royal Insurance Building is all but finished and the restoration of St Andrew's Church itself is well under way. Work on Norwich Union House has recently been completed while John Yeo's locally owned department store was nearing completion.

Boots, on the eastern corner of New George Street was open and trading, as was Marks & Spencer next door. The Corn Exchange, a Blitz survivor, has gone but parts of the old market are still to be seen. The original, turn-of-the-century, Drake Circus building still stands, opposite the newly finished Burton building – the former was to survive for another decade or so, while the latter would only be good for half a century, before a third incarnation of Drake Circus would occasion its demolition. A second version of Drake Circus came and went during that same half century.

Among the other notable wartime survivors no longer with us are: a handful of properties on the northern side of Whimple Street; the entire western end of Ebrington Street and the whole of both Park Street and Clarence Street to the north of it − their sites swallowed up by Drake Circus and Arts University Plymouth (Plymouth College of Art & Design). Long gone too are Saltash Street that ran up from Old Town Street past the front of Central Methodist Church, Duke Street, and just behind Drake Circus, the Bedford Vaults and the short-lived but much loved El Sombrero cafe.

As for a few more links in common, check out the former Public School campus, the redbrick buildings below The Box and St Luke's chapel.

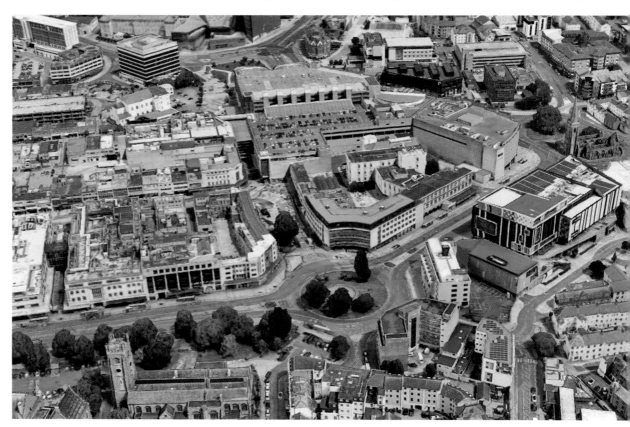

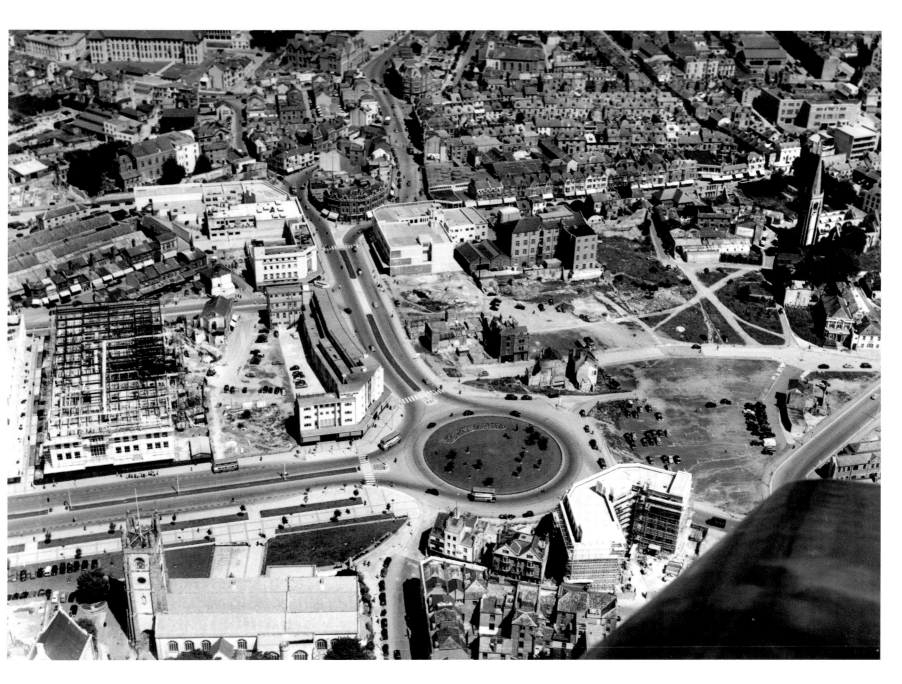

ARMADA WAY LOOP c1953

The top end of Armada Way has changed massively since it was first laid out. Designed to run from the post-war North Cross roundabout to the Naval War Memorial on the Hoe, here we see an early version of the stretch between Cornwall Street and what would become, in the early 1960s, Mayflower Street.

Our main key here is Public Secondary School in Cobourg Street: built in the late-1920s and soon to celebrate its centenary, the structure is now an integral part of the University of Plymouth, as is what is now known as the Reynolds Building on the opposite corner of the lower end of James Street – currently obscured here by Beckley Point and the student accommodation block on the south side of Cobourg Street.

Many past pupils will recall Public School and the wall in the middle of the playground separating the boys from the girls, others will also remember the YMCA building, opened in 1958, which preceded Beckley Point, and Allen's Garage, later partly redeployed as the Chicago Rock Cafe and later later Kepi Blanc before being replaced by a building more than twice the size. Some will also remember this stretch of Armada Way when it provided short term parking in 'the loop' – tree-less for years – it curved around between Cornwall Street and Mayflower Street.

Clearly this area has not only greatly changed from what it was before the war but what was here 50 years after the war. It will doubtless change significantly again over the next few years, as Armada Way is reconfigured, again, and the city centre itself shifts further in the direction of residential accommodation and away from being purely a retail destination.

Incidentally, it is pre-war Richmond Street that runs down the middle of the earlier picture, with Milton Street on the far right running almost parallel and, towards the corner bottom left we see the old South Western Hotel and Richmond Brewery on the corner of York Street and Richmond Lane South.

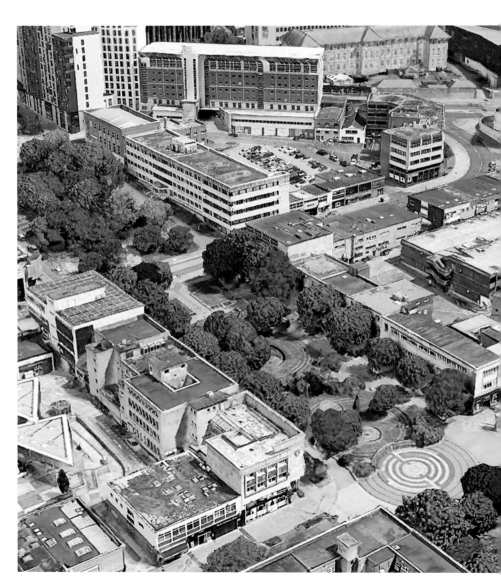

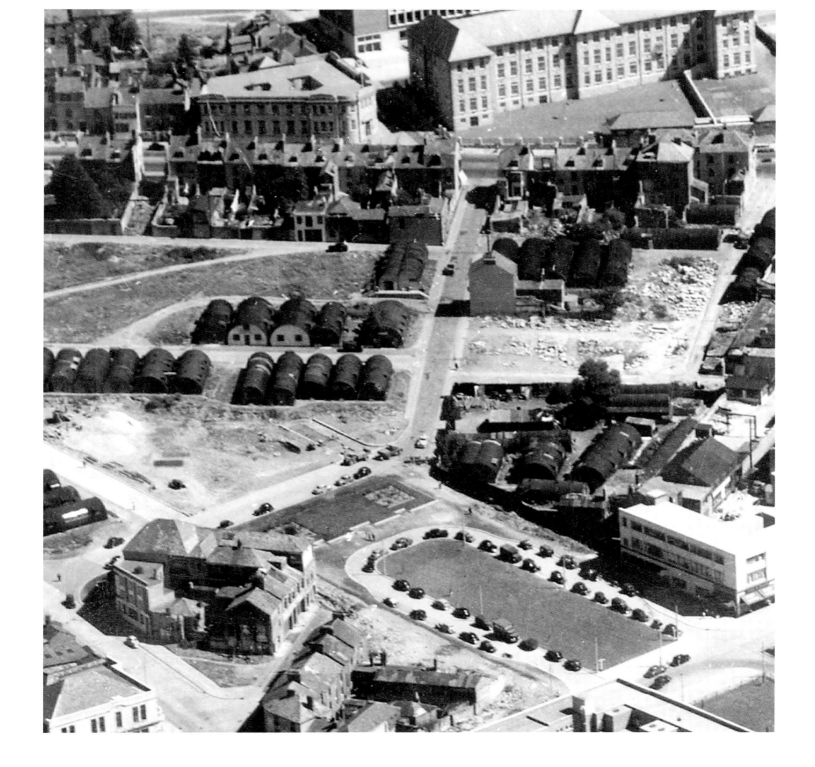

CENTRAL METHODIST 1947

If any one pairing of images in this book encapsulates the changes between pre-Blitz and post-Blitz Plymouth this has to be it. There's very little here to link the past and present, just the line of Oxford Place, top left and Cobourg Street top right. The latter of course includes the former Public Secondary School and it's near neighbour on the other side of James Street. There are a couple of other, isolated pre-war structures – Central Methodist Hall, half-way down on the right – and Leicester Harmsworth House, opened just before the war, in what was Frankfort Street and is now New George Street, although little more than the façade of the former Evening Herald/Morning News building remains today.

Otherwise what we see here is the essential encapsulation of the *1943 Plan for Plymouth*, with its simple grid pattern feeding off the central north south spine that is the modern Armada Way.

Sadly however, although Armada Way is the key element to the post-war plan, it has not, to date, been allowed to become the clean and simple pedestrian boulevard that its principal advocate, City Engineer, James Paton Watson, intended. However, there are, at the time of going to print, proposals on the table that might, hopefully, go some way towards fulfilling that vision. It is after all, the key to understanding the significance of a city that has the largest number of post-war listed buildings in Britain today.

With so many bomb sites in the earlier image it is significant that the principal survivors here were relatively new buildings in 1941, including the Regent cinema (opened in 1930 and subsequently restyled the Odeon) and the Co-op's furniture emporium (bottom left), opened in 1932. The other major features here are the old Pannier Market and Corn Exchange, bottom right. All were destined for demolition.

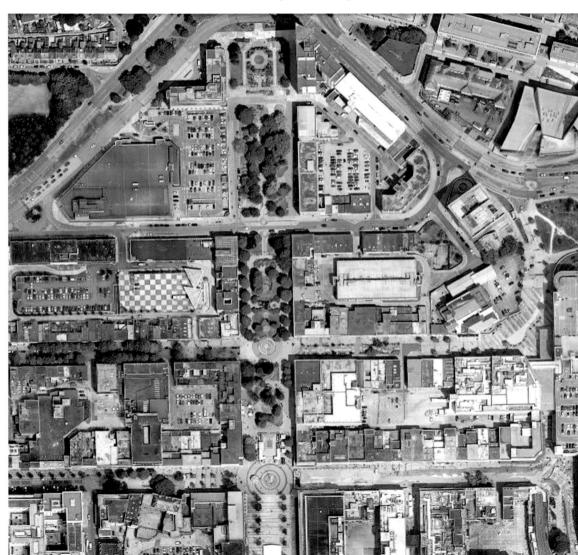

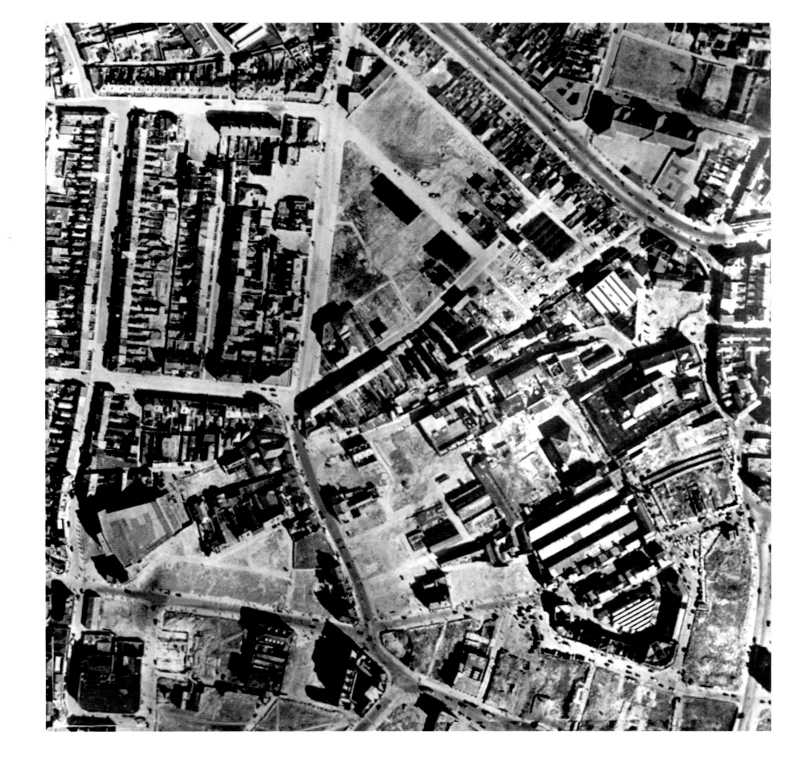

53

NEW GEORGE STREET 1948

For orientation purposes, Royal Parade, the former Public Secondary Schools, the Central Library (aka The Box) and the erstwhile offices of the Herald are clear links between the two images.

Royal Parade here is newly laid out and work has yet to begin on any of the properties that now front that iconic carriageway. New George Street is similarly yet to be lifted off the drawing board, however the then new Leicester Harmsworth House (December 1938) that was home to the *Western Morning News* and *Western Evening Herald* stands isolated in what was Frankfort Street. Indeed one of the most intriguing aspects of this image, which appears to date from September 1948, is the extent to which all the pre-war streets and alleyways are so easily identifiable. Russell Street here runs from just above the Herald building across to the left, with Willow Street running at right angles down towards the Odeon (formerly the Regent) cinema, then Willow Plot, before reaching a junction with Morley Street and Richmond Street (on the right). Coming back down Russell Street we see Mill Street snaking its way up to the back of the Central Methodist Hall and then

Frankfort Square and Library Lane, before reaching the junction with Frankfort Street and Cornwall Street. Cornwall Street itself ran up to the old market and into Market Avenue, then Old Town Avenue, before reaching into Old Town Street and crossing into Ebrington Street. Branching off the end of Cornwall Street to the right, up towards the Corn Exchange, is East Street which also terminated in Old Town Street. All of them are now buried beneath the modern city centre.

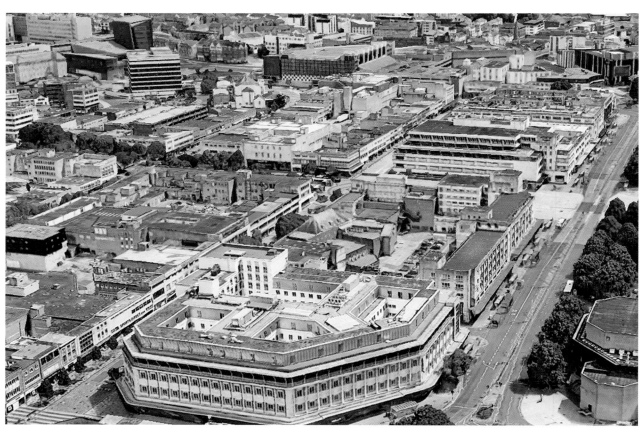

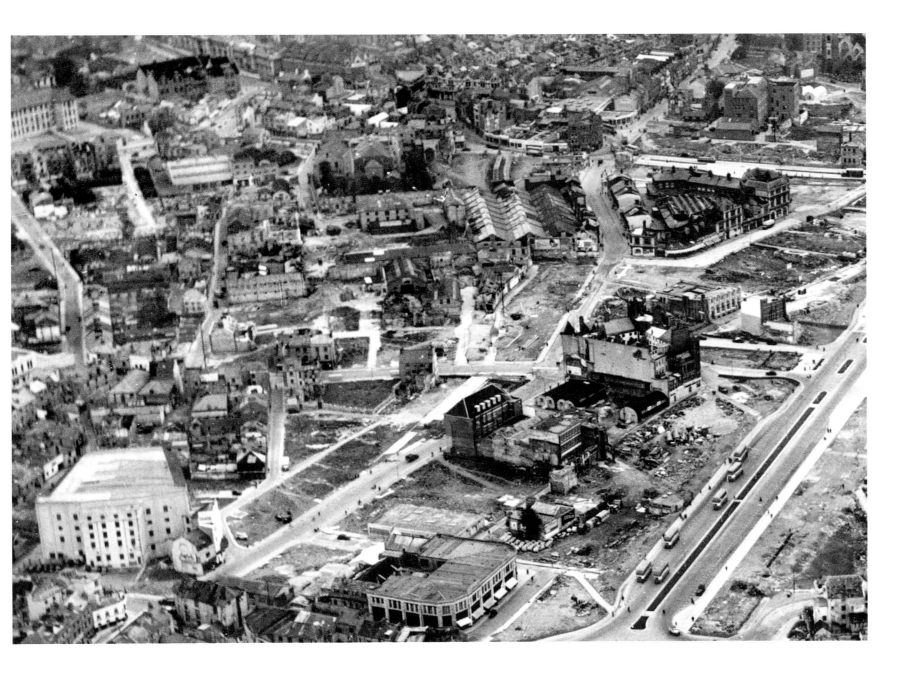

THE ODEON 1951

The Civic Centre was regarded in many respects as being the crowning glory of Plymouth's post-war city centre. Officially opened by Queen Elizabeth II in 1962, a key year in Plymouth's history, and yet it was barely 17 years since the end of the war and just 21 since the main Blitz assault on the city.

The Odeon cinema, looming large in the foreground here, closed in 1962, which means that when our Then picture was taken it still had some ten years of trading ahead of it. Remarkably the more modern entertainment emporium, the Theatre Royal, is still largely regarded as a modern building, and yet it opened only 20 years after the Civic Centre, which was 41 years after the Blitz and, as I write this, 41 years ago. Future historians will doubtless regard it as an integral part of the post-war redevelopment and indeed the site the Theatre Royal occupies is more or less on the footprint anticipated by the *1943 Plan*.

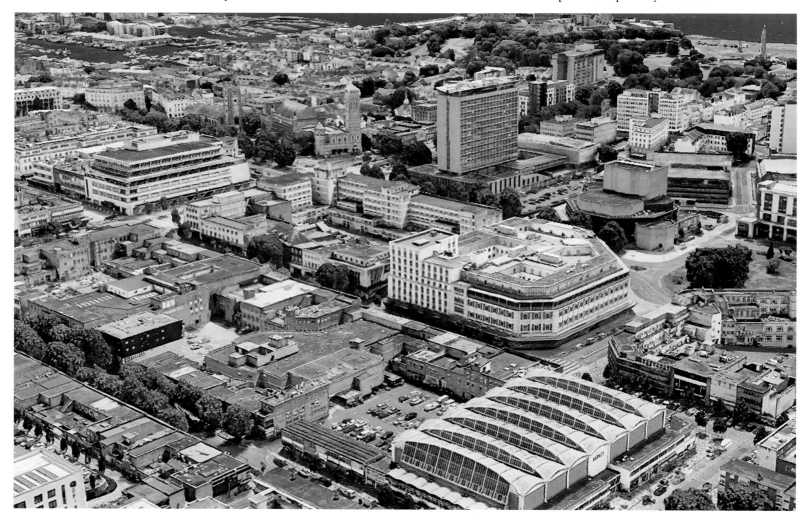

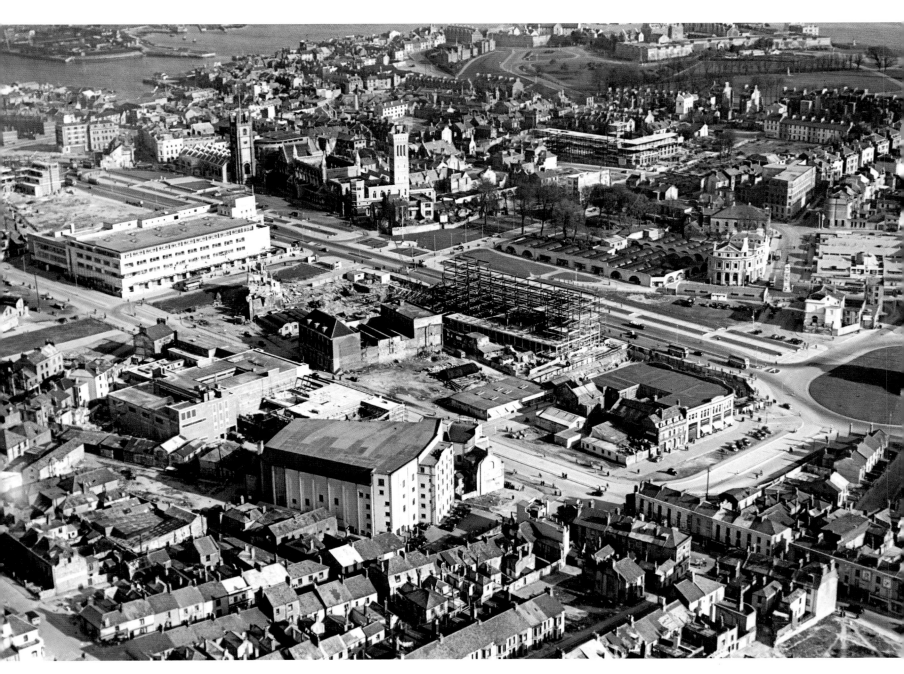

RALEIGH STREET 1951

October 1951 is the date we have for our Then image and for an interesting link between the two images have a look at the bottom right hand corner of both and there you will see the top two floors and roof of the former Car Sales/Habitat building currently located in Colin Campbell Court. Raleigh Lane runs left to right across the bottom of the image, right from King Street, which, as we see here, didn't quite align with the post-war New George Street. It's hard to imagine that all those smaller properties in the foreground were scheduled for demolition over the next few years and that the new Pannier Market would open here before the end of the decade.

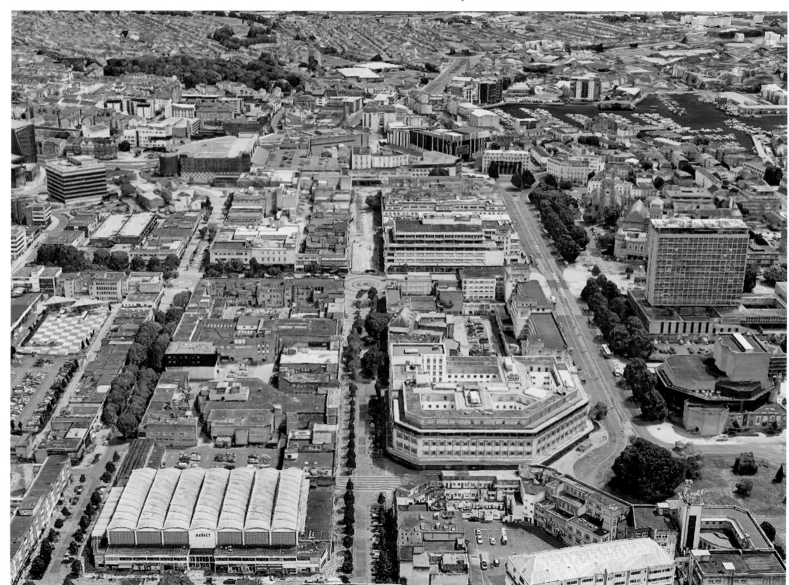

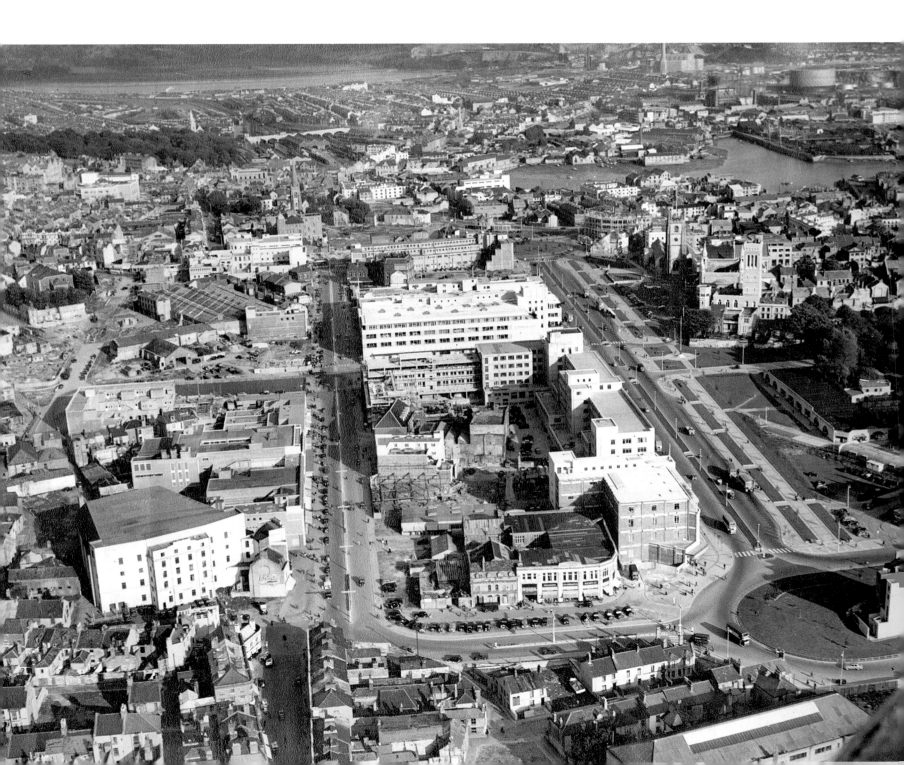

DERRY'S CROSS 1952

Just as King Street, the former Stonehouse Lane, didn't quite line up with New George Street, so Royal Parade didn't quite line up with Union Street. Doubtless this was in no small measure down to the decision to retain St Andrew's Church and the Guildhall forcing the grand new boulevard a little to the north. Oddly enough Union Street, laid out in the wake of Foulston's commercially motivated desire to unite the Three Towns and provide a a direct line to the original Theatre Royal, didn't quite line up with George Street and needed a dog-leg stretch – Bank of England Place – to complete the connection.

The first phase of the new Co-op is almost complete, the hoardings are still up, and the last days of the Co-op's 1932 furniture store are counting down. The 1930 Odeon will still be standing when the Co-op is completed, but by that time the Drake cinema will have superseded the earlier structure. Hard to believe though that the Drake wasn't destined to last a whole lot longer than the Odeon and that it would come to be demolished and replaced by a private casino, something that wasn't even entirely legal when the Drake cinema had opened in 1959

The line of that dog-leg can still be seen here, running in a north-westerly direction from the bottom of Lockyer Street and Derry's Clock tower.

Standing eerily alone in the middle of the then new Derry's Cross roundabout, we find what were the last survivors of pre-war Union Street on this side of Western Approach – No.s 190 and 191 – Levy & Sloggett and Halford Cycles.

Levy & Sloggett would later move to 32 Royal Parade and would later still be taken over there by Bowden & Son jewellers. Halfords meanwhile moved into Cornwall Street.

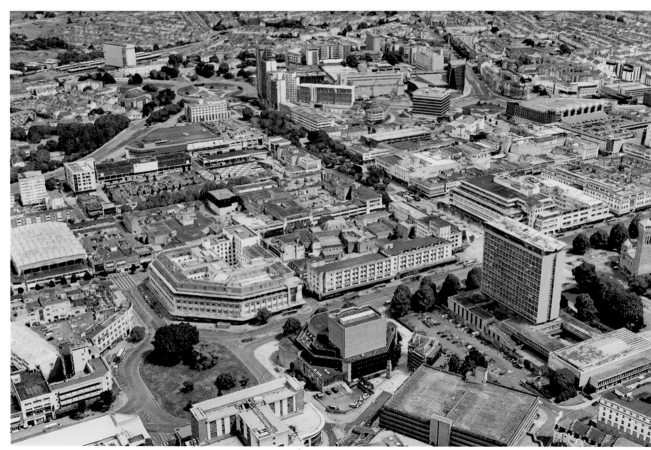

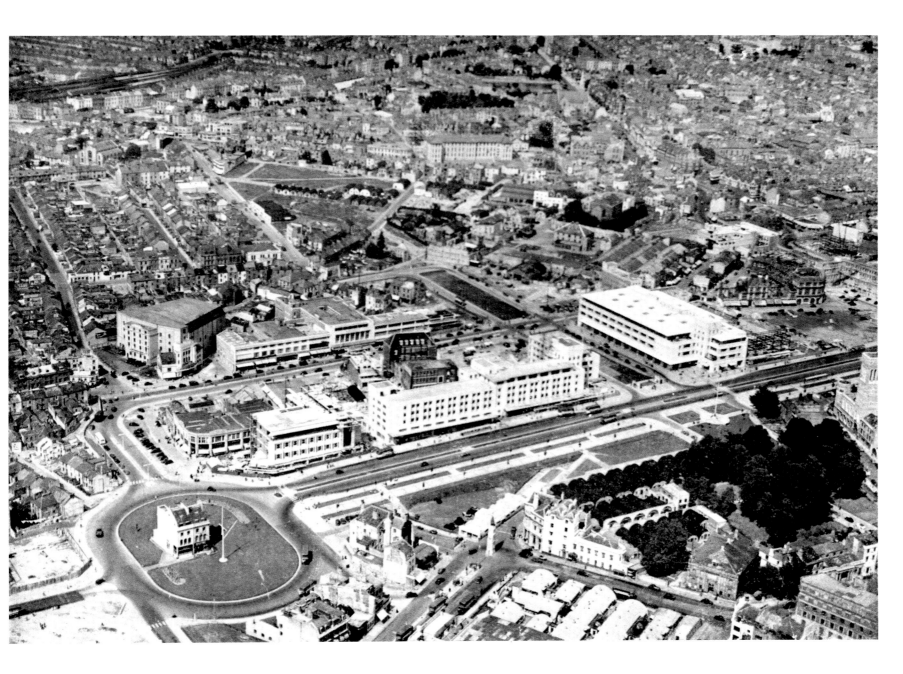

CO-OP & CRESCENT c1954

The first phase of the new Plymouth Co-op opened in November 1952. A large crowd gathered to witness the event and to explore the ground and lower ground floors. Generally people were heartily impressed with the size and scale of the new store, marvelling at the range of merchandise and fixtures and fittings. Four weeks later, and just in time for Christmas, the first floor was opened up for the sales of millinery, fashions, carpets and lino, and four days after that, 8 December, their new tobacconists, on the corner of Royal Parade and Courtenay Street, was open for business.

Before long the second floor was ready and the furnishing department, previously housed in the building alongside, moved up there and the earlier building was swiftly taken over by the tailoring and pharmacy departments. The third and top floor was given over to storage, soft furnishings and drapery workrooms, as well as a staff canteen, while the mezzanine floor was occupied by the ladies' hairdressing salon.

Time for the older building next door though was running out for, as we can see here, work on the second phase, of the Co-op's massive new development – starting on the corner of Raleigh Street and New George Street, was under way.

Meanwhile, another feature not destined to survive the changes, was the pleasant little park that was laid out in front of the Crescent, as now the extended Notte Street provides an alternative traffic route through the centre.

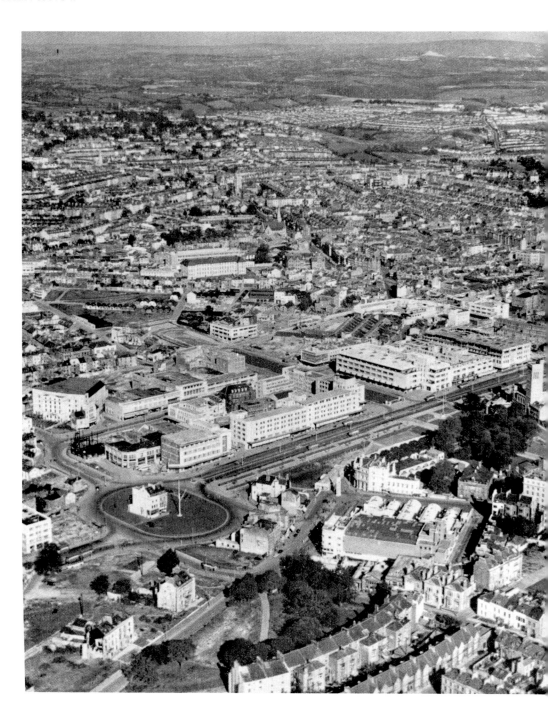

While the heart of the post-war Plymouth City Centre sits relatively as it was when 'completed' in the 1960s, the perimeter is rapidly forming a virtual wall around it. The Civic Centre, currently being given a much needed revival by Urban Splash, was the city centre's first tall building, now it is regularly being eclipsed by its near neighbours.

At 78 metres tall at its highest point, Beckley Point is currently the tallest building in the south-west, with 23 storeys to the Civic Centre's 14, it is more than three times the height of all other post-war, pre-Civic Centre buildings. Short-listed for the Carbuncle Cup as an ugly building it has divided local opinion as did the slightly earlier Roland Levinsky Building which actually won two awards, 2007's Best New Building (Abercrombie Architectural Design Award) and the 2008 Structural Award (Institute of Structural Engineers). Users say it would be better if its windows would all open but at nine storeys, like many of its Cobourg Street neighbours, it is also much taller than the post-war buildings it replaced. As is the building we see here in the bottom left corner, that was erected on the site of the four-storey, early-sixties Ballard Activity Centre. Imaginatively designed by architect Ian Penrose this ten-storey structure is full of features that help disguise its height. Meanwhile the 13-storey Crescent Point, further along on the eastern side, is more of a slab-like set of building blocks that have posed challenges not only on account of its original candy coloured cladding but also in terms of its failure to deliver adequate living space in its '400 modular pods'. Due to open as student accommodation in 2018 a series of long running legal battles meant that it was still closed as of the summer of 2022.

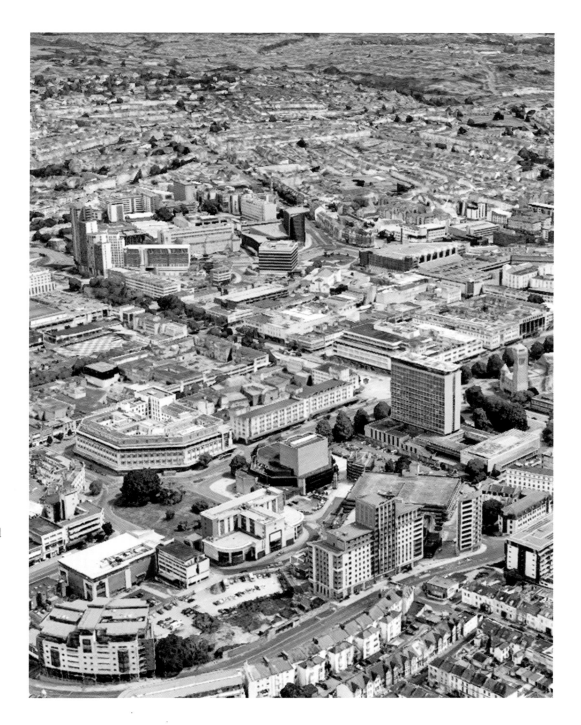

PLYMOUTH CO-OPERATIVE 1955

Opened in 1959 as the Co-op, the completed store was rebranded Derry's almost 40 years later, in 1998, after a major refurbishment. But the world was changing and out of town retail units were starting to impact on all of the city's department stores, here and elsewhere. In 2009 the Co-op sold to the Liverpool-based Vergo Retail Ltd, but very soon afterwards Vergo went into administration and in 2010 Aberdeen Property Investors purchased the whole block. Five years later the London-based Thames Bank Property Company bought the whole complex and in 2017, EHA, a Northern Ireland-based endeavour, armed with planning permission, began to transform the complex into accommodation for 500 students, seven retail outlets and 110 hotel bedrooms. The work was completed in early 2021 after some £60m was spent on the project. Argos, Ryman and a Premier Inn restaurant are among the ground floor occupants. Meanwhile all the other department stores have struggled, including Debenhams, British Home Stores and Dingles. An ever-increasing amount of residential accommodation is being introduced via redevelopment. It will be interesting to see what the city centre looks like in another 20 years.

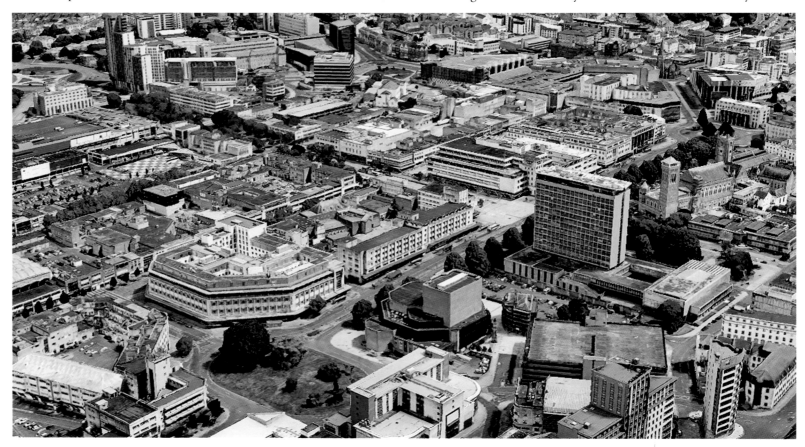

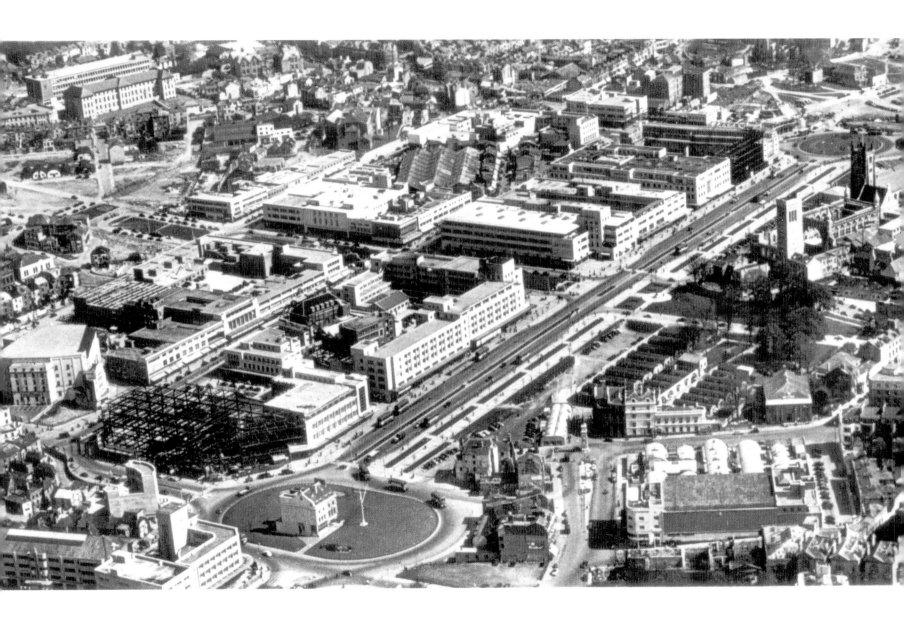

65

TRACEY STREET & KING GARDENS c1955

What is immediately striking about this pairing is to see just how much of Harwell Street, Well Street, Tracey Street, King Gardens, Cambridge Street and Morley Place was still standing some 16 years or so after the Blitz, or in other words, how many families were yet to be displaced in order to achieve the vision of the *1943 Plan*. One can't help but wonder if in the light of global concerns over carbon footprints it would be deemed acceptable today, particularly considering that Plymouth was said, once the city centre redevelopment had been completed, to have one of the highest retail footprints per-capita, in one area, in the country. Doubtless this was driven by the fact that Devonport and Stonehouse were to a certain extent 'shafted' after the war as the increasing number of motor cars and buses meant that planners didn't consider that improving the retail offer in Stonehouse and Devonport was all that necessary.

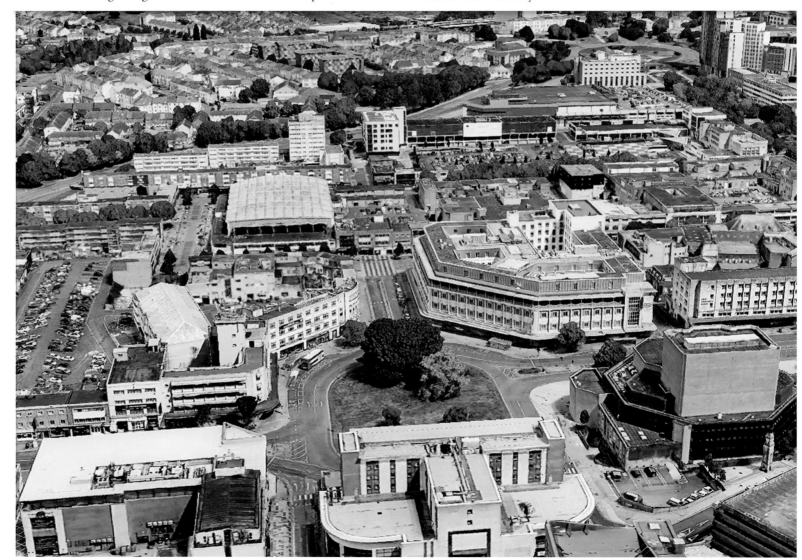

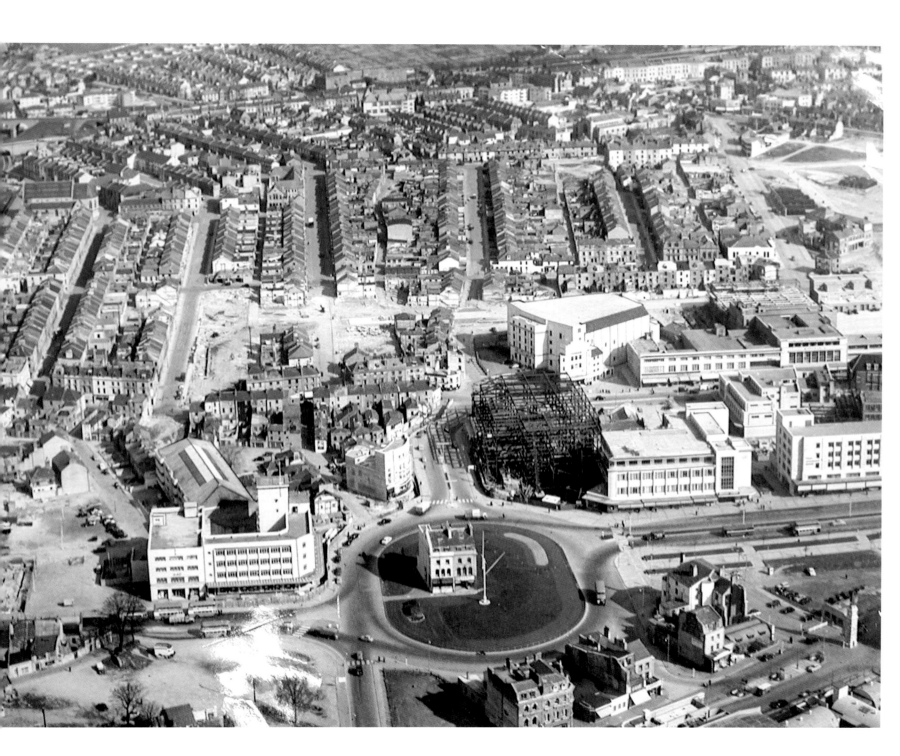

KING STREET 1954

We have a date of March 1954 for our Then image, the hoardings were still up on the new Costers building on the corner of Courtenay Street which was opened later that year, while the new FTB Lawson store had already been trading for sometime. Lawsons had opened on Saturday 22 November 1952 on the same site as its pre-war counterpart, indeed workers excavating the site found tools and a wheelbarrow from the shop's original stock. Costers and Lawsons have both moved on, the former building has now been occupied by WH Smith for many years now, while Lawsons now have a handful of outlets in SW Devon. Once again we can take stock here of the number of Blitz survivors in King Street and the streets either side of it, including Summerland Place heading up to the still-standing Car Sales property, with Henry Street, Summerland Street and Devonshire Lane heading west from it.

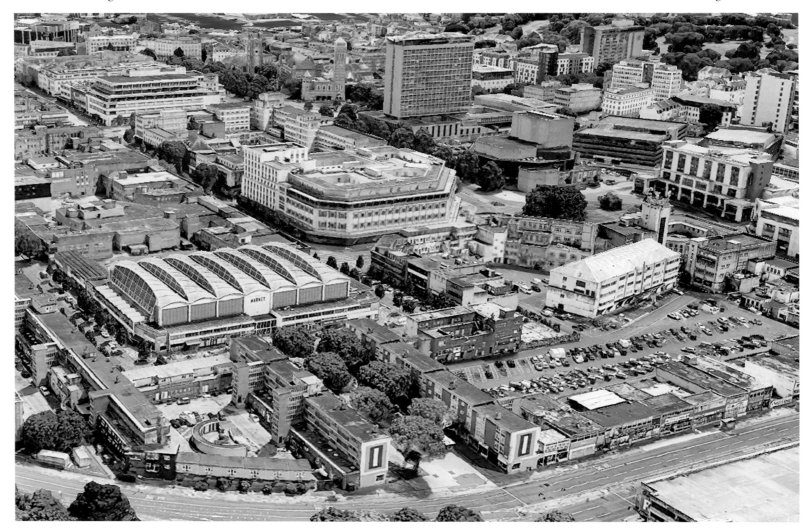

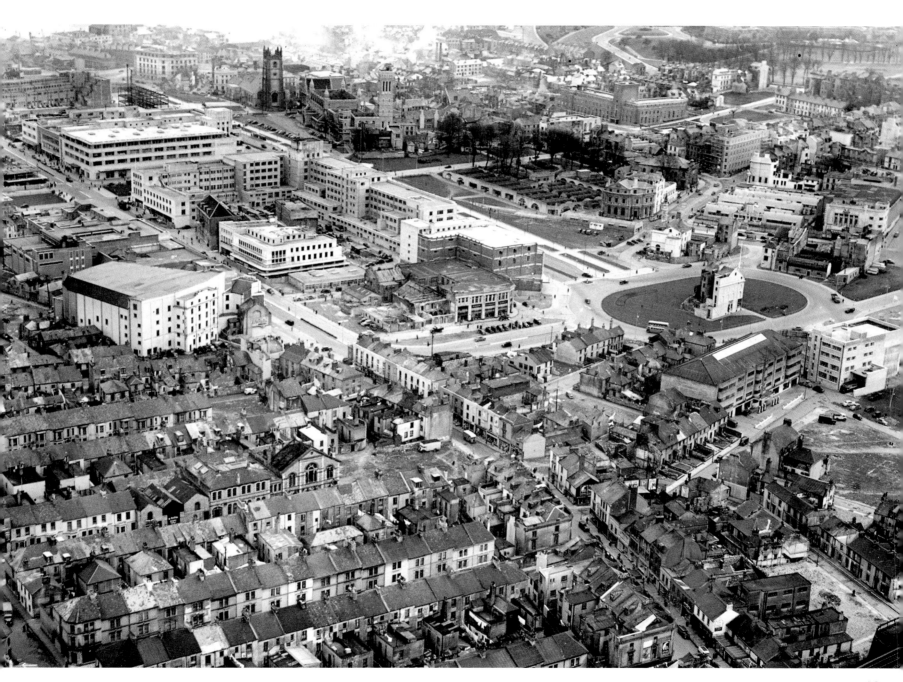

ARMADA WAY 1954

One early suggestion was to name this grand boulevard 'The Peoples' Way', the idea that this veritable spine running through modern Plymouth, the key to everything in the plan that branched off it on either side, including Royal Parade, should celebrate everything that all Plymothians lost and forfeited during the Second World War. Instead it bears a name that harks back centuries to a time when Plymothians might have suffered great setbacks, but didn't, as our Devon sailors, thanks to some help from the weather conditions, made light work of the Spanish Armada and the plans of conquest that lay behind it. Maybe, in the light of the public consultation that may actually go

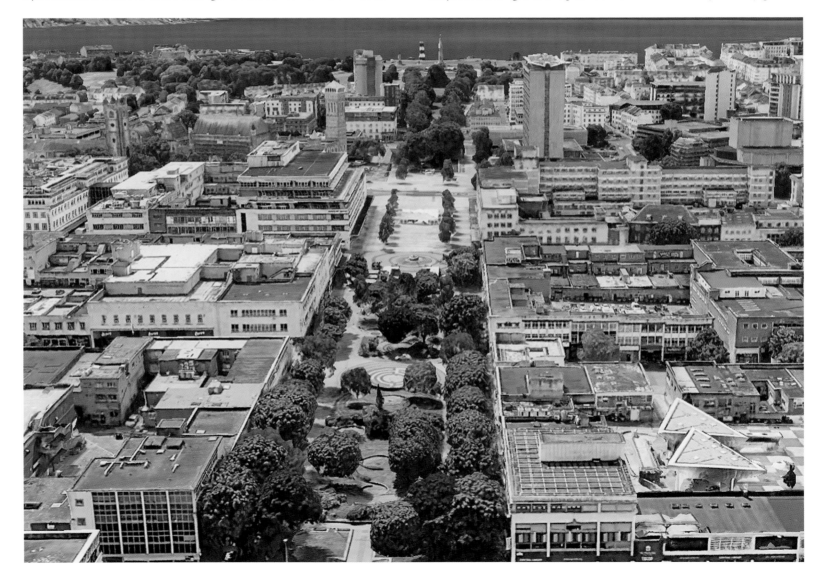

some way towards realising the original vision it may well be time to revive that name. This, after all, has the potential to be a world class walkway and one that could put Britain's Ocean City firmly on the world map. A walk way that doesn't lose itself in inappropriate planting, a walkway that leads all comers to our jewel in the crown, a walkway that looks as good on the ground as it does from the air. March 1954 is the date ascribed to this image: note how, while New George Street is nearing completion on the southern side, we still have the pre-war Russell Street cutting across Cornwall Street and bending around into the lower reaches of Richmond Street.

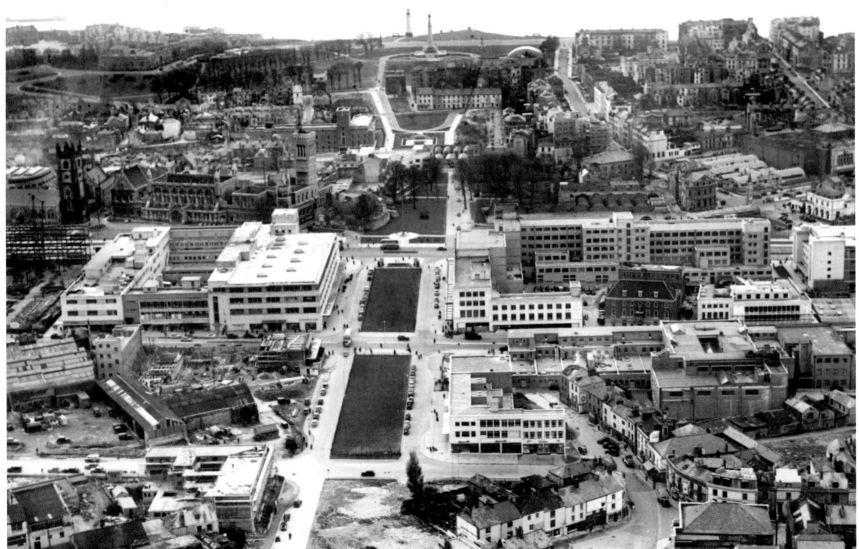

MILLBAY STATION 1947

The football ground in Millbay Park provides the most obvious link between the two images, while the line of Union Street and the distinctive shape of the Octagon provide a bearing across the top of the images. Millbay Road, Citadel Road, Martin Street and Bath Street also provide valuable keys to unlocking the myriad of changes that confront us here.

Foremost among them is the removal of the railway line into Millbay Station and its eventual replacement by the quirkily shaped Pavilion Complex. One can but wonder at the future of this early 1990s development, particularly now that so much of the complex is either redundant or little used today. Perhaps the recent designation of Bath Street as the city's link between the sea and the city centre will provide a boost to this neighbourhood, particularly in the light of the construction of the Moxy Hotel (2023) in part of the Pavilion's car park. The two impressive, Victorian hotels here, the Duke of Cornwall and the New Continental (incorporating the older Albion Hotel), still provide key features, but it is interesting to note that a number of key post-war buildings have come and gone in the years separating these two pictures, including: the Ballard Centre, a youth and community focussed facility, replaced by flats; the Drake cinema, replaced by a Casino; King Street Methodist Church, superseded by residential apartments at the end of the Crescent and the former Westward Television Centre alongside the Athenaeum.

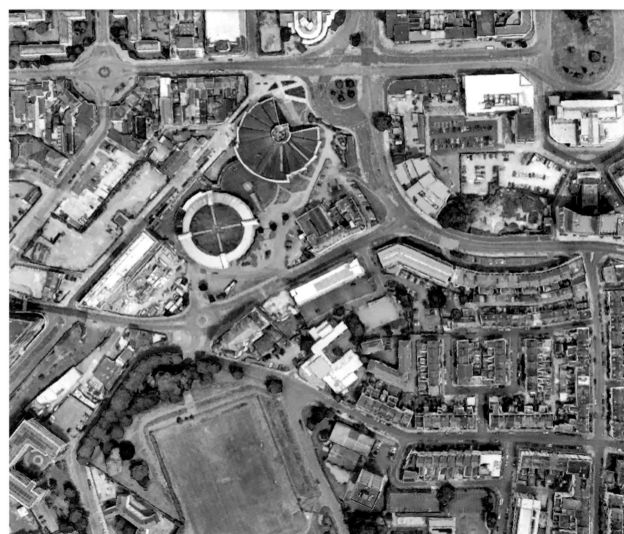

73

HARWELL STREET 1947

Quite a few bomb sites are visible here, notably in Wyndham Street East, Cecil Street, Hastings Street, Penrose Street, King Street and Devonshire Lane (at the bottom of the earlier image running parallel to Union Street, just out of the picture). As can be seen here, Well Street, Tracy Street, King Gardens and Cambridge Street, all substantially survived the aerial wartime bombardment, but clearly not the *1943 Plan for Plymouth*.

The curving line of Western Approach did much to alter the situation as everything to the south and east of it was demolished over the next decade or so – apart from the then new Car Sales building. Better known in more recent years as the Habitat building, it stands in the corner of Colin Campbell car park (and in the bottom corner of both images). Begun in the late 1930s this was a big building in its day, but clearly on nowhere near as grand a scale as Plymouth's Pannier Market seen here at the eastern end of the post-war Frankfort Gate.

Change was by no means restricted to the east of Western Approach though and below Wyndham Street West we can see that Cecil Street has been substantially redesigned. However, undoubtedly the biggest post-war changes that weren't part of the 1943 plan are those that have taken place along the line of the old railway network that serviced Millbay.

From the bottom up we find Sellon Close and Prynne Close, both named after major, nineteenth century ecclesiastical characters from the area. We also have Hetling Close running west off Harwell Street and Ocean City Place, named after the strapline for Plymouth that followed Spirit of Discovery in the early part of the twenty-first century.

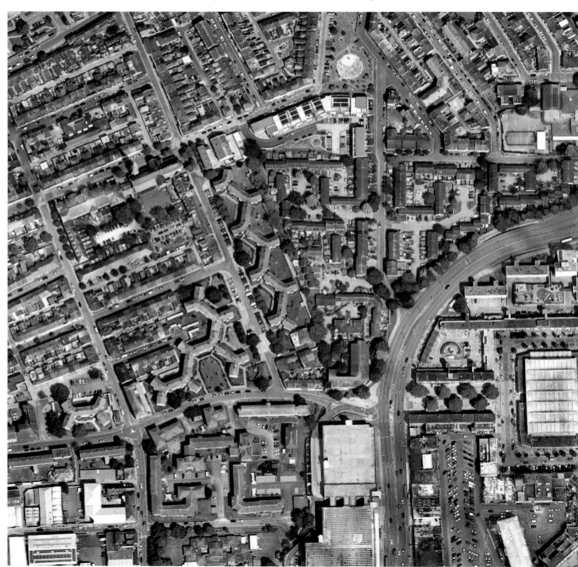

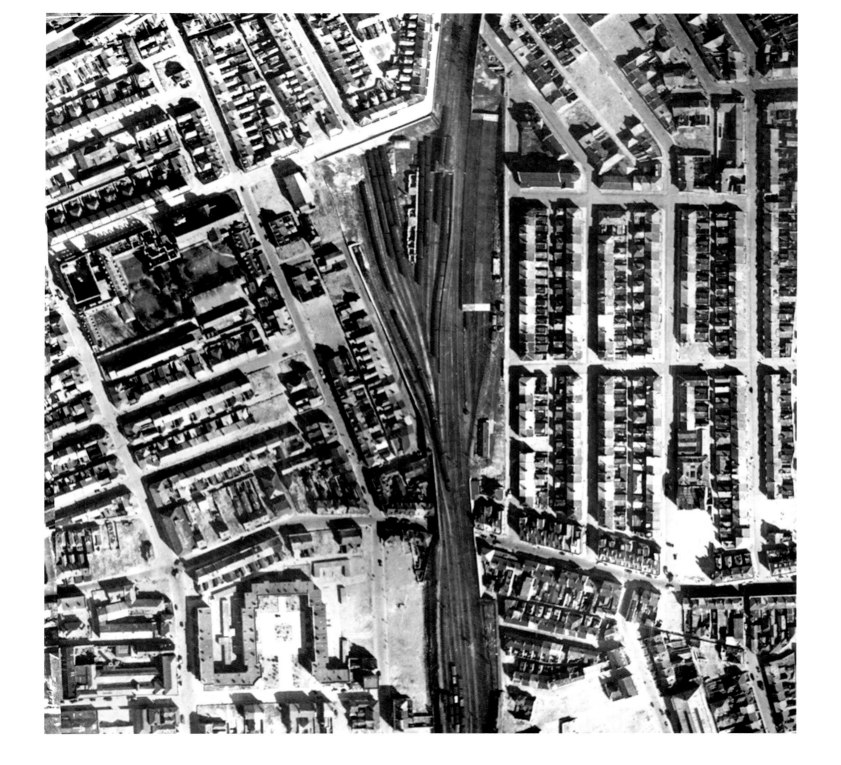

ST PETERS, ST MARY & ST BONIFACE c1951

The bronze-capped tower of St Peter's and the slim spire atop the Roman Catholic Cathedral of St Mary and St Boniface are distinctive landmarks towards the top of each image. The former and slightly earlier of the two survived the war, but like St Andrew's and Charles, only as a shell. It was rebuilt with many of its original features, apart from the new roof which was flat. The cathedral meanwhile survived largely intact, although it had already been in ruins before, indeed before it was even finished, as a design flaw led to it's partial collapse in 1857.

While many of the streets and buildings in the immediate neighbourhood of these two ecclesiastical edifices survived the war and still stand today, note how everything this side of the railway tracks and the railway tracks themselves, are long since gone, apart from that Car Sales building bottom left, and those structures either side of the then newly completed Woolworth building in New George Street.

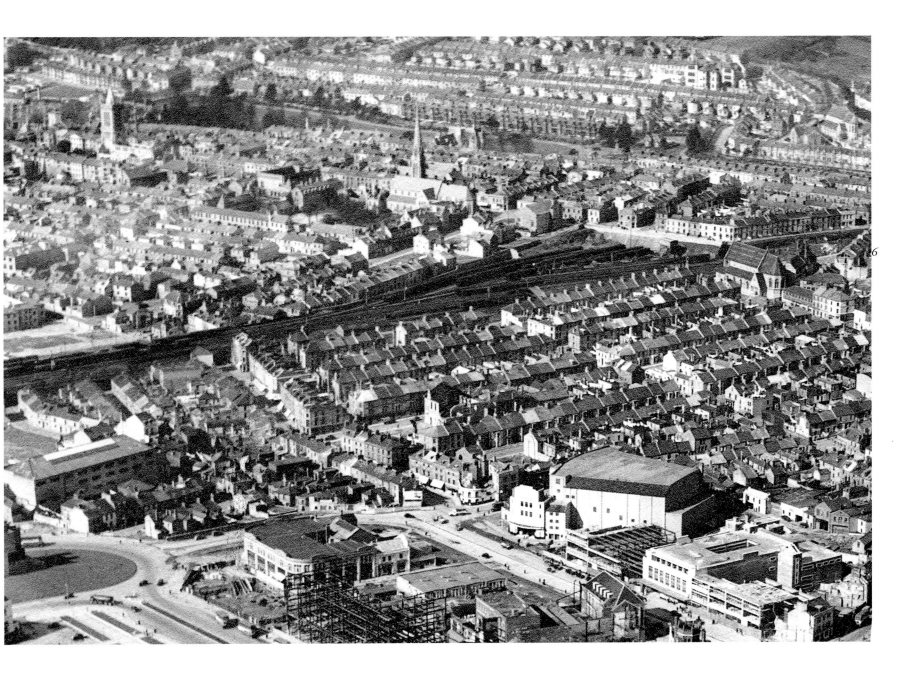

POST-BLITZ PLYMOUTH c1946

The war is over, the bomb sites are tidy, but the rebuilding has yet to begin. Here we see the extent of the damage to Plymouth city centre during the Second World War, and we see exactly what survived. The railway into Millbay Station, opposite the Duke of Cornwall Hotel, cuts a dark scar across the lower part of the scene. Below it we see that half of the Octagon has gone. Above it, little remains of the eastern end of Union Street; George Street and Bedford Street too have been flattened, but the art deco building that is still with us, in Colin Campbell Court, stands proud, as does the erstwhile Odeon (Regent) cinema, and the Prudential Building (at the junction of George Street, Bedford Street and Frankfort Street) and the shell of the Municipal Building, alongside the Guildhall.

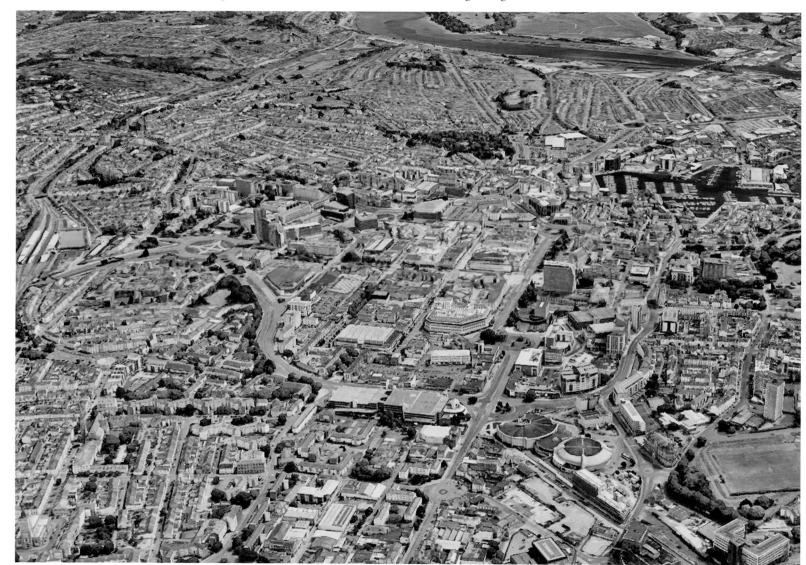

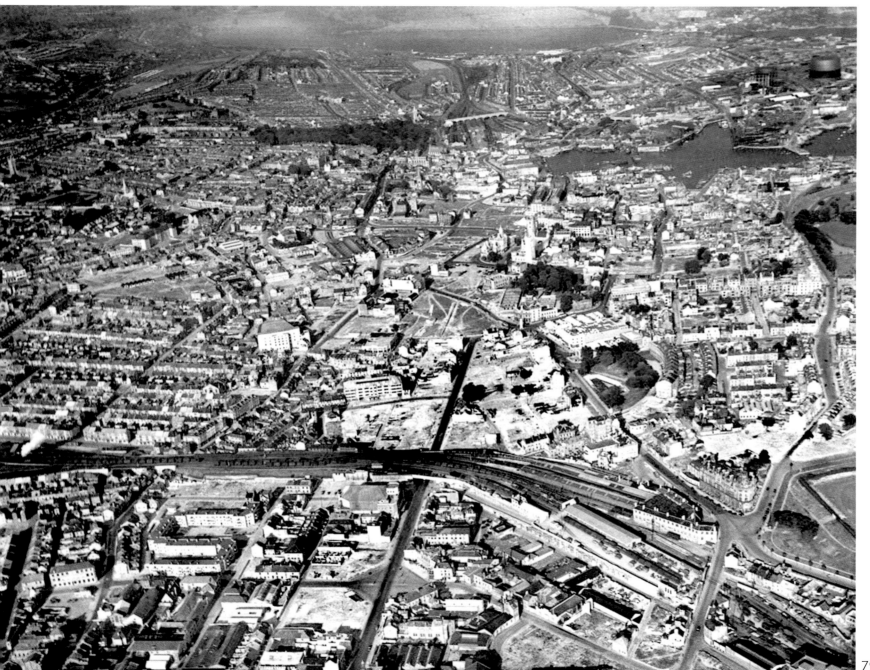

WEST HOE 1947

The scarring of the landscape on the earlier image is fairly evident, and it is the result of the devastation caused by high explosive bombs dropped during the Second World War. However the biggest blot on the landscape today is the scar left by the clearing of the hotel built at the top of Cliff Road in the late-1960s and demolished a few years after it was closed in 2014. A replacement has yet to materialise.

Other contemporary scars are to be found on the edge of Millbay Docks where a number of nineteenth century industrial buildings have been taken down. Many have already been replaced by large residential developments – houses and apartments, and there are long term plans to build on the piers as well, but it is likely to be ten years or more before these proposals come to fruition.

For an area that sprang up relatively quickly in the wake of the closure of West Hoe Quarry – which made the prospect of development on the flat area created that much easier, there have historically been one or two bomb sites that have taken decades to make good. Indeed the Mayflower Hotel itself, opened in 1970, was erected on the site of the devastated Royal Western Yacht Club which sustained a direct hit almost 30 years earlier.

It's interesting to note that, until the closure of the quarry, a man-made dock reached in from above the middle pier here through as far as Radford Road. Today there are only two survivors here from the mid-nineteenth century – the old octagonal Custom House at the head of Millbay Pier, and Grand Parade, built as West Hoe Terrace in Great Western Road, looking out to sea at Rusty Anchor.

CHAPEL STREET, STONEHOUSE 1947

The bomb sites here are instantly obvious, especially at the end of Edgcumbe Street, as it turns into High Street, on the corners of Emma Place as it reaches Chapel Street and in Chapel Street itself. On the western side of Chapel Street further along Emma Place we see the chapel that inspired the name, St George's Chapel.

The roof has been destroyed as has much of the fabric – it is a shell that wasn't rebuilt. It was where my grandmother married my Royal Marine grandfather a little over a decade earlier. The parade ground of the Royal Marine Barracks currently sports a considerable number of motor vehicles, a feature that is conspicuously absent in the earlier image. However the most obvious feature in our contemporary view is undoubtedly the massive blue roof of the sprawling Princess Yachts complex. The luxury yacht manufacturer's site leads all the way back to John Smeaton's eighteenth century Stonehouse Bridge. Widened over the years, today the bridge is only lapped by water on its southern side.

Plymouth Brewery had been based either side of the top end of Chapel Street before the war and part of the post-war rationale of the *1943 Plan for Plymouth* was that below the line of Union Street (and Edgcumbe Street) the redevelopment of Stonehouse should focus on industrial usage, and here particularly we can see that such a programme was pursued.

It is only in relatively recent years that residential developments have started to be created here and one by one industrial units are being replaced by apartment blocks. These are, for the most part, more expensive per square foot than the accommodation that was here before the war. Ocean Court at the end of Richmond Walk, on the other side of the creek was one of the first such moves back in the 1970s.

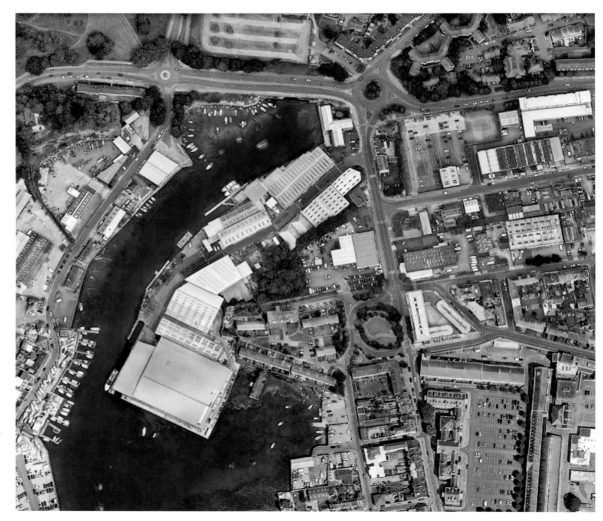

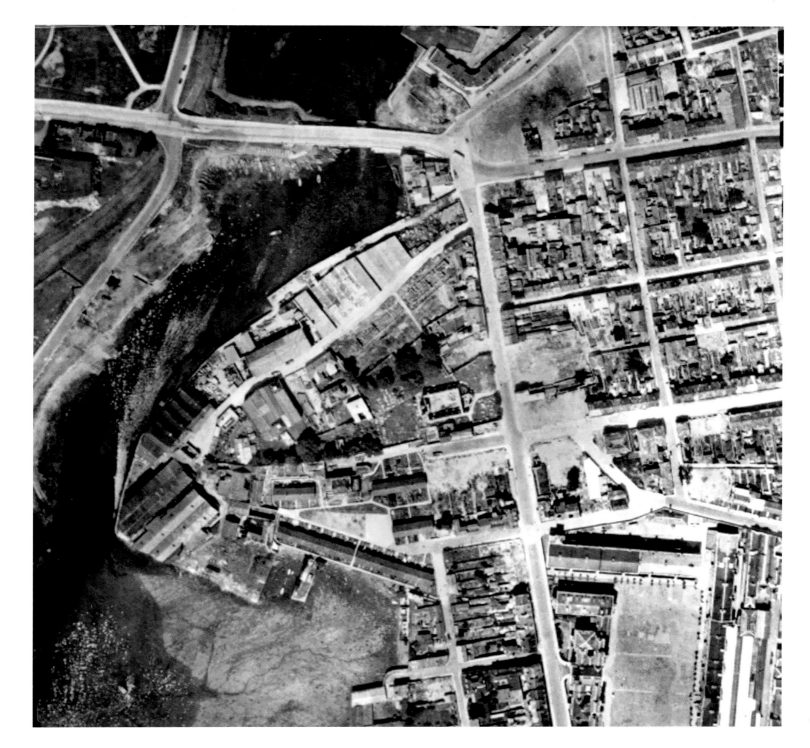

83

MILLFIELDS 1947

Built on the mill fields adjacent to the original mill at Millbridge and surrounded by a great high wall, essentially to keep patients in rather than intruders out, the eighteenth century Royal Naval Hospital was constructed on the southern bank of Stonehouse Creek in the 1760s. It was the first hospital of any substance in the area and its arrangement of detached blocks, designed to allow air flow and minimise the spread of infection proved infectious and was developed by hospital planners generally thereafter. The Military Hospital, completed in 1797 on the north bank of the creek, is a fine example.

The choice of location for both developments was logical at the time – roads were uneven or unreliable in poor weather and as the sick and wounded soldiers and sailors were being brought home by sea, a journey 'up the creek' was likely to provide the smoothest ride.

The upper part of the creek was filled in in the 1890s – and christened Victoria Park. Its aim, to provide playing fields for the young men of the Three Towns and to tempt them away from the Hoe. The stretch to the west of the sixteenth century Millbridge was infilled in the early 1970s and today provides a green space much of which is used as playing fields by Devonport High School for Boys, who have occupied the former Military Hospital since the last war. Another notable educational institution, St Dunstan's Abbey School, occupied the complex we see here west of the wooded area in North Road from the

middle of the nineteenth century to the end of the twentieth when they relocated to the Naval Hospital site – the hospital closed in 1995 – soon afterwards merging with Plymouth College. Plymouth College Prep was here until 2021 when they joined the main school at Ford Park.

Note the burnt out shell of St Peter's Church, now fully restored, in the earlier image and the bomb site in Stoke Road

85

THE RECTORY 1947

The charmingly named Paradise Road runs across the top of the image with the terrace that is Paradise Place on the left. At the eastern end of that terrace sits the inn erected as the Royal Military Hospital Inn – 200 years ago George Parnall was the landlord here.

The Royal Military Hospital opened on the north bank of Stonehouse Creek in 1797. For well over 100 years this remained a hospital but in the 1930s plans were put forward to convert it to educational purposes and in 1939 Valletort Senior School for Boys, Stoke Senior School for Boys, the Junior Technical School for Boys and Tamar Central School, moved in here. Months later the outbreak of the Second World War saw the boys all move out and it was not until the war had ended that it operated again as a school. Shared for many years by Tamar and Devonport High School, today the whole complex is occupied by DHS for Boys. In the meantime the Military Hospital Inn was rebranded as the Terminus in the wake of the arrival of the London & South Western Railway seen in our earlier view south of Paradise Road. With the closure of the station and the L&SWR line the site here came to be occupied by the College of Further Education (now City College). The Terminus later changed its name again, this time to the Albion, because Plymouth Albion had moved to the Brickfields and the pub was keen to pick up travelling rugby fans. It is currently known as the Firkin Scholar to appeal to students.

Other notable features include: Paradise Road School at the top, it was gutted during the war; the Rectory rugby ground, home of Devonport Services; the infilled section of Stonehouse Creek and the then new but short-lived prefabs in King's Road.

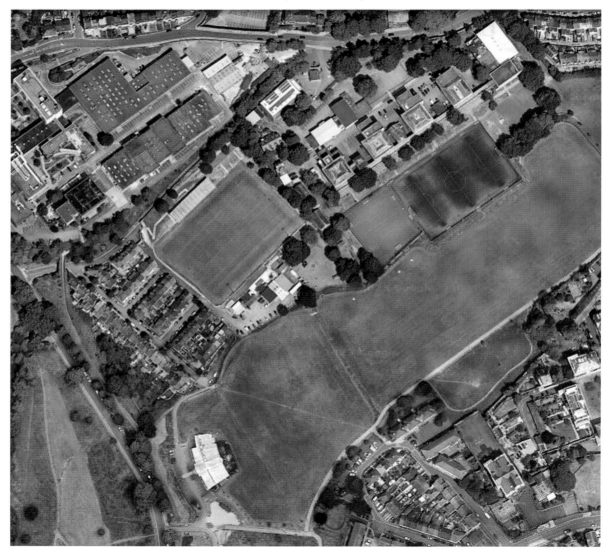

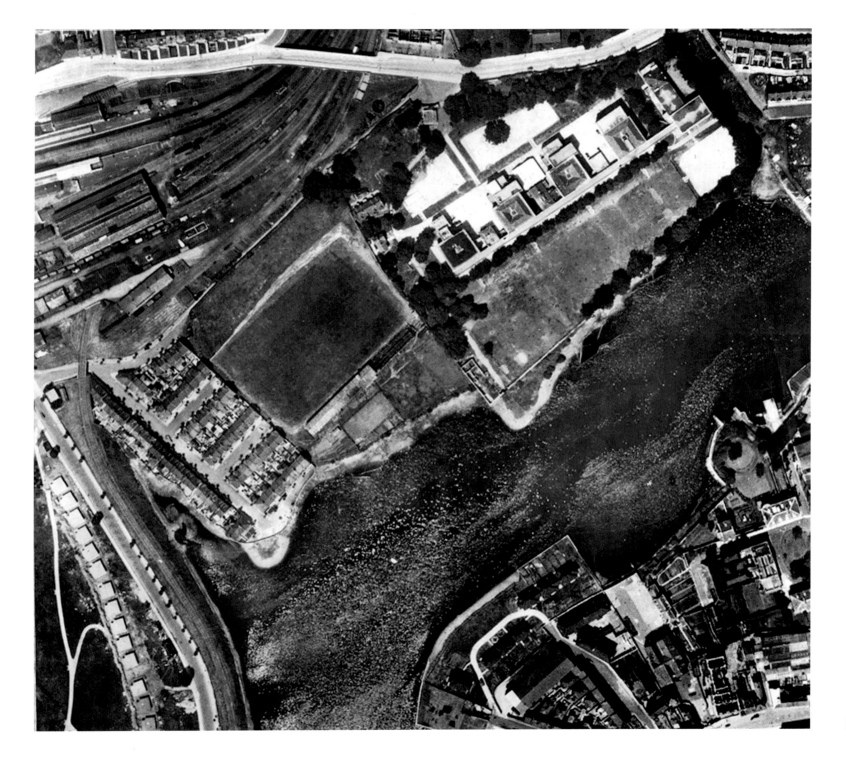

PENLEE 1947

Of all the images in this volume few, if any, are as dominated by allotments as the one on the opposite page here. Between Somerset Place and Penlee Way and the then relatively newly laid out Ponsonby Road, all we see are green fields and a patchwork of cultivated strips of arable land. Remarkably a good number survive today, in situ, while others have been created on a site just north of the old quarry we see here half way up the earlier image.

Immediately below that point is the site that was developed in the early 1950s and opened in 1955 as Penlee Secondary Modern School.

The familiar maroon-based uniforms were seen on pupils trooping in and out of here until 1989 when the school was revamped and restyled Stoke Damerel Community College. Immediately below the school site sit the three distinct properties that make up New Zealand House, a development worked on by local architect Ken Bingham around the same time as Penlee School was being built.

Raynham Road and Maker View are among the additions since the 1940s while Ponsonby Road, running up the right hand side of both views, was completed shortly after the former rector of Stoke Damerel (1894-1922), the Reverend Stewart Gordon Ponsonby, died at the age of 84, in 1938.

Other notable features here, apart from the playing fields of the Community College, include part of the much expanded Plymouth Corporation Tramway Depot (Milehouse Bus Depot) which opened on the corner of Alma Road and Tavistock Road opposite the Britannia Inn, in 1923.

89

MOLESWORTH ROAD 1947

It's amazing how clear the road pattern is on our earlier image, and indeed on most of the earlier images in this collection. This is largely because there are very few motor vehicles to be seen driving along the roads or parked alongside pavements. There are a few larger vehicles passing through Stoke Village and Tavistock Road, presumably buses, but note how devoid of car-like blobs all the other streets are. However in the context of this comparison, this is perhaps not the most noteworthy feature here, as that accolade must surely go to the perfectly circular reservoir – Bowden Reservoir that sits to the east of Ann's Place and Park Street. Originally constructed by the Devonport Water Committee in 1830 it was designed to hold four days supply. It was deemed necessary because Devonport Leat had, on occasion, been blocked by heavy snowfall, forcing local inhabitants to rely on wells! The reservoir remained a prominent feature on the landscape until the 1960s when the Reconstruction Committee of Plymouth City Council approved a proposal for Messrs Herbert Terry and Sons, spring specialist of Reddich, to take a 1.78 acre site here and build a factory that hoped to 'employ between 100 and 200 people, about 65 per cent of whom will be women.' The company is still going today but no longer in Plymouth – I recall working on the Christmas post there as a student in 1970.

Clearly the site around the reservoir has seen further industrial development but many green spaces have been preserved here, most notably the site behind the former Salisbury Terrace (now part of Tavistock Road), Penlee Gardens and around the Foulston designed Belmont House. Built for the Devonport banker John Norman in 1820, it served as Plymouth's Youth Hostel for many years from 1948.

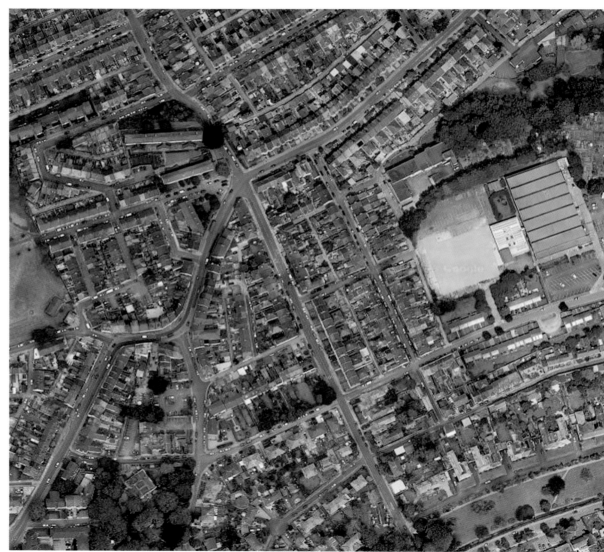

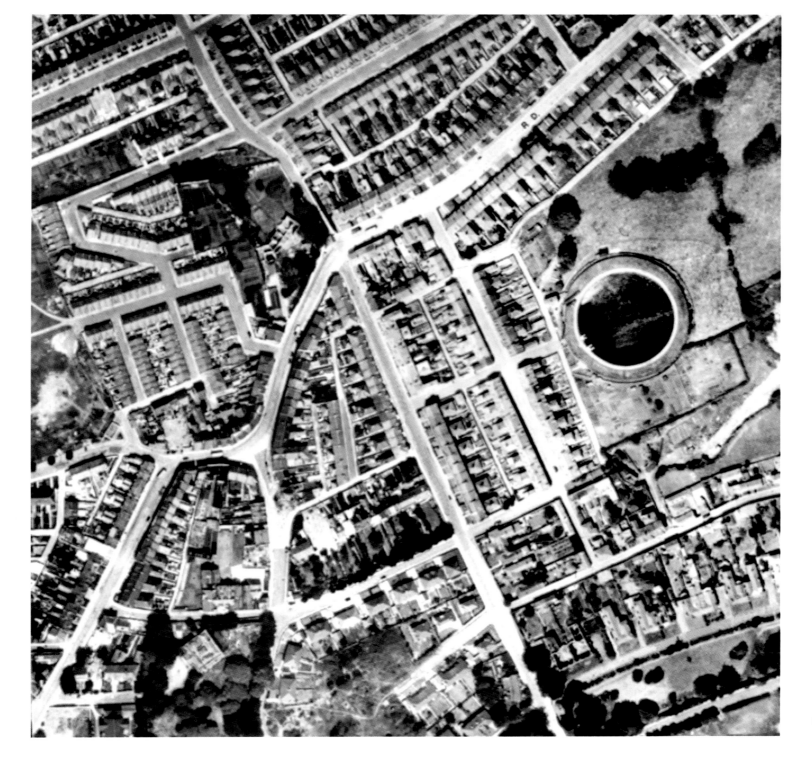

STOKE DAMEREL 1947

Stoke Damerel Church predates most of the community it served as a parish church by hundreds of years. It wasn't until the 1690s that a substantial population started to appear between here and the Tamar and that came with the establishment of Plymouth Dock.

The town that sprang up around the King's new dockyard however grew so quickly that within a century or so it had started to expand beyond the defensive lines designed to protect it. The new town had also become bigger than its older neighbours, Plymouth and Stonehouse, and indeed bigger than any other town in the county. In 1823 the people of Plymouth Dock petitioned the King for a name change, one that didn't make them feel like an offshoot of Plymouth, one like Stoke Town, as Stoke Damerel was their parish church and Stoke had more social cache – that was where all the admirals, captains, surgeons and successful business people lived, in their grand and detached houses. Such houses didn't exist behind the lines, apart from Government buildings.

The King approved in principal but thought that 'Devonport' would be better as this was the biggest port in the county. Today there are still no detached private residences behind the lines, but we have some grand villas in Stoke, notably here, with Osborne Villas and Wingfield Villas above the surviving railway line and Collingwood Villas as well as other grand isolated examples here and there.

We also have some of the area's oldest terraces including the post Napoleonic War developments of Waterloo Street and Wellington Street and the slightly earlier group known as South Hill.

Over the years there have been many changes, notably the arrival and subsequent departure of Devonport Station goods yard (now an industrial estate). Meanwhile the heavily wooded Stoke Damerel church yard still dominates the scene west of Valletort Lane and Valletort Place.

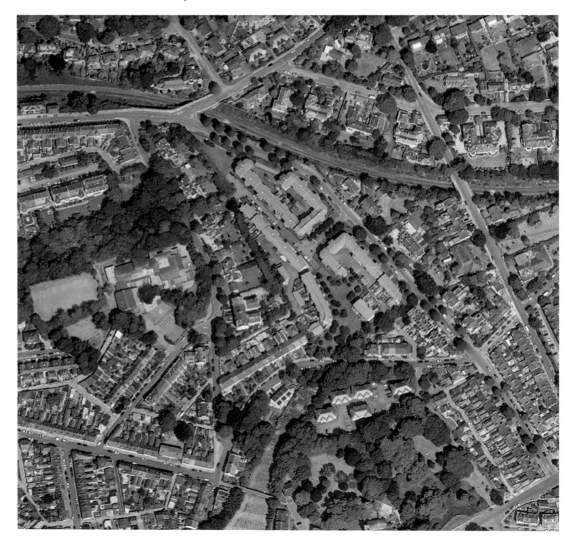

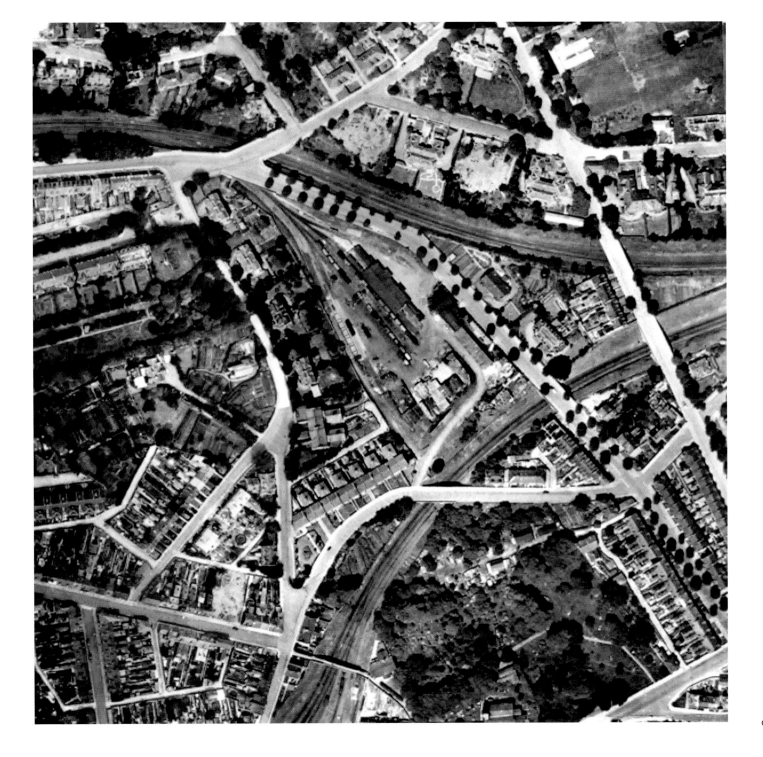

93

MOUNT WISE 1947

So many key elements that leap out to bind the two images together as we see Devonport Hill snake into Cumberland Road, the somewhat reduced but still impressive Mount Wise cricket ground and the green slopes of Mount Wise itself, which surrounded the very isolated Elizabethan Mount Wise house. The Wise family had acquired the Stoke Damerel estate through marriage, back in 1428, but for many years chose to remain in the family seat at Sydenham, near Launceston, rather than move here where the original manor house then was at Keyham.

Doubtless Sir Thomas Wise was inspired by his neighbours across the water – the Edgcumbes – to move here. Richard Edgcumbe had moved down the river from Cothele and had Edgcumbe House built in 1550, naming it Mount Edgcumbe. Hence Sir Thomas's decision to name his new loftily-located property 'Mount' Wise. Clearly there have been a lot of developments here over the last 70 years or so, many of them coming since the end of the twentieth century, after the Government released the Mount Wise site for redevelopment.

Turn the clocks back before 1690, before work began on the dockyard, and there would have been very little here but green fields and the Wise house. Defensive lines protected the landward access to the dockyard and the Mount Wise redoubt – marked more recently by the Millennium Mast – and the open area occupied by the cricket pitch and much of the Brickfields site still reflect that. However the open ground around the various barrack block sites that surmounted the lines have gradually been repurposed for housing. Of those blocks it was George's Square Barracks that sat here below Cumberland Road.

The Cumberland Centre itself is built on the Timber Pound and the Keep that stood on the north side of the road leading into Plymouth Dock or Devonport as it became 200 years ago.

The flat ground around Richmond Walk incidentally is the result of extensive quarrying and for many years the London & South West Railway ran along here to Ocean Quay. Look closely at the earlier image and you will see a few wartime bomb sites.

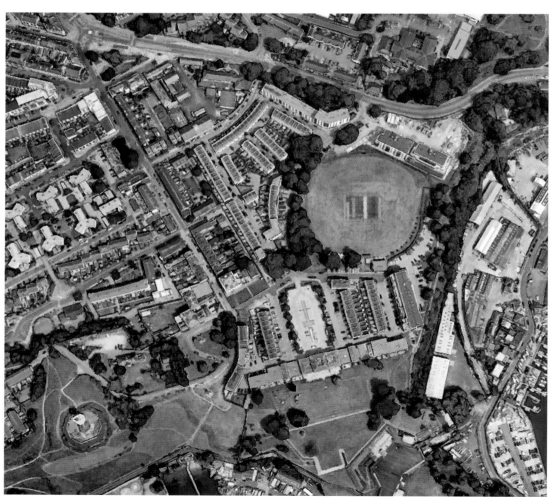

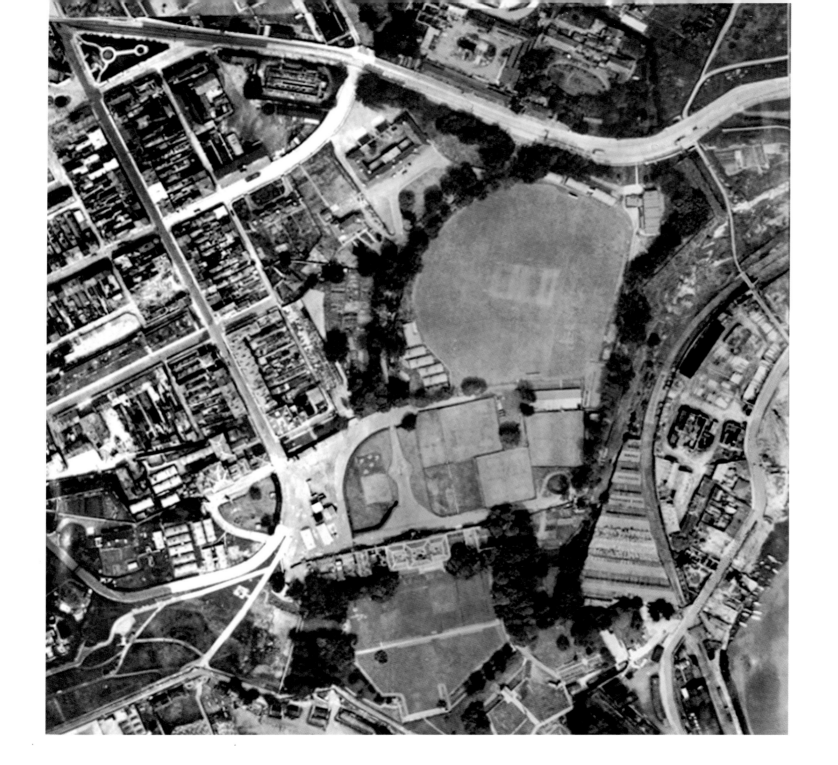

BRICKFIELDS 1947

'Brickfields – site of clay pits and bricks manufactured: upper part known as Brickfields and lower as Parsonage Fields – now all Brickfields.' So wrote Henry Whitfeld in *Plymouth and Devonport in Times of War and Peace* at the end of the nineteenth century. Actual evidence of these clay pits and the manufacture of bricks here is more difficult to unearth, but there is no reason to doubt the explanation.

Long since owned by the Crown and at one time an integral part of the defensive lines of Devonport, hence the massive drop that separates the two levels, the Brickfields – once the scene of frequent military reviews – is better known to present day Plymothians as a sports and athletics arena.

A centre of athletics activity for over a century now, the Brickfields currently boasts the only major athletics track in the city. A popular base for hockey in the area too, the Brickfields site became the home of Plymouth Albion Rugby Football Club in September 2003 after their move from Beacon Park.

A sports centre was built soon afterwards along with a grandstand capable of seating 1500 spectators.

There has also been substantial development on the site of the former Raglan Barracks and its impressive parade ground on the western side of what was Military Road and is now Madden Road, with Raglan Gardens running off it.

Raglan Gatehouse still stands, awaiting redevelopment, while as of March 2023 an ambitious new partnership was launched to regenerate Brickfields Recreation Ground.

A working group formed by the Argyle Community Trust will see Plymouth Argyle Football Club working with Plymouth City Council, Plymouth Albion Rugby Club and Devonport Community Leisure Limited, with the aim of transforming the sports centre into a community hub with sports at the centre and with wellbeing and general health as key secondary goals.

ST LEVAN PARK & LINEAR PARK 1947

It wasn't that long ago, before the railway cut through here and before most of the housing had been built in this area, that Keyham Lake extended beyond Keyham Bridge and covered all of the green space (St Levan Park) that we see here just above the line of the southern bank of the creek, a line now defined by St Levan Road.

The Eagle Tavern (long since better known as the Ford Hotel) sat at the end of the then as yet undeveloped Alexandra Road and there was but one house in the road running parallel above it, Tamar Villa in Sussex Road. The London & South Western Railway cut through this rural idyll in 1890, by which time Cambridge Road, Kent Road, Alfred Road, Clyde Street, Bedford Street, Melville Road and Seaton Place had all appeared on the eastern side of the tracks while the area to the west remained relatively green. Ford Station serviced the population on that side while Station Road was later laid out for housing and to guide dockyardies to the transport link. That link closed in 1964 when the last trains stopped here, but the line and the viaduct carrying it here remained in situ until 1987. Following the removal of the

massive, seven-arched structure that bridged the 135-yard gap across the valley plans were put in place for a 39-dwelling city council housing development on the south side (14 flats, 25 houses), while on the northern side, Berkshire Drive was laid below the 500 metre stretch of railway that now forms the aptly named Linear Park.

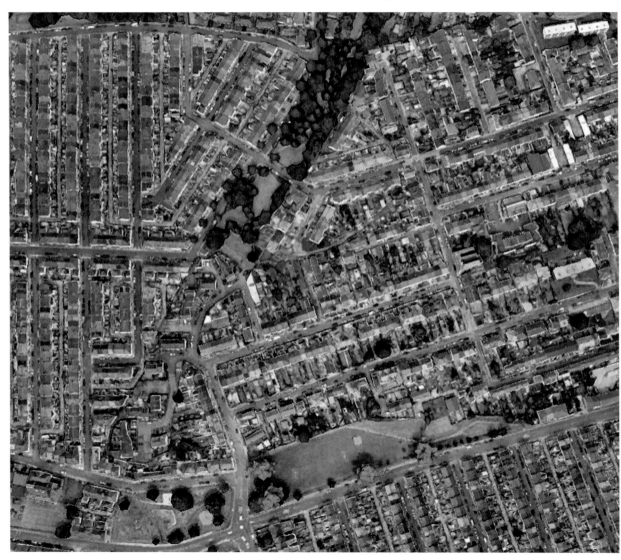

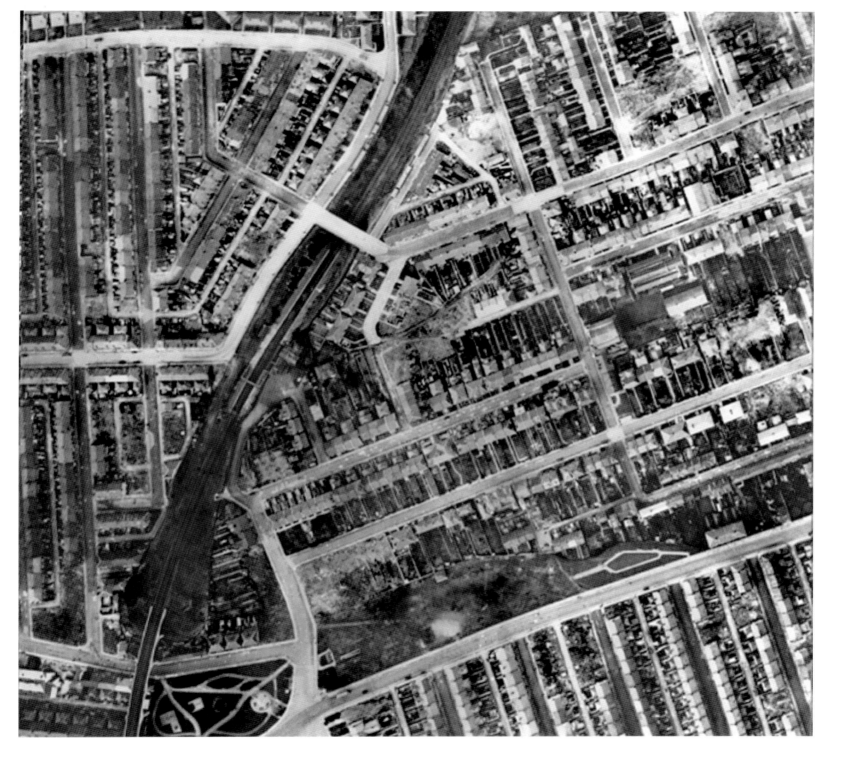

DEVONPORT 1949

Fore Street, on the far left, the foremost street of old Devonport, runs down towards the original dockyard gate before it turns at ninety degrees right and then left down Cornwall Street, at one time probably the oldest street of old Devonport or Plymouth Dock. As Plymouth Dock the area long felt like an adjunct rather than a proud town in its own right. That changed with the change of name 200 years ago on 1 January 1824, but then somehow that status seemed to return post war when almost all that was rebuilt here was housing. A few shops, one pub, a temporary church (to replace a handful of Victorian churches), but no theatres or cinemas just flats, lots of flats. Notably that included a few tall tower blocks, the like of which were not to be seen in Plymouth. Plymouth's new housing was in low rise properties,

mainly two-storey affairs on the new estates, and not even in terraces, but semi-detached with neat little gardens. And yet few voices were raised in anger. Devonport's biggest store, Tozer's moved happily into Plymouth's shiny, new, state-of-the-art city centre, while Marlborough Street, Devonport's prime shopping street that led to Devonport market, was truncated, along with Fore Street, as the Admiralty grabbed some 50 acres of prime land for their new storage facility, a facility that swallowed up what was left of the market. Little survived the bombing here and even less the re-planning process.

There is however a nice footnote to all this as, in May 2002, the Defence Minister Lewis Moonie announced that all of the land appropriated for the storage enclave would be handed back to the people of Devonport and since that time the area has been able to be redeveloped sensitively for the first time since the war, as we see here, south of Granby Way.

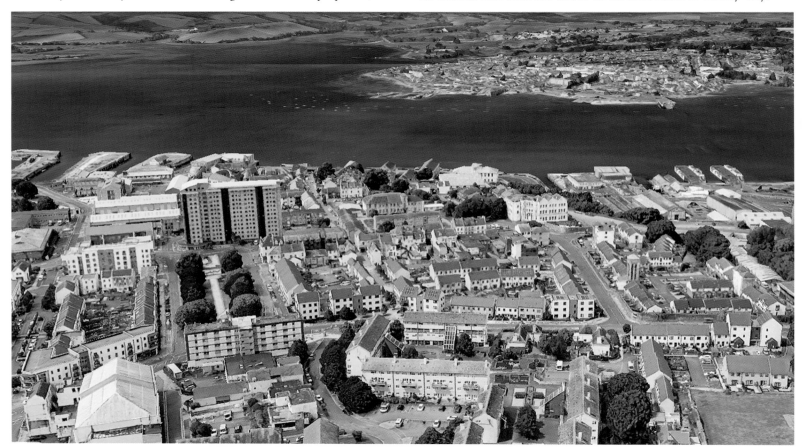

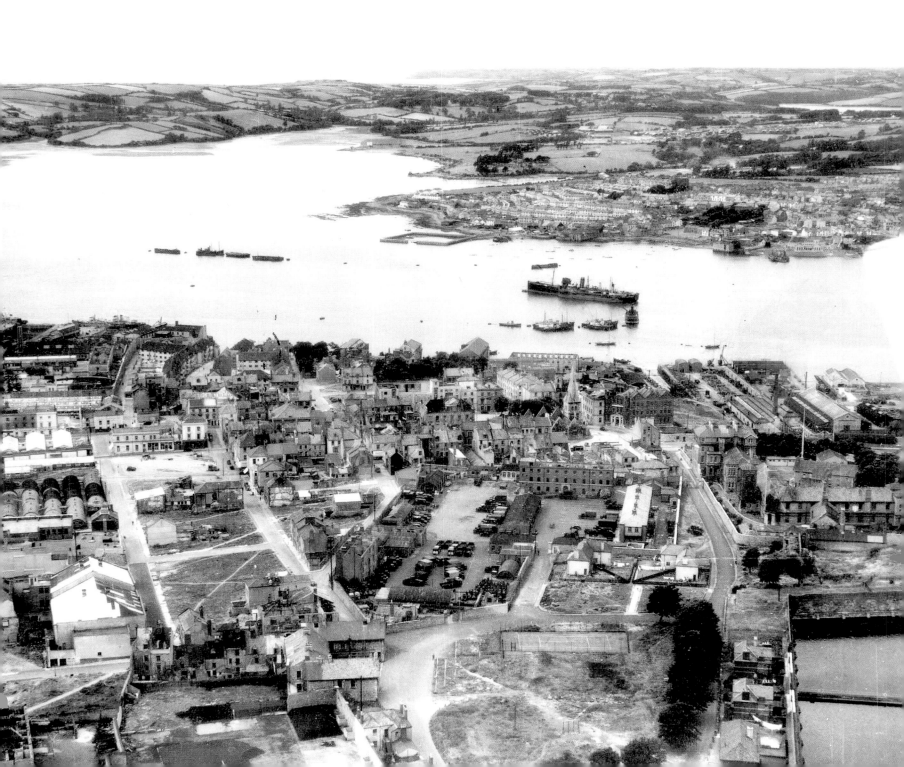

KEYHAM STEAM YARD 1951

Here we have an excellent view of No.3 basin at the Keyham Yard with the date 27 July 1951. The view contains many buildings no longer with us ... on both sides of the wall.

To the right in the photo we see the old torpedo shop, the electrical factory (in front of the waterside crane), both since demolished.

In front of No.3 basin itself is the Quadrangle, also known as the main factory, and the Royal Naval Engineering College – which closed in 1958, after Manadon had been opened, and which reopened the

following year as the Dockyard Technical College. A splendid building, it was finally demolished in 1985. Long gone too is the South Western Gas Board's Devonport Unit – the coke works that stood obliquely across from the Royal Naval Engineering College.

Meanwhile the first official flooding of the Frigate Complex was in June 1976 – which meant that now ships could be worked under all weather conditions and "in secret". The Complex was formally opened by Dr David Owen on 23 September 1977. The ships seen here in the earlier image, incidentally, are the cruiser *Nigeria*, in midstream is the destroyer *PNS Tughril* (formerly *HMS Onslaught*) and in the basin itself is the paddle tug *Pert* and the Hunt II Class destroyer, *HMS Beaufort*.

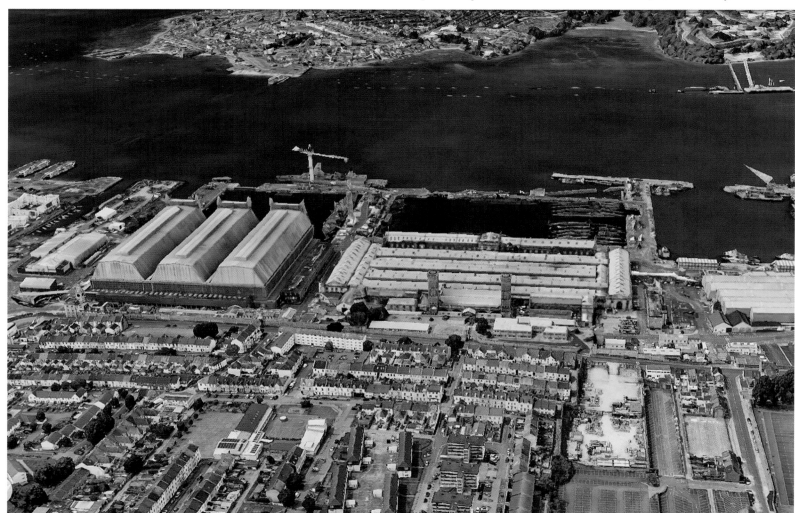

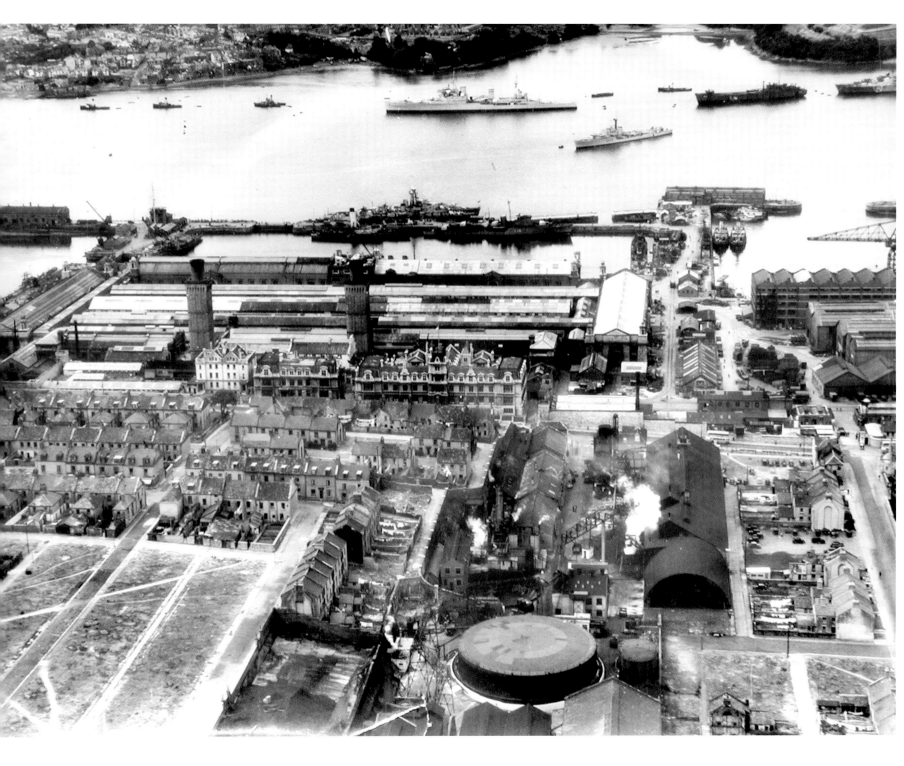

CAMEL'S HEAD 1947

Over the last couple of hundred years around 1000 acres of waterfront has been claimed from the sea and here at Weston Mill such gains are clear to see. It's noticeable however that there is little or no substantial development on the infill area, most of it given over to car parking and single storey reception buildings for His Majesty's Naval Base.

included the feeder road in from the then new Parkway. Another victim of changes in transportation was the old London & South Western Railway line that ran to the side of what is now Ferndale Road. Meanwhile, among many other changes note the number of allotments that were here in the late 1940s around Wombwell Crescent.

Remarkably, although the scale of Weston Mill Lake/ Creek has been dramatically reduced here, there is a section still to be found to the north and east of what we see in the earlier image as Camel's Head School and is now Weston Mill Community Primary School. Opened just before the Great War, it was one of many, then state-of-the-art, schools that were deployed as a hospital during that conflict.
The school stands just above Ferndale Avenue, Third Avenue, Second Avenue and Erith Avenue in that tight group of housing that was constructed opposite the even earlier, but now long gone, Westham Terrace. Just beyond that row stood the Camel's Head pub which was apparently built in 1825 at the expense of the local landowner, the Reverend CT Collins-Trelawney, of Ham, for the men who were working on the new road from Plymouth – Wolseley Road, now part of the A3064. The Camel's Head, latterly known as the Submarine, was itself demolished in 1985 to make way for the improvements to the road system here which

BARNE BARTON c1955

The early major development on this area of Barne Barton saw the construction of that stretch of Poole Park Road that we see here, with the creation of a new school across from the bridge that led into the heart of St Budeaux. Poole Road was then extended and new roads were created to house what quickly became the biggest naval estate in the country. However, subsequently the married quarters were repurposed and new blocks of flats were built. More recently the area has been subject to more changes and in the last decade plans for a 'mixed-tenure community with a variety of housing types,' have been put in place.

In 2008, Barne Barton Primary, like so many of Plymouth's post-war schools, was closed and subsequently demolished and merged with the other educational establishment at Bull Point to become Riverside Primary at the top of Barne Barton. Bridge View has recently been constructed on the old school site.

The heavily wooded area, this side of the railway bridge across what remains of Weston Mill Creek, is known as Barne Brake, where brake here is used in the context of an area of undergrowth, or brushwood. It sits adjacent to the massive 21st century MVV Devonport Limited Waste to Energy Plant in Creek Road.

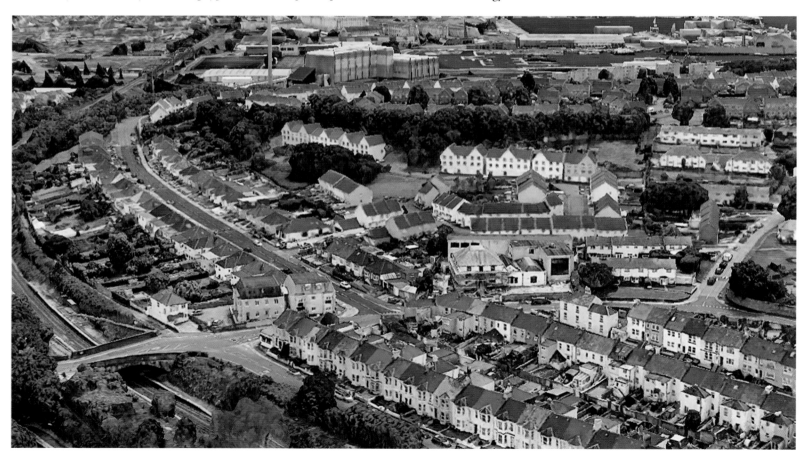

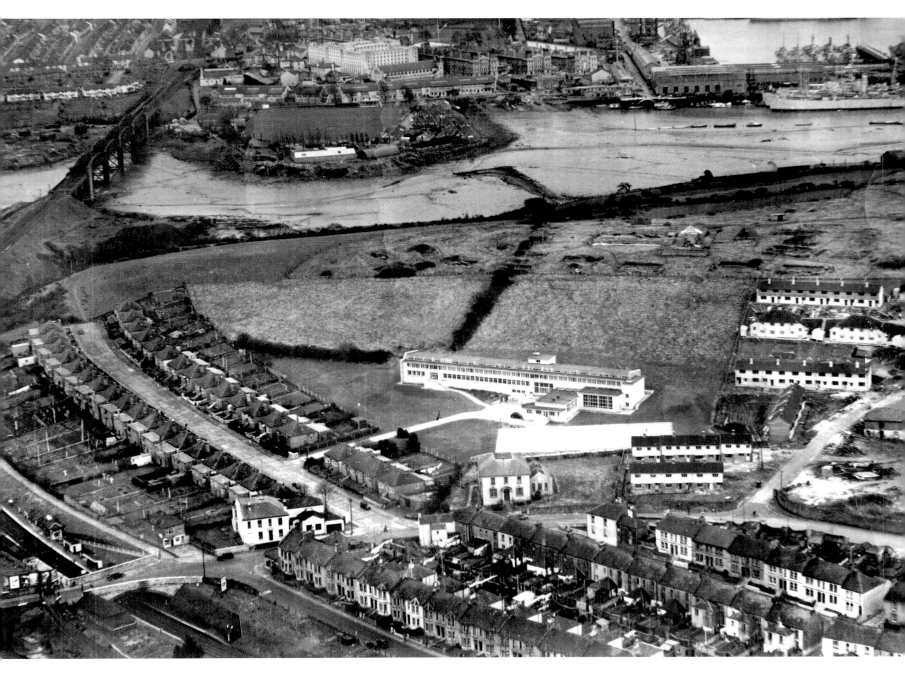

BARNE FARM c1955

The development potential for Barne Barton, as an almost island-like location – overlooking the Tamar and the Hamoaze, with Kinterbury Creek winding down from the north and Weston Mill Lake from the south – was enormous. For centuries it sat with just Barn(e) Farm at it's heart. Owned by the Beele family 500 years ago, the farm was in the middle of what amounted to around 168 acres of arable land. When the last male heir of the Beeles married the daughter of Jonathan Trelawny, in the late seventeenth century, the estate fell into the hands of the Trelawny family, who leased it out to a variety of tenants who continued to work the farm. William Luscombe was the last to farm here and eventually he sold his interest to Plymouth Corporation.

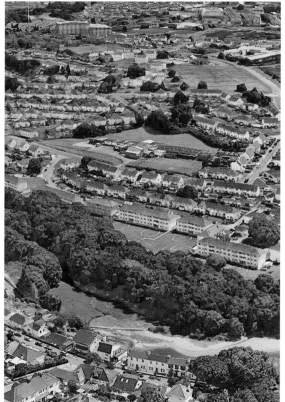

BULL POINT RNAD c1955

Bull Point first became a strategic site in the middle of the nineteenth century when the Admiralty, who were busy with the construction of the new Keyham Steamyard, were minded to move their magazines from Keyham Point – where they had been since 1775 (they had started out in Morice Yard in 1720). Curiously enough it was the last major project undertaken by the Board of Ordnance (which was abolished in 1856). Bullpoint Barracks were later created north of the road that connected St Budeaux to Kinterbury House and Villa. With the dockyard extension at the beginning of the twentieth century the site became an increasingly sensitive one for the Royal Navy and slowly development started to take place south of Kinterbury Road.

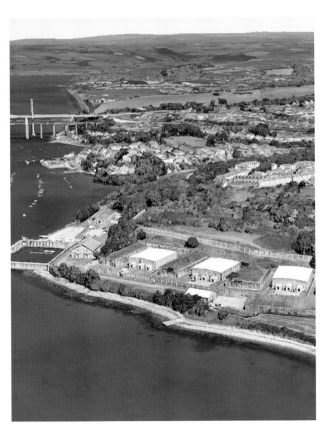

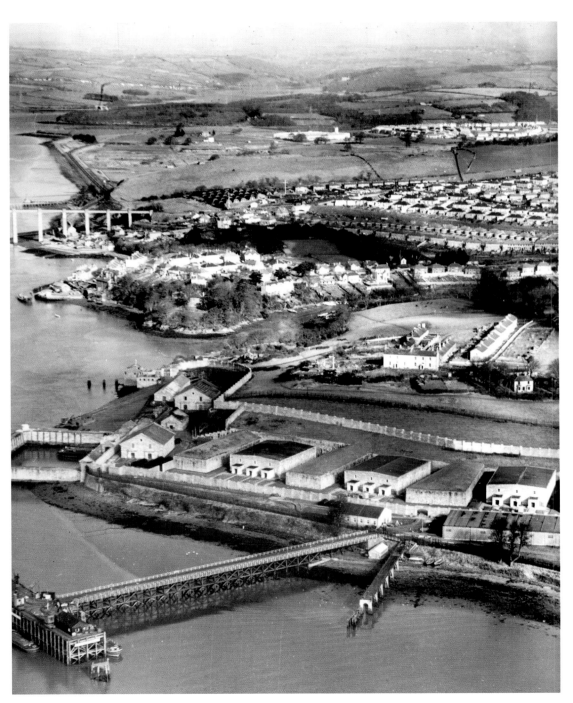

RIVERSIDE, SALTASH PASSAGE 1947

It had been the ancient route to Cornwall across a bridgeless stretch of the Tamar for centuries, hence the Ferry Inn on the Devon side of the river being located at Saltash Passage (aka Riverside). Either side of the crossing point were a handful of cottages, including Littleash Cottages and Littleash Farm, the latter just to the north of Littleash Quarry. For many years the ferry rights were tied to the Manor of Trematon, and Little Ash, until the early nineteenth century, was regarded as being part of Cornwall (curiously Maker and the Rame peninsula was officially part of Devon around the same time).

Today the river divides the two counties and since the construction of the Tamar Bridge (1961) there is no longer need for a ferry service here as travellers no longer have to head upstream to Gunnislake to find the most southerly pedestrian crossing. Nevertheless the Ferry House Inn still trades today, as does the former Devonport Inn, later renamed the Royal Albert Bridge Inn following the completion of Brunel's metal masterpiece in 1859.

The early twentieth century saw a lot of development at this end of Wolseley Road and although by no means constructed on level ground Little Ash Gardens appeared on the quarry site of the same name, while Little Ash Road appeared on the elevated ground above Kinterbury Creek off Kiln Bay.

Meanwhile St Budeaux Wharf, opposite the bottom of Little Ash Gardens, has been substantially extended over the last 100 years or so and today many patrons of the Tamar River Sailing Club keep their small craft moored offshore.

Meanwhile, nestled between the lines of the old London & South Western Railway and the Great Western, we see another development from the early part of the twentieth century – the looping streetscape that is Vicarage Gardens.

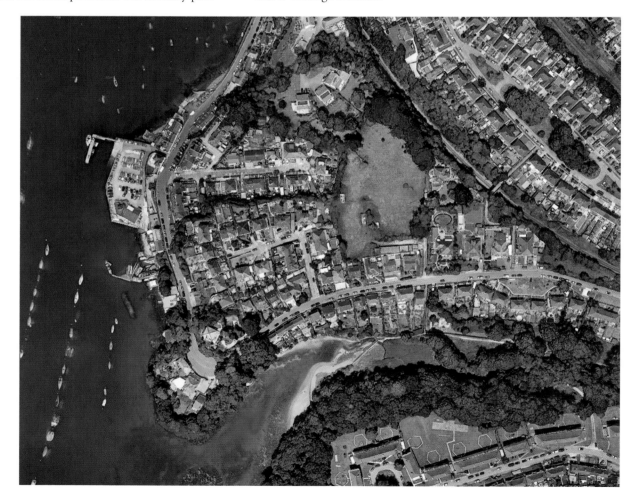

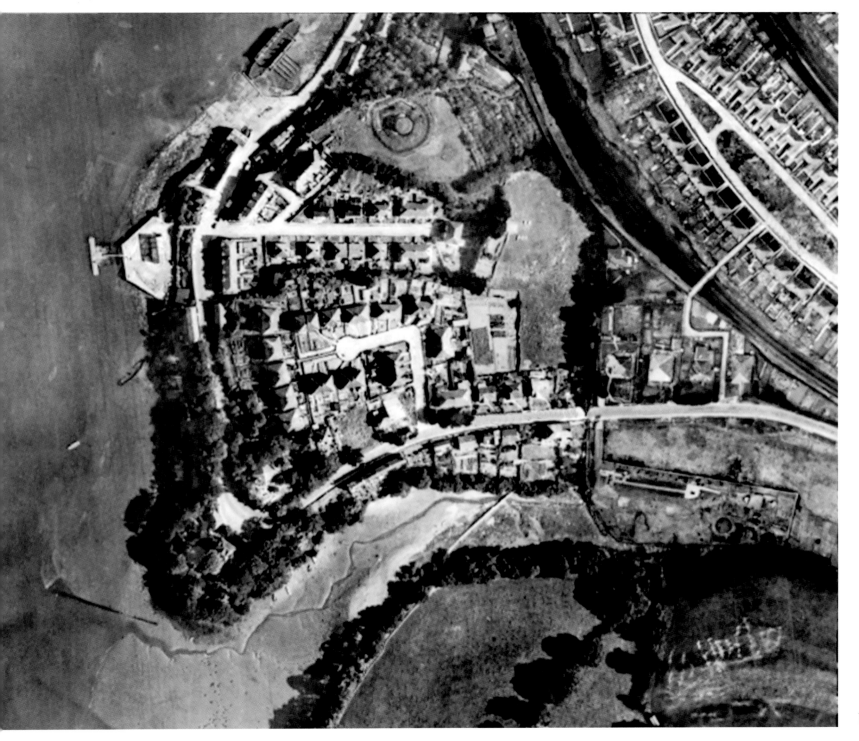

BRUNEL BRIDGE 1959

Over 60 years separate the two images, the earlier one being from sometime around late 1959. We can see the footings for the new Tamar Road Bridge but at that time Brunel's magnificent Royal Albert Bridge straddles the river alone, indeed earlier that year, in May, the marvellous metal edifice had been spectacularly lit up in celebration of its centenary. Just off the slipway at Saltash Passage, below the Ferry House Inn we see the Saltash Ferry itself. Car carrying for little more than three decades, there had been a ferry service here for over 600 years, although before the era of steam and the construction out in Plymouth Sound of the Breakwater, the crossing could be a little tricky. The noted novelist and social commentator Daniel Defoe considered himself to be 'well escaped when he got safe on the shore at Cornwall' after his voyage on the 'bad' ferry in 1724. Prior to the era of ropes and chains it was not unknown for the ferry to drift, on an ebb tide with a strong north-west wind, as far down as Coombe Creek going across to Cornwall, or Bull Point coming back towards Saltash Passage (which despite being on the Devon side of the river was on paper part of Cornwall, in St Stephen's parish, until well into the twentieth century).

Clearly the construction of the road bridge impacted significantly on the existing road and housing arrangements on both sides of the river, and relieved the traffic flow around the waterfront on both sides too. Meanwhile there have been significant alterations in the way in which the waterfront is being used today with much more emphasis on water-based leisure activities. Also note the housing development that has appeared south of Coombe Creek on either side of the railway line.

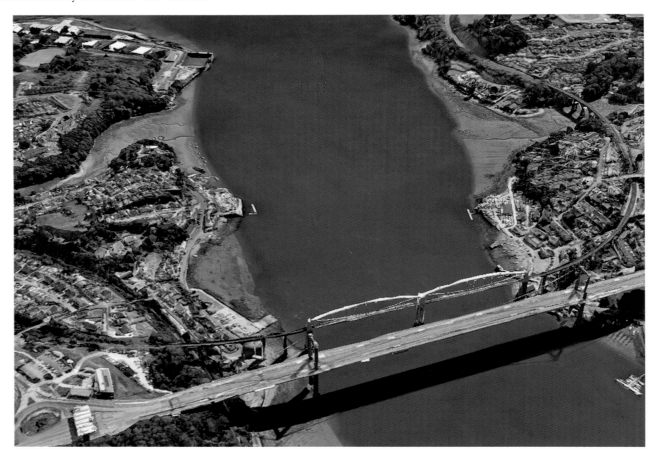

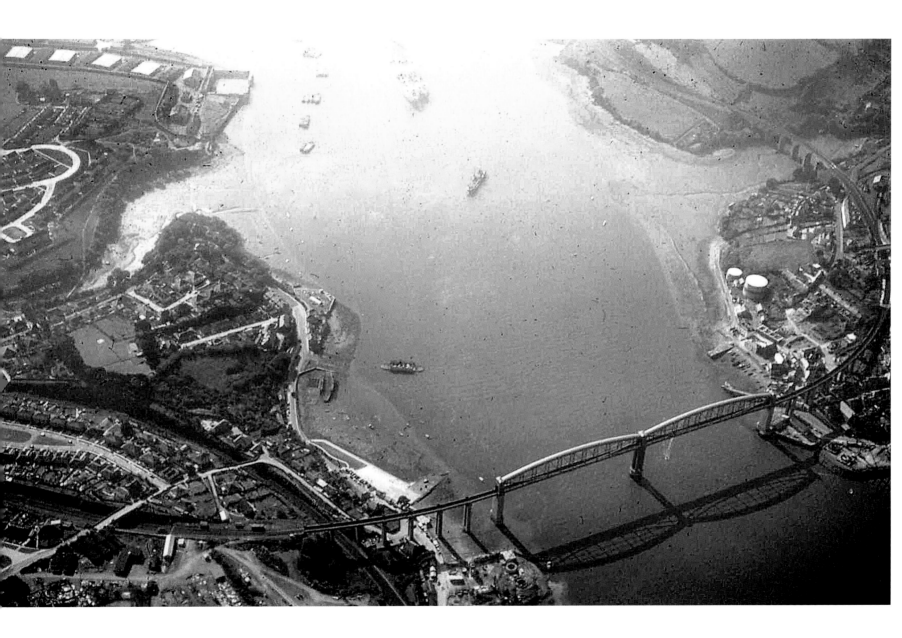

ERNESETTLE 1948

Lakeside Drive curves around overlooking Tamerton Lake, morphing into Uxbridge Drive beyond the road at the top of the Mill Pond. Budshead Mill itself is long gone but we see it quite clearly here at the bottom of the picture. Our early aerial view was apparently taken on 25 October 1948 and it was published in the 1949 revised edition of Pat Twyford's *It Came To Our Door*. Originally the book had focussed on the war years, now there was an extra chapter on the post-war rebuilding of the city. In relation to Ernesettle the former *Herald/Morning News* journalist/war correspondent wrote: 'This estate lies on the side of the hill from Higher St Budeaux, almost down to the bank of the Tamar and bounded to the north-west by Tamerton creek. On this estate has been erected the magnificent new Bush Radio factory, which is already employing several hundreds of employees, and when in full production will be producing up to a set a minute.'

Television was still some years off arriving in Plymouth at that time! Twyford continued: 'On this estate there is provision for 1,204 houses and flats, which will accommodate approximately 4,000 people. The building of houses here is in operation at the time of writing and the first occupations have taken place.'

Remarkably some 75 years later the estate appears little changed, the old field pattern is still discernible here and there, marked out by trees. Ernesettle Green survives, and Tangmere Avenue, Hornchurch Road, Manston Close, Catterick Close and West Malling Avenue make up the bulk of the nearest development, while Hawkinge Gardens and Croydon Gardens fill the loops to the right and, in line with the other street here and down towards Budshead Creek, they all take their names from World War II RAF bases.

Today Bush is long gone but Vispring, Gregory Distribution and the Marwood Group are among those operating out of the industrial estate at the end of Ernesettle Lane

ERNESETTLE 1954

Just six years after the image on the previous spread was taken this shot was captured of the then new Ernesettle estate. New it might have been, but it was almost fully formed: what is now Ernesettle Community School has had a few additions to its building stock over the years, but not many; the basic streetscape is much the same – although there are few extras, among them Coltishall Close, Catterick Close, Duxford Close – essentially however it looks much the same as it did in 1954.

Wind the clock back a decade or so before that though and you'd mostly be looking at green fields south of Tamerton Lake with Frankham Lane running down to Budshead Manor at the head of Budshead Creek and Ernesettle Lane reaching almost all the way down the railway line running past Lower Ernesettle out towards Warren Point and Agaton Fort commanding a splendid rural view with little or no development between it and its neighbouring batteries – Ernesettle to the west and Knowle to the east.

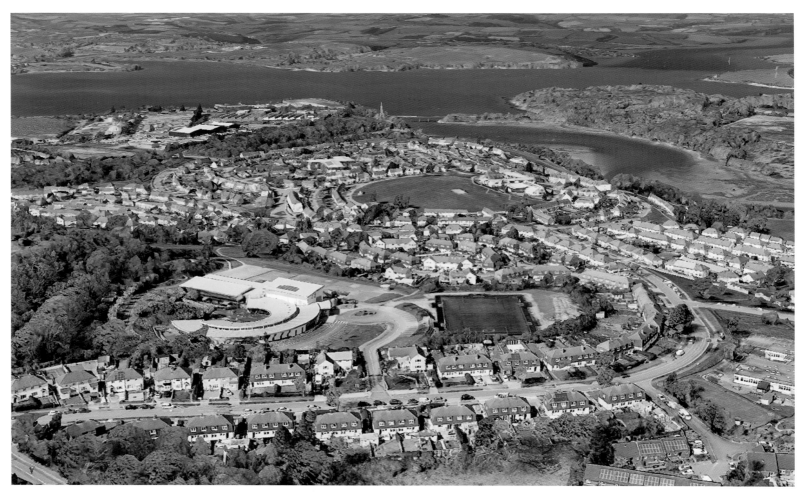

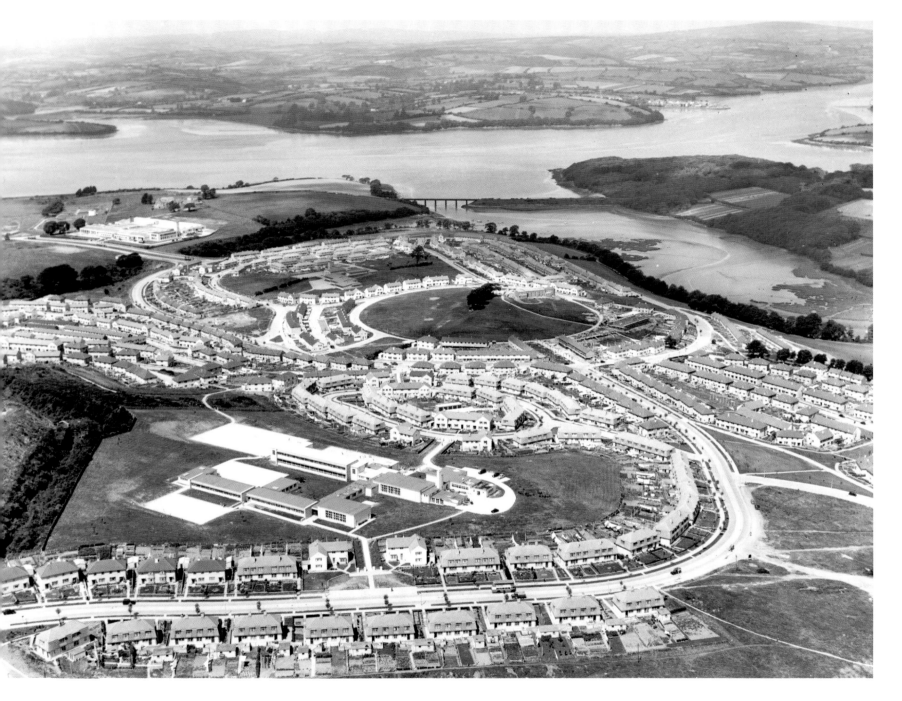

KING'S TAMERTON 1948

We're looking across the top of King's Tamerton, Weston Mill Hill is bringing traffic in from the right leading into Trevithick Road which runs around the front of the school site with King's Tamerton Road looping around the back until it joins back up with Trevithick Road. Today the school here, currently known as Marine Academy Plymouth, sits more or less on the site of the original King's Tamerton School. In the paper that contained this earlier aerial view, dated 1 November 1948, we read that the school was started before the war, 'and had already reached the roofing stage when the Admiralty stepped in and requisitioned it. They put a temporary roof on. Since de-requisitioning the authorities have retained the roof, completed much of the remaining work to make it a school expending nearly £14,000 since the Spring. All the rooms are now occupied, with the exception of the gymnasium.' Most of the original fabric has now gone. Meanwhile another pre-Blitz building in the area, the Fellowship pub, which opened in 1940 in Trevithick Road, just off the ancient Plymouth to Saltash route, has also now gone. Closed in 2010 it was demolished the following year and the site redeveloped for housing.

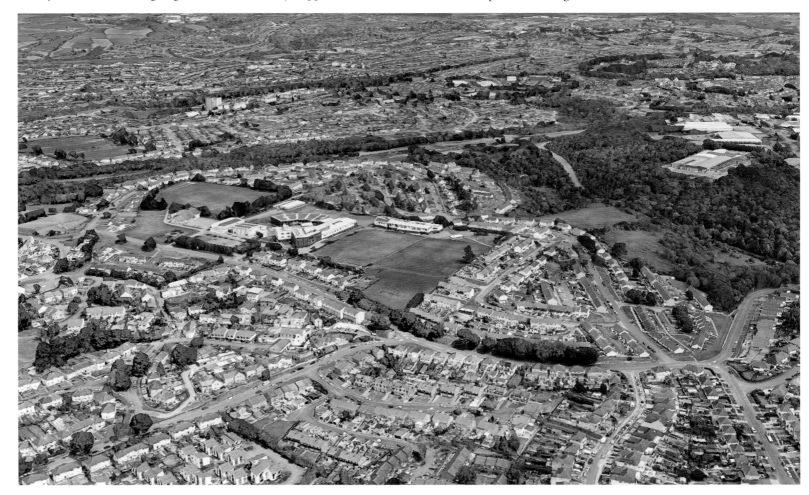

HAM 1948

We're hovering over Ham Woods, oddly enough the ancient Ham House is probably more visible now that it was then from this vantage point. Dryburgh Crescent with Jedburgh Crescent set within it form the conspicuous semi circle sitting above Ham Drive in the bottom right of our images. The school that was being built in the heart of it all is now long gone and Notley Gardens occupies the site today.

Meanwhile Mayflower Community Academy and St James the Less Church now appear on the bottom reaches of the large open area between this development and the housing estate to the north of Buckfast Close and Careswell Avenue. Here we have another curved street layout that was all shiny and new when our earlier photographer captured the scene. With Lowerside sitting above Ham Brook here we find Abbotsbury Way, Cleeve Gardens, Waltham Place, Hexham Place and Dunkeswell Close, with Tewkesbury Close curving around to the west of Ham House.

It's hard now to imagine Ham House standing for centuries surrounded by nothing more than green fields and woodland, but that is how it was until the early-middle part of the twentieth century. King's Tamerton Road bounds the development there while in the distance, along the half hidden Weston Mill Hill and Little Dock Lane, hundreds of post-war pre-fabs line what was then known as Tamar Way, all of them long-since cleared to make way for the Parkway, which was on the drawing board even then.

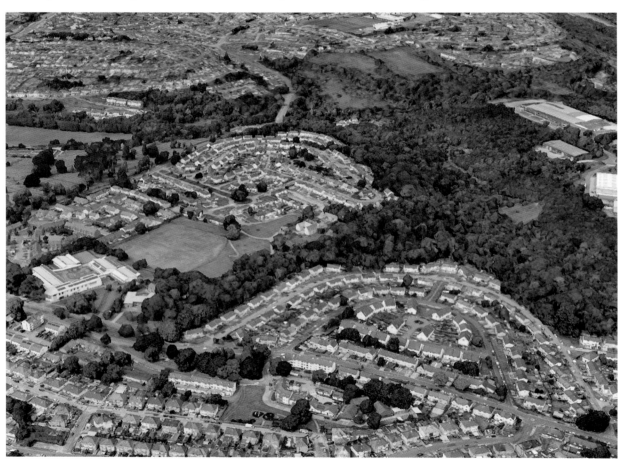

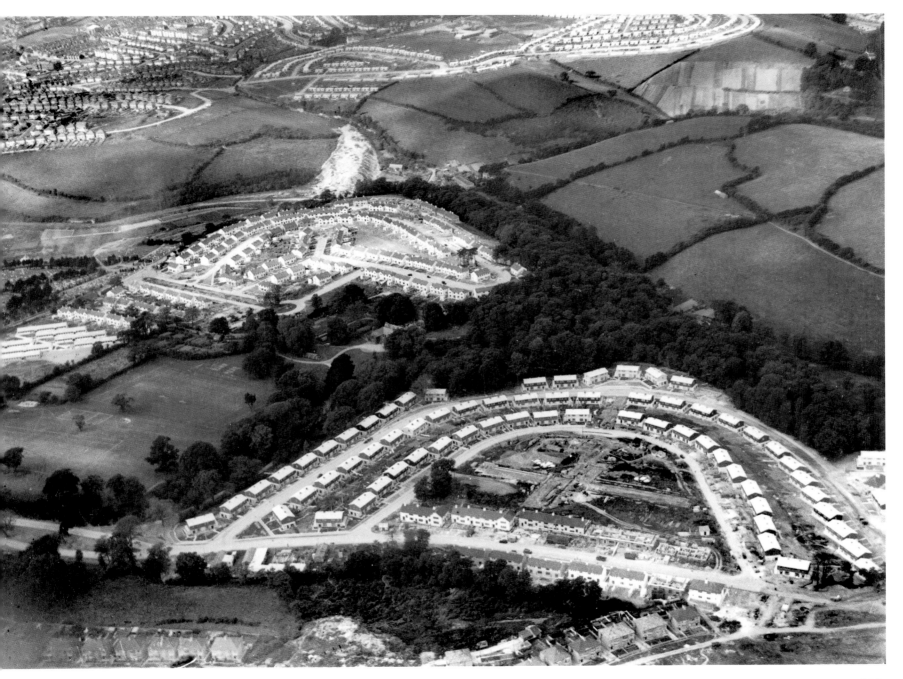

HONICKNOWLE 1948

We're looking down Shakespeare Road towards Honicknowle Lane, Dickens Road is coming in from the left with Burns and Byron Avenues stretching down to Cobbett Road which itself forks left off Shakespeare Road before it reaches Honicknowle Lane. Somewhat more permanent properties will be built here within a generation, but for the time being pre-fabs proliferate and predominate.

The line of Ham Brook is largely represented by the dark swathe of trees that runs across both images from the bottom right corner. Shakespeare Primary School occupies the middle distant field adjacent to the empty one, while the field in the foreground on the right is largely given over to car parking for the developments – Matalan, Tesco Superstore, Argos, Lidl, etc, in Transit Way – some of it standing on the site of the former brick works at Honicknowle.

The distinctive circular feature, almost in the middle of our earlier image, is the roundabout that sits at the point at which Honicknowle Lane, Farm Lane, Honicknowle Green, Warwick Orchard Close and Butt Park Road all meet. The long road on the right running all the way down to the Saltash Ferry then, and ultimately the Tamar Road Bridge today, is Crownhill Road. The Tamar itself runs across the top of the image, while Tamerton Creek can be seen in the top right hand corner.

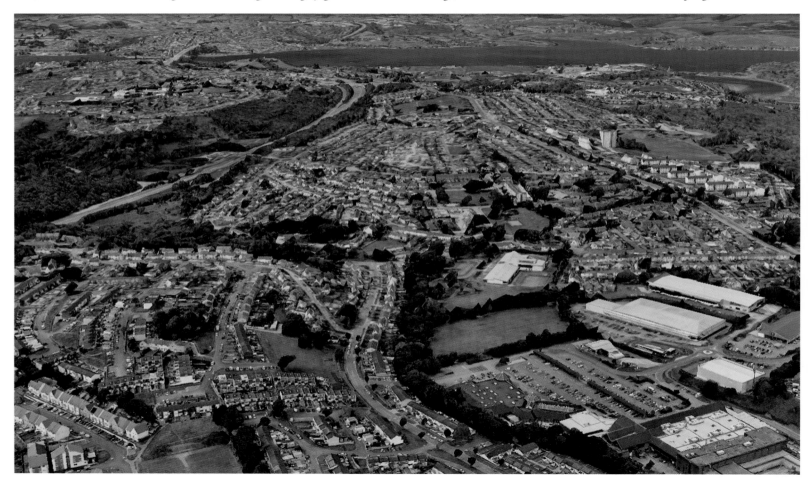

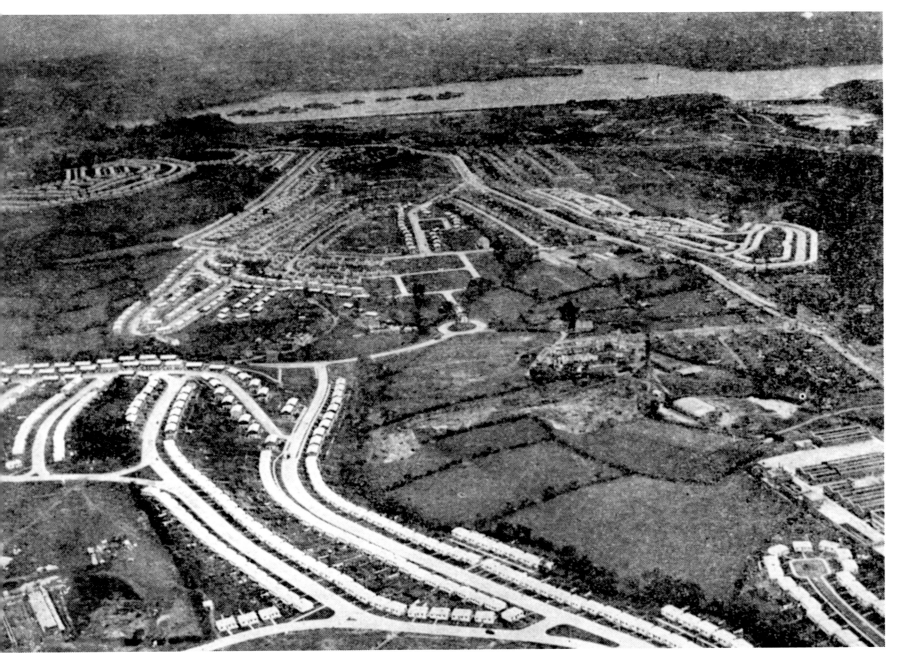

WHITLEIGH 1948

We're looking at Whitleigh a lifetime ago, on 20 November 1948, if we are to trust the date written in pencil on the back of our black and white image. Whitleigh was then a work in progress. In 1949 Pat Twyford in a revised edition of his wartime account *It Came To Our Door*, wrote: 'At present time this estate is being laid out. It lies between Crownhill and Tamerton Foliot and so is actually outside the present boundary. This will accommodate something like 1,870 houses and flats and will be the largest of the city estates.'

From our aerial perspective the land here appears distinctly flatter than it is and Tamerton Foliot is the built-up community we see in the middle distance with St Mary's Church tower just visible to the right of the village behind the line of trees that appeared on maps as West Whitleigh Woods. Budshead Wood is the large, vaguely triangular expanse of trees in the middle of the scene here and it is Budshead Road, formerly known as Agaton Road, that snakes around the southern boundary of

that woodland, eventually linking up with Crownhill Road via a section once called Tamar Road.

West Whitleigh Farm and West Whitleigh sit either side of the old Agaton Road, while Agaton Fort itself is just out of picture to the left. To the right we see Knowle Battery basking in the winter sun. Work on Anzac and Valiant Avenues, at the end of an extended Parade Road, is clearly well under way above the pre-war parallel roads – Marina Road, Queen's Road and King's Road.

Meanwhile, over to our left we see that work is also well under way on the new elements of the Ernesettle estate with Rochford Crescent curving into Budshead Woods and the beginnings of Biggin Hill below it. Mill Ford School and Knowle Primary are among the post-war developments that now sit conspicuously in the foreground of this vista. Today Tamerton Foliot appears largely as was but now rather than sit outside the city, the city has grown to meet it.

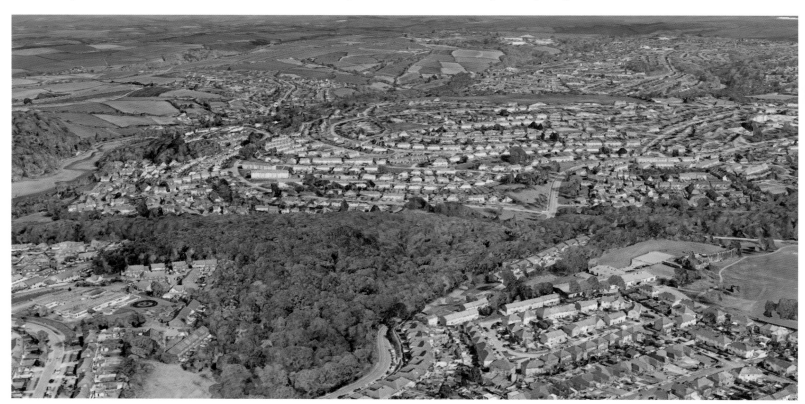

NORTH DOWN CRESCENT 1947

Time was when Royal Navy Avenue ran no further east than the bottom end of Ocean Street, and once the London & South Western Railway reached out beyond the end of Alfred Road, Ford, there was a brief stretch of open countryside before the line crossed Wolseley Road.

Along the bottom right hand corner of both images we see a number of allotments, to the west of which can be found Keyham Green Spaces, a project managed through Community Regeneration Outreach Projects (CROPS) which has its own gardens and horticultural growing area.

To the west, and just above and to the left of North Down Crescent, was the original North Down Plantation, replete with a fish pond, fed by a spring, which in turn filtered down into the upper reaches of Weston Mill Creek.

Of course that railway line has been gone for many decades now and there have been developments at various points along the way, notably here with the road that snakes into Biddick Drive to the right of the top of North Down Crescent.

South of that point the line of the railway is still discernible between the back of the crescent and North Down Gardens.

The oval shaped area to the left of the large block of flats on the south side of Wolseley Road opposite the end of Wordsworth Road incidentally is the North Down Basketball Court.

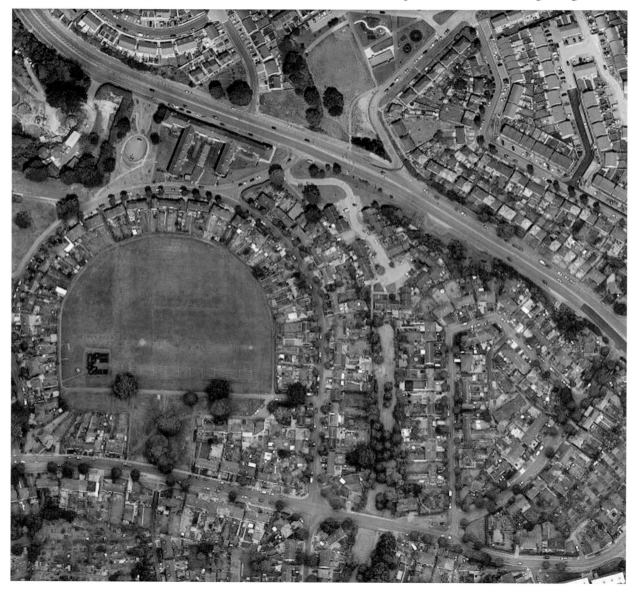

MILEHOUSE 1947

One of the earliest detailed maps we have of this area shows a turnpike at Milehouse. Originally this was known as Mile End, the location then being one mile outside of Plymouth.

An early incarnation of the Britannia Inn, thought to have been built around 1830, stood overlooking the point at which the road from Devonport to Tavistock crossed the road from Plymouth to Saltash Passage – a skittle alley occupied an adjacent site.

Two properties, Flora Cottage and Lifton Cottage, the latter much the larger of the two, occupied a part of the site that, in 1923, saw the distinctive, redbrick, Plymouth Corporation Tramways building erected across from the Britannia. Another early property, Elm Cottage, stood on the southern side of the road to Tavistock where today we find the Elm Cottage Veterinary Practice. Branching off the main road, then as now, was what was originally known as Gilbert Lane, while on the northern side of the road there was a development known as Outland.

Based around Outland House, the property that Robert Falcon Scott's grandfather had purchased after retiring from the Navy in 1826, was an assembly of ten or twelve buildings that sat around what is now Scott Road. Outlands was where the famous explorer was born and grew up.

There are a handful of other small streets in this development named after men who accompanied Scott on his ill-fated trip to the Antarctic – Wilson, Bowers, Evans and Oates. There is also Terra Nova Green, named after their ship and, of course, Outland Road.

Note the extensive allotment site that was previously to be found here ... and remember the laying out of Central Park itself was a relatively new development when our Then photograph was taken in the late 1940s.

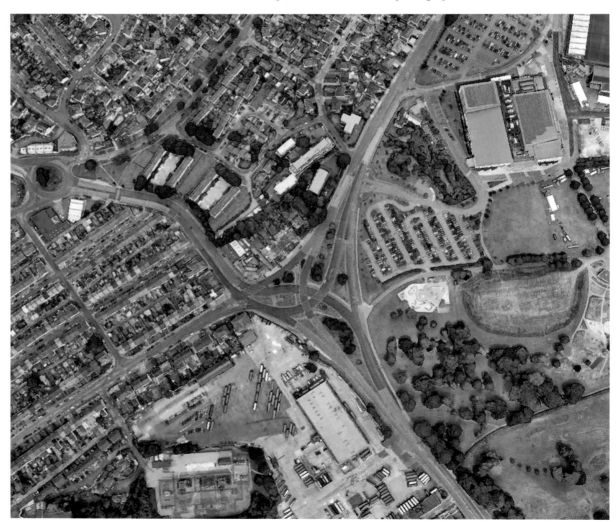

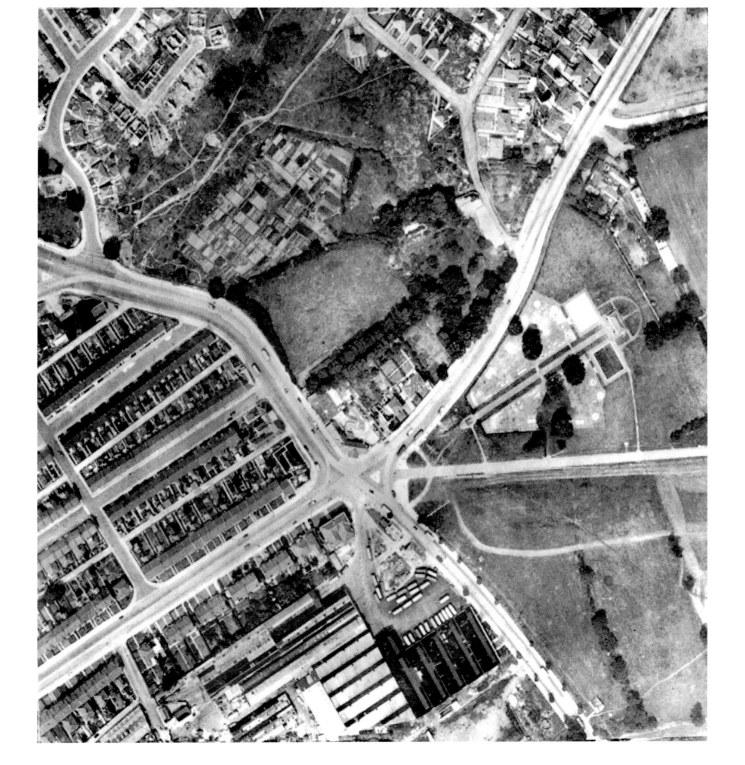

129

HOME PARK 1948

Central Park was officially opened on 29 July 1931. Home Park Recreation Ground had sat in rural isolation for decades already but after the Great War there was a desire to build 'homes for heroes' for those who survived the life draining conflict of 1914-18. Within a few years the area west of Tavistock Road (subsequently renamed Outland Road after the demolition of Outlands, the family home of Robert Falcon Scott, which stood near Milehouse) was developed for housing along with parts of Ham. Another prominent property, Higher Swilly House, which stood to the right of the area shown here within the boundaries of the new park, was also demolished.

Local architect Arthur Southcombe Parker had first proposed the idea for a major park here straight after the war, part of the rationale ultimately being that the work involved in creating such a facility would 'provide relief for unemployment in the City.'

The opening day programme contained a grand plan, most of which was realised, certainly in size and impact, but the swimming pool that was to be built on what is now a clear site behind the main stand at Home Park never got built, and it was to be another 34 years before

any pool would be opened here. Oddly enough the Life Centre now occupies the former tennis court site on the other side of what was Gilbert Lane.

Of course Home Park itself has been greatly improved over the years, although its capacity is still well short of the 35,000 plus crowd that piled into the ground on 10 January 1948 when our Then photo was taken. Note how the avenue of trees running up from Barn Park was still very much in its infancy.

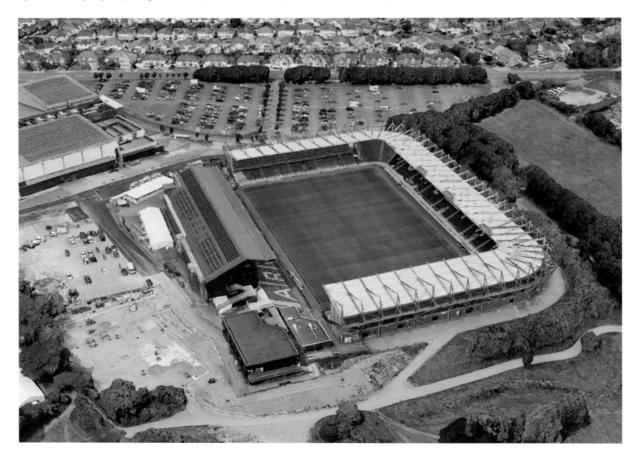

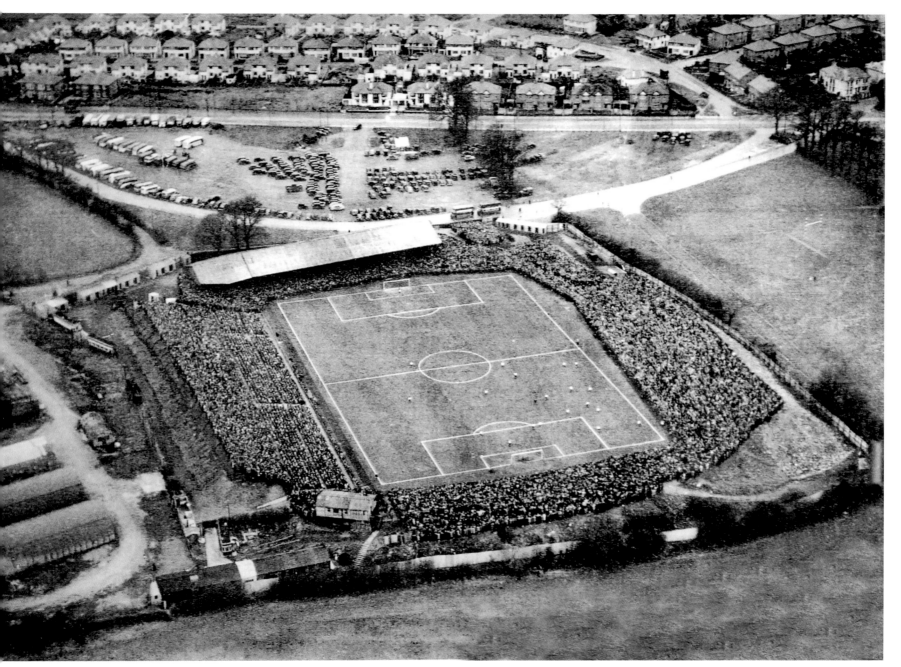

CENTRAL PARK GOLF COURSE 1947

Today this area is dominated by the Central Park Pitch and Putt golf course which sits in the area to the left of the long straight path that runs from the crossing of the paths all the way through to Outland Road. The path has a name, as do all the main paths running through the park, it is Discovery Way, after the ship Captain Scott sailed to the Antarctic in 1901. Leading left from this crossing of pedestrian routes is Eddystone Walk, on the grounds that, on a clear day, you can see the lighthouse 14 miles out to sea.

The distinctive pink half semicircle that we see today is Wilson Field Baseball Park, presumably another nod to Scott as Edward Wilson was one of the men who died with Scott on his last expedition to the South Pole.

To the left of the baseball arena in our earlier picture is what was thought to have been a site for wartime searchlights and above that is Knolly's Terrace (named after one of Sir Francis Drake's fellow captains) where we see what was another wartime feature, an encampment for the Auxilliary Territorial Service (ATS) which later, and at the time the earlier image was taken, served as a Prisoner of War camp holding German, Austrian and Italian prisoners. It is believed that among the tasks given to these prisoners was the laying of slabs and infrastructure works for the pre-fabs we see at the bottom of the picture. There were 35 erected above Wake Street and Holdsworth Street. An access road was created off Alma

Road and the development was christened Monroe Gardens. These temporary affairs sat just below some of the additional allotments that were created as part of the 'Dig for Victory' campaign. They remained in situ for the best part of 20 years. Meanwhile the round feature just to the right of Upper Knolly's Terrace is an anti-aircraft battery.

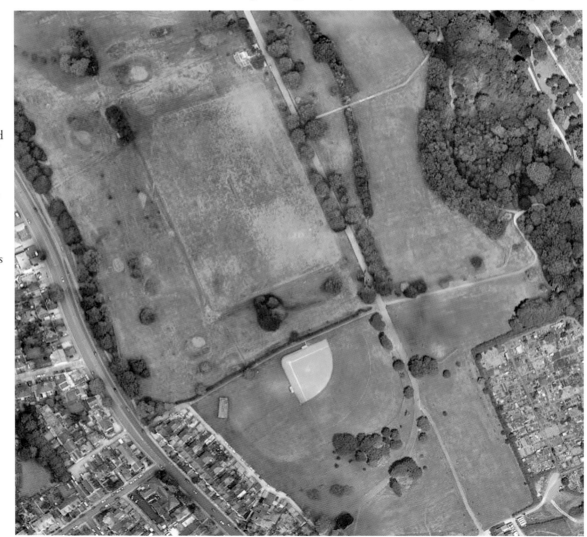

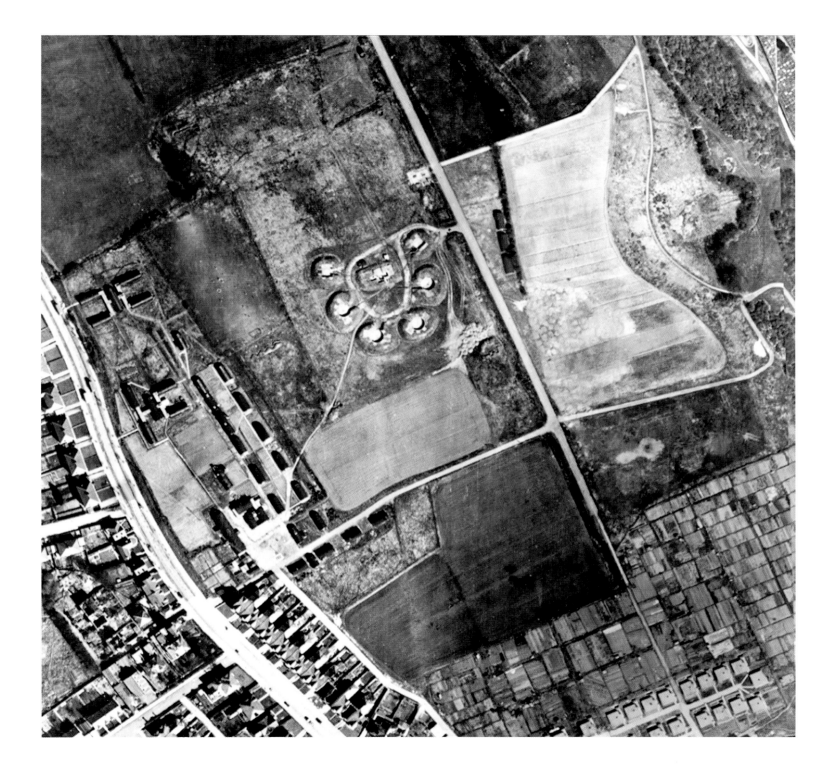

133

PEVERELL PARK ROAD 1947

Central Park had been open only 16 years and Venn Lane, which was still then open to traffic, cut across the bottom of Pounds House, indeed it ran from Outland Road, right across to Mannamead Road, those two thoroughfares being the principal routes from Devonport and Plymouth respectively, towards Tavistock.

Currently there is a major water feature being created at the Barn Park entrance to Central Park and doubtless the man responsible for the original layout, Thomas Mawson, would approve as it echoes and expands upon a long since disused pond and stream he created here nearly 100 years ago.

Pounds House itself dates from the late-1820s while the neatly arranged Park Roads that we see here laid out west of the wobbly line of Weston Park Road (known earlier as Mutley Lane), down to the very straight Peverell Park Road, date from the first two decades of the twentieth century.

The allotments lining the park side of the road followed soon after and here we see them running all the way down to Barn Park Road, the only break in their arrangement being the site that, in the 1860s, was developed as two major reservoirs to service Stonehouse. As it transpired the gradient was insufficient for them to be fully fit for purpose and by the early-1890s they were no longer in use. In 1972 they were finally filled in and a football pitch was created on what is now referred to as Reservoir Field.

NORTH ROAD STATION 1947

When the South Devon Railway trains first passed through this space, bound for Millbay in 1849, North Road was precisely what the name implied, the most northern route running around the top of the town. Above it there was very little development, below it the development either side of that part of the road to Saltash that had recently been named Cobourg Street, we found a number of then modern streets that had, since the early 1820s, been styled 'New Town.' They included quite a few streets with names designed to give them a certain social cache, like Oxford Place, Cambridge Street, York Street, Eton Place and Portland Villas.

Plymouth was expanding rapidly around this time and responding to a need to create a facility to better serve the transport needs of the Three Towns, North Road Station was established here in 1877.

Today, having largely avoided enemy bombs, it is the main station for the area. There was plenty of heavy bombing around the former New Town however, pulling large parts of this area into the zone that would become subject to post-war redevelopment.

Thus it was that North Cross roundabout was designed to act as the very head of the spine that runs through the body of post-war Plymouth city centre – Armada Way Having designated the area to the east of North Cross to be the academic quarter of post-war Plymouth, it is not surprising that Plymouth University campus now occupies a site that stretches west from the old Tech College in Tavistock Road/North Hill, north of Cobourg Street, south of North Road and includes the early nineteenth century Portland Villas and John Lane.

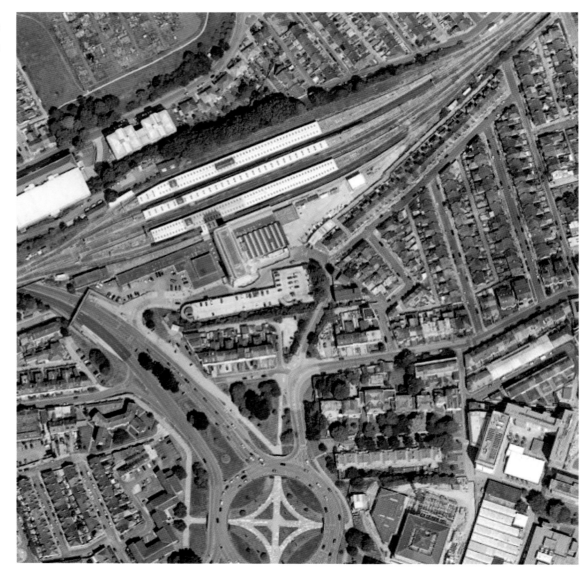

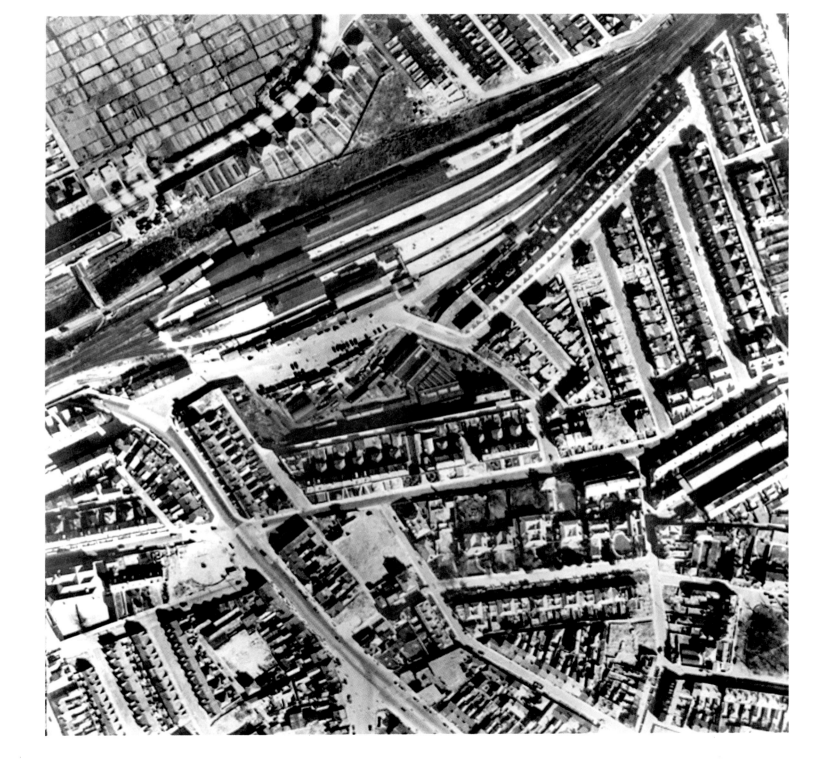

NORTH HILL 1947

At the dawn of the nineteenth century, little over 200 years ago, there were primarily only green fields north of the Old Town Gate that stood at the top of Old Town Street. This area, or at least part of it, was known as Old Town Without.

Drake's Leat filtered through the site and serviced the town as well as the mills that Drake had owned. The two distinctive parts of the reservoir, so clearly visible here, had yet to be built (1825 and 1828).

Sherwell House, on a site now occupied by the northern end of Queen Anne Terrace, was another early development on the landscape here, with Sherwell Church following in 1864.

By the end of the nineteenth century pretty much the whole of this area had been filled with streets and houses, along with the odd commercial property and half a dozen or so pubs. Portland Square (partially visible in the bottom left corner) and Drake's Place Park, below the reservoir, were the only open spaces of any consequence left undeveloped. Today the former has been largely infilled as part of the University campus, the latter is too, and has recently been revamped, while perhaps the largest open space now is that above the reconfigured Mount Street School which was created towards the end of last century.

FORD PARK, MUTLEY 1947

Although it's possible to pick out a handful of bomb sites in our earlier image, Mutley Plain's wartime experience was relatively untroubled, hence the decision of so many stores that were bombed out of the city centre to relocate here after the Blitz.

For the most part the buildings here were much newer than those in the heart of Plymouth, and indeed, Devonport and Stonehouse. Apart from Houndiscombe Farm, which had stood roughly where Beechwood Avenue and Hillside Avenue converge, off to the left of these images, there were very few buildings within our parameters here. Lewis Jones cottages at the southern end of Mutley Plain, that stood alongside the turnpike introduced after the levelling of the plain, were somewhat isolated.

That all changed in the second half of the nineteenth century. Nottingham Place, Nottingham Cottages and the Nottingham Inn (now the Junction) were among the first to appear at the southern end of the Plain (then still recorded as a stretch of Tavistock Road). While at the northern end we found a handful of substantial villas around Ford Park (now all contained within the Plymouth College campus). Just above them, and on a corner site not an island site, was the Townsend Inn (later superseded by the Hyde Park Hotel), the name itself suggesting the limit of development – the end of the town.

By the end of the nineteenth century most of what you see here had been laid out: Napier Terrace, Ermington Terrace (where Plymouth College started as a school in 1877), Seaton Avenue, Trematon Terrace and Coryton Terrace (which would appear to be the original name for the

road leading westwards off Mutley Plain) were first and then came those streets west of Pentille Road and east of the Plain.

Mutley Baptist, above the railway tunnel, and Mutley Methodist, appeared within a decade of each other in the 1860s and 1870s, although the latter was demolished in the 1970s. The railway itself preceded most of these developments and we can still see part of Mutley Station (closed in 1939) on the northern side of the tracks.

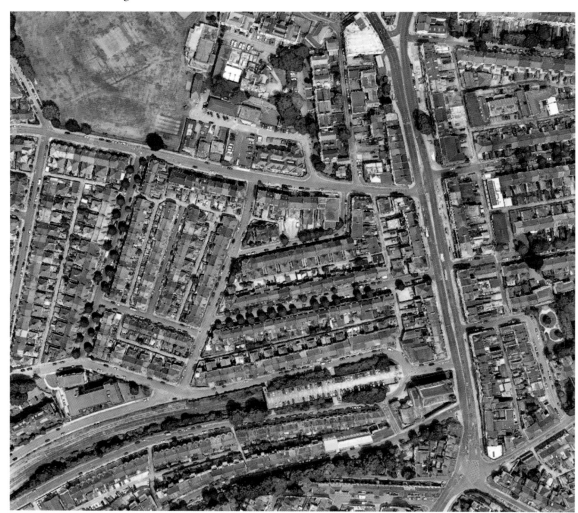

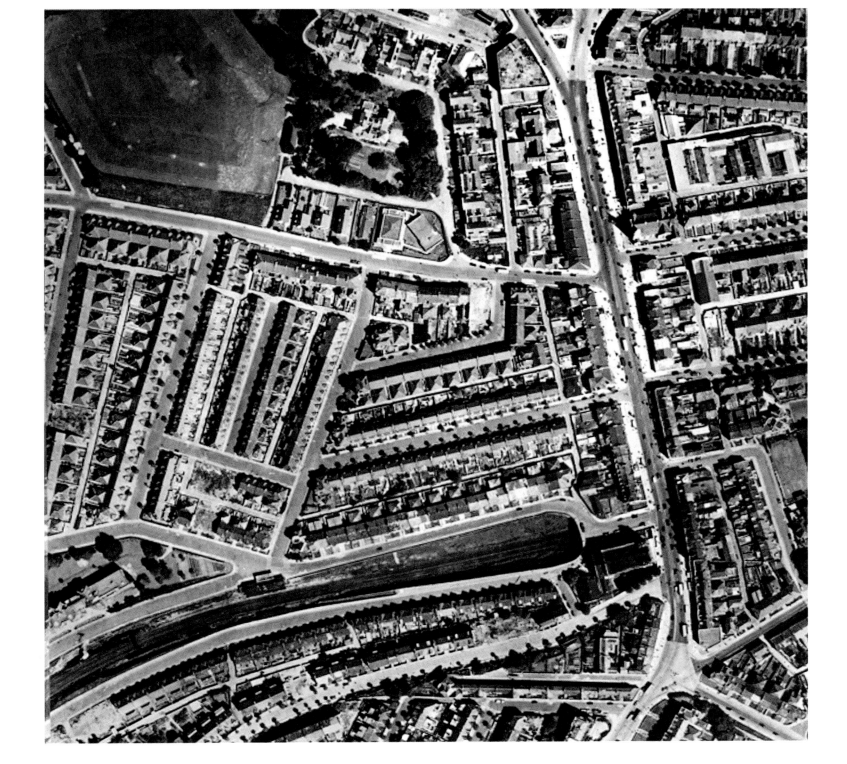

SEYMOUR ROAD 1947

It was in the 1850s that an enterprising group of property developers, Messrs Ellery, Fowler and Bennett, purchased the two fields then known as the Mannameads (East and West Mannamead) from the Seymour Estate and 'had the two fields laid out by Mr Damant for a series of villas'. One of the first of these was Wellington Villa (the Duke of Wellington, a national hero, had died in September 1852) and in March 1854 the property became the home of the newly established Mannamead School (it closed and merged with Plymouth College in 1896).

Initially this appears to have been a gated community and there were four large pillars across the entrance to what was a rather grand housing estate. The gate posts were removed sometime around 1897, shortly after Mutley, Mannamead and Compton were incorporated into the greatly expanded late-Victorian town of Plymouth. Before the foundation stone of Emmanuel Church had been laid in 1869 some 20 or so villas had been constructed in Seymour Road, and Mannamead Avenue and Seymour Avenue either side of it, with a gap before East Mannamead which stood at the top of what is now Glen Park. In that gap soon appeared Ingledene, the villa that belonged to the family of

Sir James Douglass, architect of the Eddystone Lighthouse. The BBC acquired this building at the end of the 1930s and have been here ever since although currently, after years of expansion, their activities here on the corner of Seymour Park, are starting to reduce.

143

HENDER'S CORNER 1947

Higher Compton Road runs across the top of the image and Lower Compton Road runs across the bottom while Compton itself sits some way to the east of this area. Both roads lead to Compton from Mannamead Road that runs north/south here, while Eggbuckland Road forms the right limb of the 'v' that meets at Hender's Corner.

Hender's Corner itself is perhaps the best known Plymouth place name not to appear on any map and yet this well known junction, with its handful of shops, has been referred to as such for over 100 years. The name was adopted following the establishment of a tram depot here, on the site south of Brandreth Road: in the bottom right hand corner of the earlier image the tram sheds are still visible although the last Plymouth tram had already run, back in September 1945. The tram depot was originally next to the nursery gardens that William Hender had set up here in the late-1870s and which stayed with his family until the 1930s, hence when describing the terminal location of this branch of the local tram network, it was logical to refer to it as being at Hender's Corner.

Clearly the depot site has now been redeveloped as blocks of apartments, as has the site of Hartley House that stood at the end of the drive that started next to the newsagent's, Mannamead News, which has been there since long before the war.

Other notable differences include the peripheral accommodation that has been erected in the grounds of the former Pearn Convalescent Home, the construction of Compton Primary School in the top right hand corner and the building of the Church of Jesus Christ of Latter Day Saints, just below Hartley Park, itself little changed since the 1880s, although the reservoir there was covered over in the 1980s.

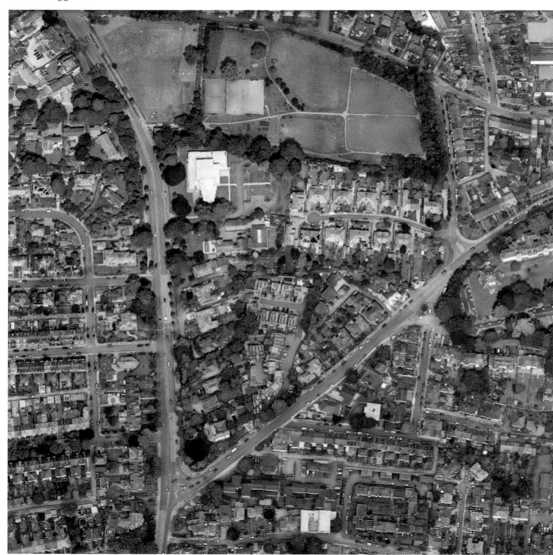

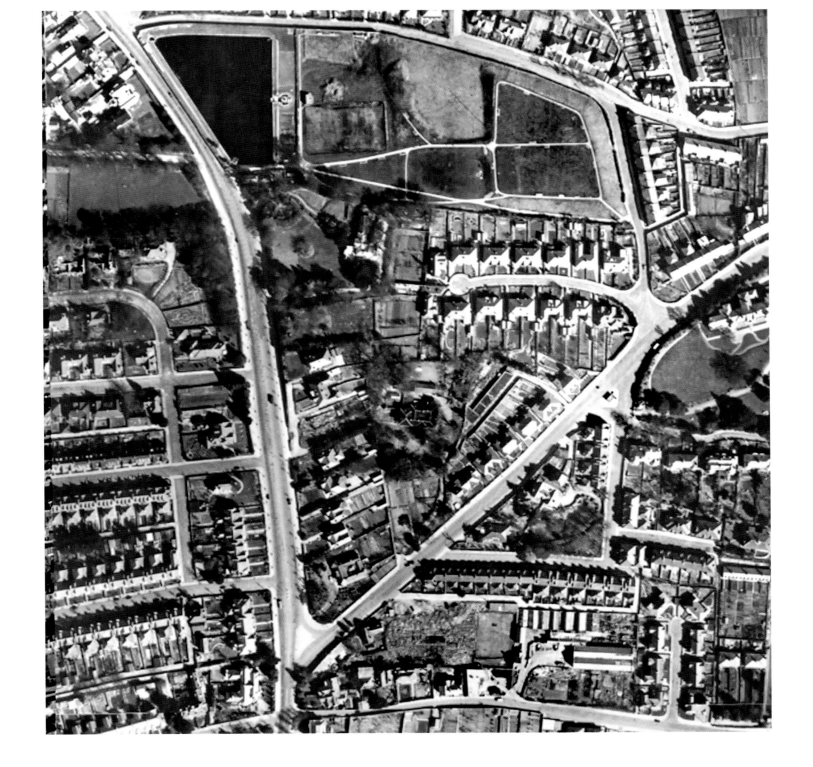

CARHULLEN, HARTLEY 1947

At the dawn of the twentieth century there would have barely been half a dozen properties evident in this otherwise rural landscape, the largest of which was also one of the newest – the grand house at the top of what would become Lockington Avenue – Carhullen.

Today home to the Plymouth Chiropractic Clinic, this impressive edifice also lent its name for many years to the neighbouring Carhullen Lawn Tennis Club (now falling under the umbrella of Hill Lane). The Carhullen name came to us courtesy of William Law, who, from 1892-95 was Lord Mayor of Plymouth and who had this house built. Law was related to the Earl of Ellenborough in Cumberland, but his branch of the family moved, apparently in the eighteenth century, to Carhullen in the parish of Bampton, near Haweswater in the Lake District.

William Law himself was a tea dealer and came to Plymouth in the 1850s and joined Underwood & Co, who operated in Bedford Street. The company employed nearly 100 people in the Three Towns and had 70 branches and agencies in Devon and Cornwall.

The widest thoroughfares in our late-1940s aerial shot are Bainbridge Avenue, Russell Avenue and Lockington Avenue, which were laid out in the first few decades of the twentieth century. It appears that the names Bainbridge and Russell have come down to us via the middle names of members of the Rendle family (Charles Bainbridge Rendle and Edmund Marshman Russell Rendle), who were, prior to the sale of the area for development, owners of this part of the Vinstone Estate. It is possible that the name Lockington was also a part of this family's heritage. Records show that a William Bainbridge bought Lockington Hall, between Derby and Loughborough, in 1576.

Work on Broughton Close began in the early 1960s and, like so many of the streets in Hartley Vale, is named after a British castle. Others that we see here constructed on the site of the farm that stood at the end of Hill Lane include Powderham, Beaumaris, Corfe, Pendennis and Saurum. Note the anchor points bottom left – Mannamead Road – and top right – the Parkway.

147

EGGBUCKLAND 1947

The difference between these two images, separated by almost 80 years, is quite dramatic but so too would have been the difference between our earlier picture and an aerial view taken 80 years before that.

Our then image shows a number of what were then longstanding landmarks: Efford Mill sat above the right angled curve at the bottom of the picture. It was fed by a small reservoir that was filled by a stream, which still runs today, along the length of the Parkway – the feature that now dominates this location. Home Park Cottages with their long strip gardens were then isolated to the left of what is now the Co-op at the entrance to Frogmore Avenue and was until relatively recent years, the Mermaid pub and to the right of Dale Avenue (and Moorfield and Downside Avenues). The original Frogmore incidentally, is just out of shot to the right.

Meanwhile, to the right of the winding Eggbuckland Road (or Mill Hill as that stretch was then known) was the original Austin Farm just above what is now Delamere Road. Austin Farm Academy occupies the fields we see below the farm site while Military Road, part of which is now hidden under tree cover, heads off toward Fort Austin.

Eggbuckland Road now stretches out to the left of the top right angled bend and a series of Walks – Beaudyn, Brismar, Bowhays and Bramble – have been built in the large v-shaped field that sits to the east and south

of it. On the right Carradale Road snakes around Greystoke Avenue. Heading from that junction in a more northerly direction today we see the entrance to Shallowford Road. Perhaps the most recent feature on our Then image was the northern tip of post-war prefab development of Little America, long since replaced by more modern housing.

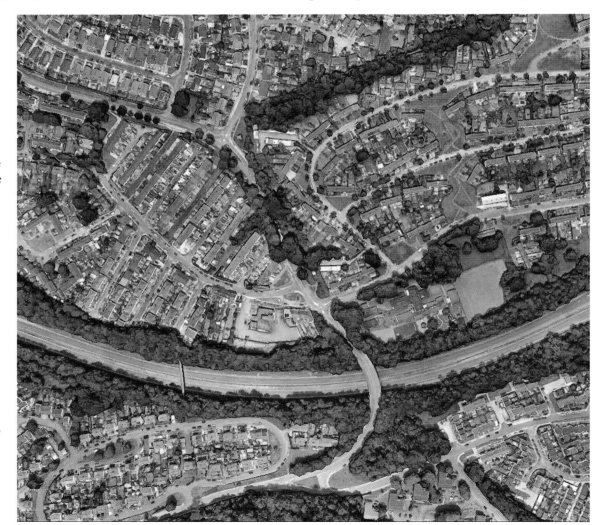

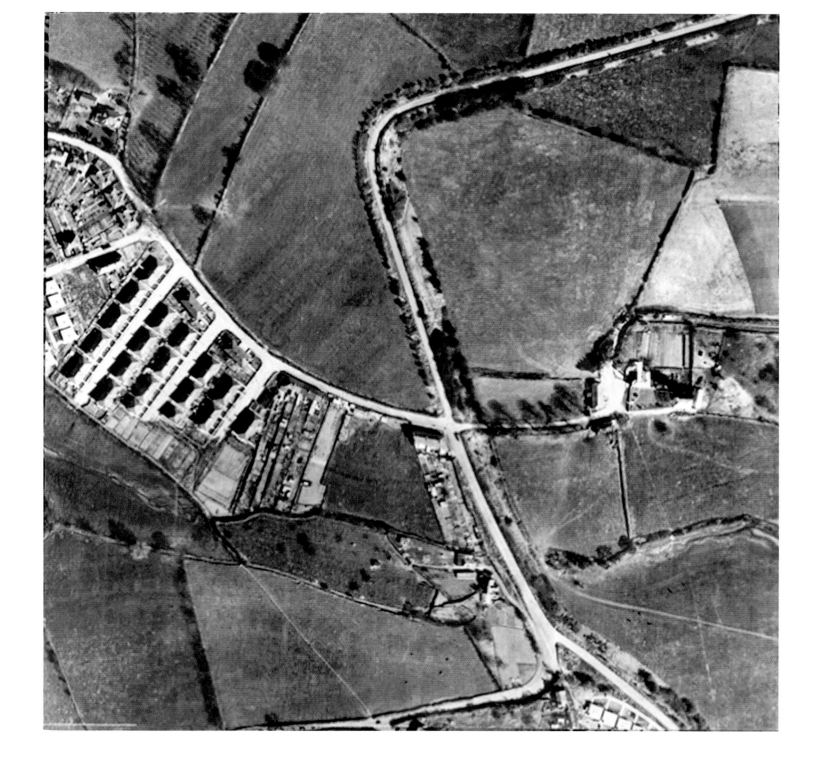

EFFORD CEMETERY 1947

Plymouth Corporation's new cemetery at Egg Buckland (as it was known then) was opened in 1907. At the time it was described in the *Western Evening Herald* as being 'about thirty acres in extent' and 'abuts on the Egg Buckland road, which forms the northern boundary of the borough of Plymouth.'

The same article noted that 'Eight feet is the ordinary depth which will be allowed for graves and vaults, but by special permission the depth may be extended to fifteen feet. 'A private earth grave eight feet deep will generally allow of three interments therein; eleven feet four interments; and fifteen feet, six interments.'

There was a suggestion that in an eight foot grave the figure should be amended to two, rather than four as permitted by the Plymouth Cemetery Company.

We also read that 'advertisements were to be issued forthwith for the office of superintendent, at an annual salary of £80, with residence and water supplied free of charge.'

Mayor J Frederick Winnicott formally opened the gates on Thursday 11 July 1907, which was described as being 'a gloriously fine afternoon.'

All that we see in our earlier image, apart from the cemetery appeared after that date.

Indeed most of what we see post-1941 is the area known as Little America, at the top of the image, the streets of light-roofed temporary pre-fabs off Michigan Way, namely, from the left: Florida Gardens, Oregon Way, Georgia Crescent, Texas Place, and Arizona Road. Impressively the Higher Efford Playing Pitches have so far resisted the bulldozers, but to the east of them and north of Blandford Road we see plenty of development around Trrevose Way, Gurnard Walk and Eddystone Close

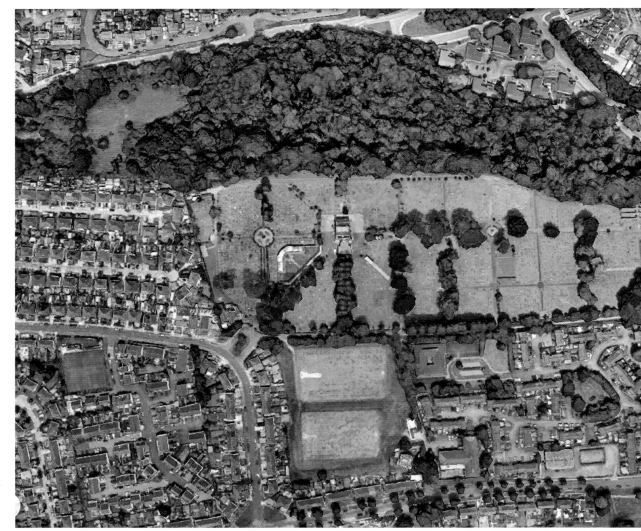

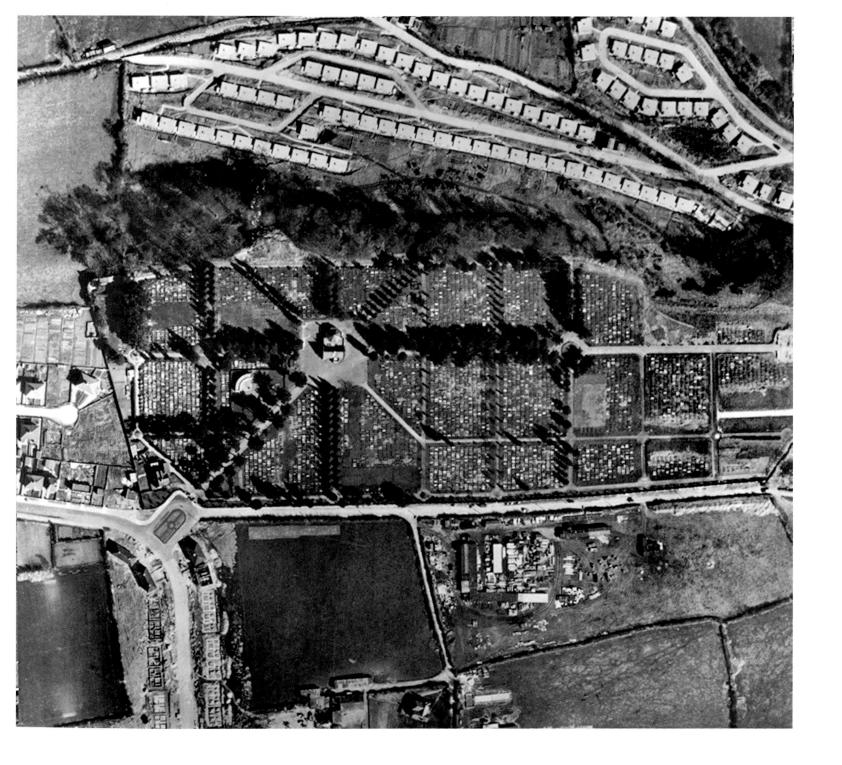

EFFORD LOOKING EAST c1948

'A view from the air of Efford housing estate looking east toward the Plym. Efford-road can be seen on the left from the Rising Sun corner to the cemetery, while Blandford-road cuts almost diagonally across the picture from Lower Compton, in the bottom right-hand corner.' So ran the caption of the earlier photograph when it appeared in the *Western Morning News* on Tuesday 26 October 1948.

Elsewhere in the paper there was an article the *Herald/Morning News* journalist HP Twyford. In the piece Twyford mentioned that an estimated 20,000 new properties were going to be required to replace those who had been bombed out of house and home during the war. 'First attentions,' he wrote, 'were concentrated on further development of the large Efford Estate, a portion of which had already been built up in the pre-war programmes.'

'But before houses could be built, public services like roads, sewers, electricity, gas, and water had to be laid on – great layout schemes with almost gigantic civil engineering works. And, bearing in mind the hilly nature of the country in and about the city boundary, it was only to be expected that there would be engineering difficulties and additional costs. 'Nevertheless, houses were needed and houses had to be built. The urgency was great, and first attentions were given to the building of temporary dwellings like the prefabricated bungalows. Everybody will remember the mushroom-like growth, of these homes on the outskirts of the city and in many odd places within the existing city where gaps could be found to accommodate them. On any vacant plots which could accommodate even half a dozen of the prefabricated bungalows, building was carried out. On the bigger estates they were built in accordance with the layout of the estate, with all the amenities of roads and services.

"Canned" homes were what some people called them, but they served a purpose and are still serving a purpose.'

As can be seen a lot of the development here, notably around the streets with river-themed names – Dartmeet, Trent, Swale, Ivel, Amber, Lune, Eden, Calder, Kennet, Therlow, Rother and Teme – were 'canned' homes and remained as such for a number of years!

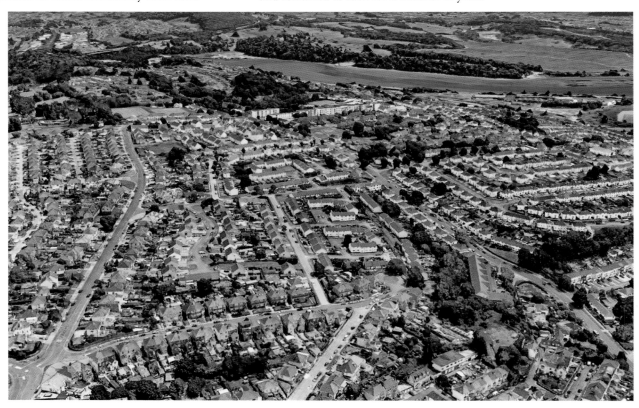

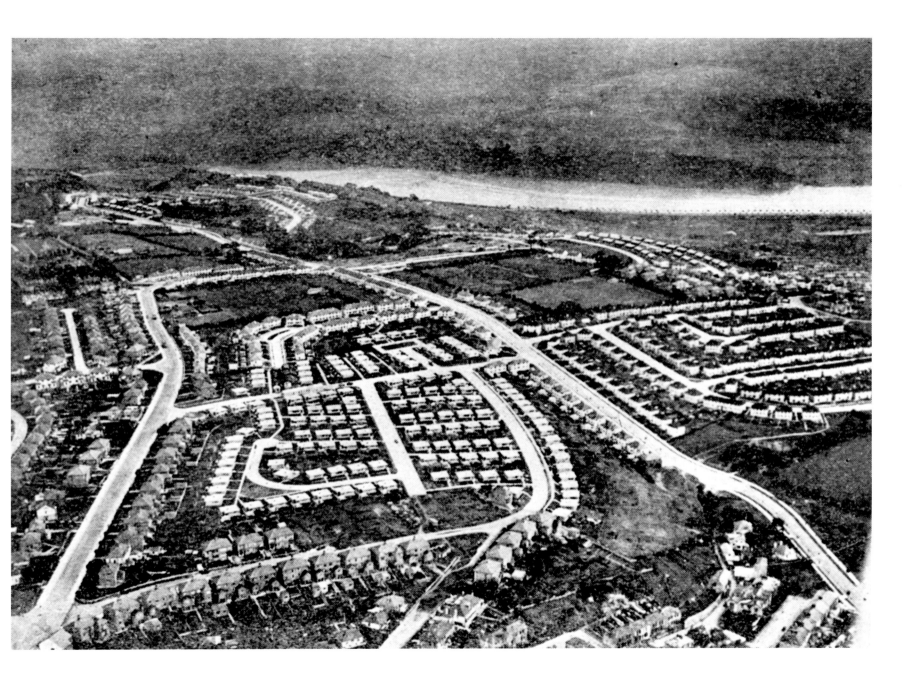

BLANDFORD ROAD, EFFORD c1948

Running top to bottom here, Blandford Road is the spine from which Efford radiates. First laid out sometime near the beginning of the twentieth century, along stretches of the old lane to Little Efford, Blandford Road was made up of no more than seventeen properties for the first 20 years or so of its existence, with odd numbered houses on the north side and evens on the south.

During the thirties there began large scale expansion, number 25 had appeared by 1937 and 65 within two more years, beyond that, curiously enough there was the lone No 142. After the war the Efford Estate expanded yet further and by 1951, what was now one of Plymouth's longest single streets had reached its present limit - No 491. This view dates from a little earlier, the key that would perhaps give us a more accurate date is the development on the northern side of the road, the eastern end of Efford Road, opposite the then undeveloped Torridge Way – the houses here have almost, but not quite, been completed. Meanwhile in the bottom left corner of the earlier aerial shot we see a temporary estate of pre-fabricated properties. With pedestrian rather than vehicular access this river-themed set of small Walks included Swale, Lune, Ivel, Eden, Amber, and Calder Walk, bounded by Trent

Close on the left, Dartmeet Avenue at the top and Efford Crescent to the right. On the other side of Dartmeet Avenue we find more prefabs in Rother Close, Kennet Place and Teme Close.

As the prefabs were replaced by more permanent structures, all now with vehicular access, so some of these names disappeared and of course there are many more changes here to note that have taken place since the late-1940s, not least among them being the loss of the large sports grounds on either side of Blandford Road, this side of Torridge Way and the appearance of Carlton Close at the bottom right.

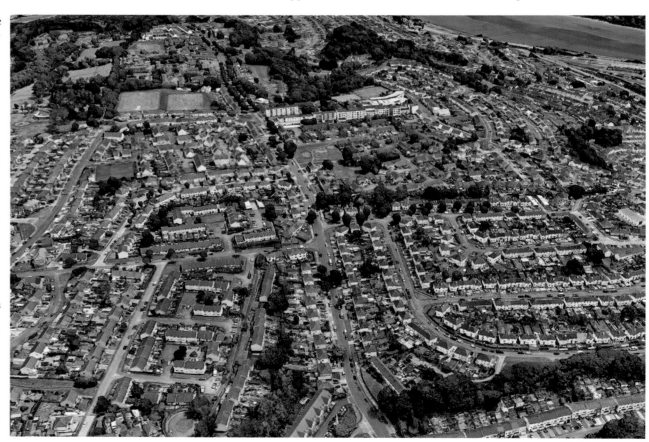

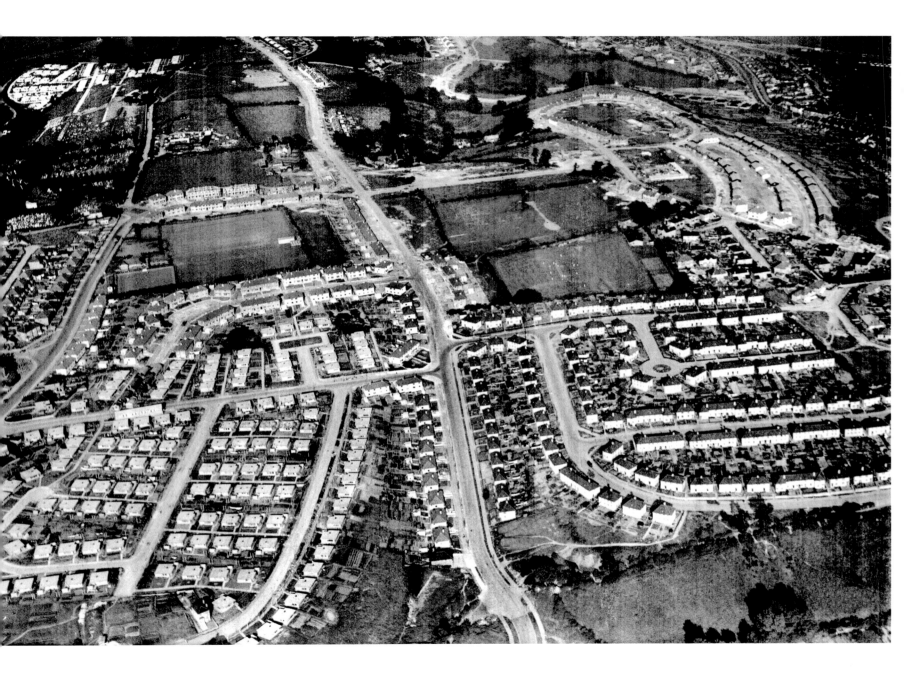

EFFORD LOOKING WEST c1949

'Take a tour the length of Blandford-road from Lower Compton to Laira; walk the length of the main road from Crownhill to St. Budeaux; try to find your way through the intricate windings of the estate which fills the country between the St Budeaux-Crownhill main road and Pennycross. You will find yourself in new habitations; you will be bewildered. The achievement meeting the housing needs of Plymouth has indeed been notable.'

So wrote Pat Twyford in October 1948 talking about Plymouth City Council rising to the challenge of rehousing the local population after the war. The earlier image taken around that time shows just how shiny and new Blandford Road was back then – and note, barely a car in sight! Blandford Road, then, as now, curves around into Pike Road, sitting inside the line of Military Road, with Efford Fort sitting just below the fork in that road in the middle of the picture. This had been a rural area with Deerpark Farm a little to the north east, Efford Manor and the later Efford Colony seen here east of Thames Gardens, with Lower Crabtree sitting above the end of the Embankment below Manifold Gardens. The erstwhile Efford Farm and Little Efford occupied the wooded area seen here to the right of the looping road that is Severn Place with Erme Gardens located within it.

It's interesting to note that almost all the housing development was carried out on open fields, and that the major wooded areas were preserved, hence the designation of what is now Efford Park and the more recent Efford Marsh Local Nature Reserve which runs down across what was Efford Warren to Marsh Mills, around Efford Fort.

As Twyford noted some 75 years ago though, there would have been very few of his readers who couldn't remember this as a rural idyll beyond the Plymouth boundary!

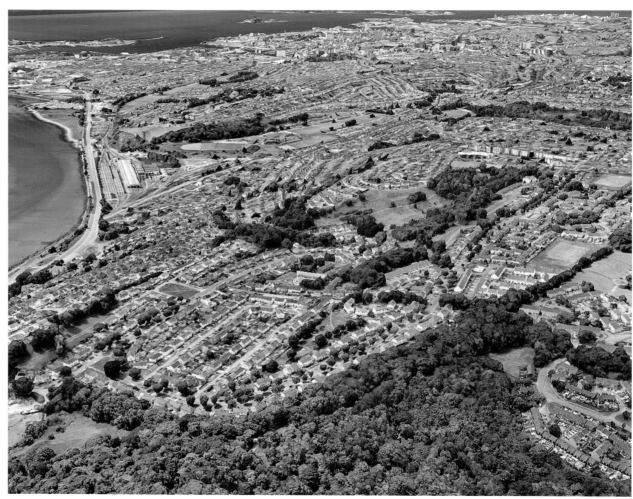

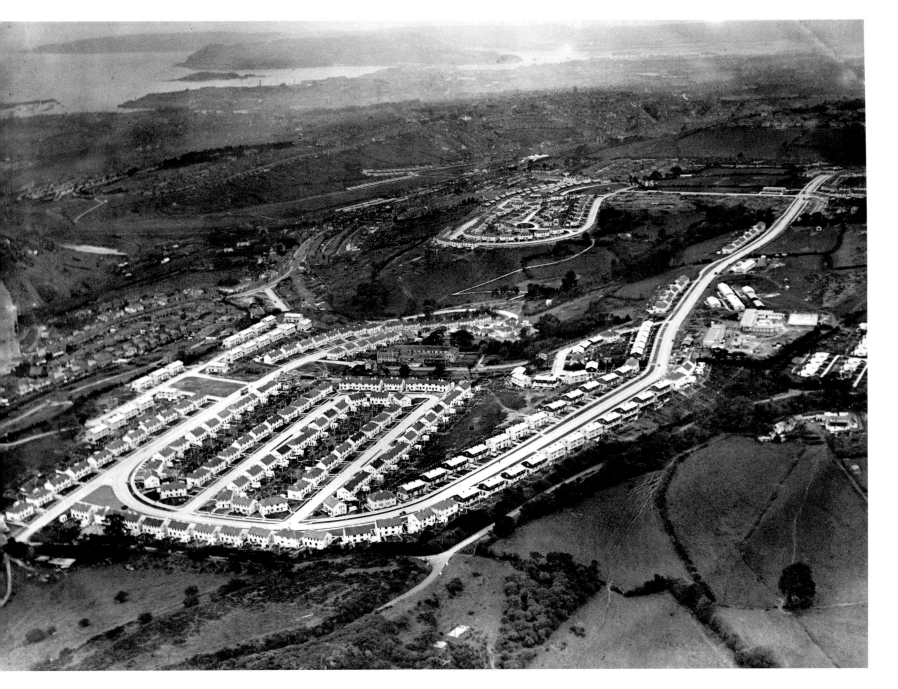

157

TECALEMIT, MARSH MILLS c1953

With the number of men employed in the dockyard bound to fall with the advent of peace, the Chamber of Commerce were one of the many voices urging Central Government to help out.

In 1946 the Board of Trade sent three firms to the area, all looking for favourable terms to start up new manufacturing bases.

First to arrive were the international lubrication and filtration giants, Tecalemit who started to establish themselves here in 1947. They could so easily have chosen somewhere in Wales or Scotland, but Plymouth City Council was very keen to lure the firm here and 'laid out a welcome mat over 62 acres at May's Meadow, Marsh Mills'. By Christmas 1951 the first phase of the factory with its soft-orange Taunton brick walls and

honey-toned, Ham hill coping-stone, was complete. Major suppliers to the motor industry, the enterprise locally was eventually more like five factories in one and quickly became the biggest factory of the largest company in that field in the world, employing thousands of men and hundreds of women.

Today, with so many more cars on the road, this is the site of Marsh Mills roundabout, with the Novotel and various superstore/warehouses occupying the factory site itself, and the Marsh Mills Beefeatery standing on the site of the old Marsh House (part hidden in the trees on the right). Beyond that, the old road out of Plymouth into Plympton can be seen running alongside the Lee Moor Railway to the road bridge over the Plym. In the middle distance we see the railway bridge over the Plym, the space between the road and railway line now taken up with the Sainsbury's supermarket and car park. As we see it here there are still traces of the American wartime occupation on that same site, with a number of Nissen huts clearly visible.

CRABTREE 1947

Looking from directly above Efford Warren and Lower Crabtree we get little indication of the differential height situation here, but all those who have used Military Road as a shortcut from the Embankment up to Pike Road or vice versa will know this is a steep hill. It is also a deceptively rural route and travelling along the stretch between Laira Battery and Pike Road you could be forgiven for thinking you were on a country road and not in the middle of a big city.

And, to be fair, 100 years ago, this was still very rural, the only real development being the Battery and a handful of properties either side of the ancient Crabtree Inn. Thought to have been one of Plymouth's oldest inns, the Crabtree would have been a very popular resort for travellers crossing the Plym at the Ebb Ford (hence Efford) before the construction of the original Longbridge in the seventeenth century. Two hundred years later and the construction of the Embankment on the western bank of the Plym would have pushed yet further traffic past its door. However as the roads improved and the amount of traffic on them increased relentlessly so the old London Road became too narrow and in 1971 the Crabtree – and the neighbouring cottages – were pulled down to allow for the widening of the carriageway. Sitting between the line of the Plymouth Road and the Great Western Railway line it's possible, incidentally, to make out the

line of the erstwhile, pre-steam, horse-drawn Plymouth & Dartmoor Tramway which opened 200 years ago in 1823.

In the top left of our Then image we see the then new Thames Gardens branching west off Pike Road with another river-themed Efford street, Manifold Garden sitting to the south.

Below them are Darwin Crescent, Fairview Avenue and Dunclair Park, with the more recent development of Willow Close top right.

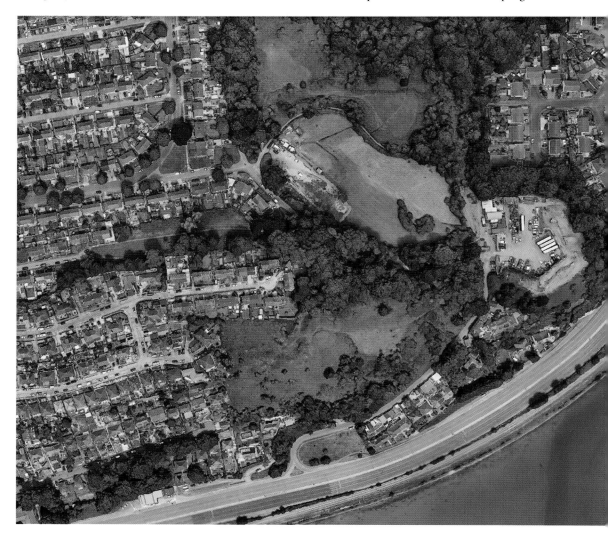

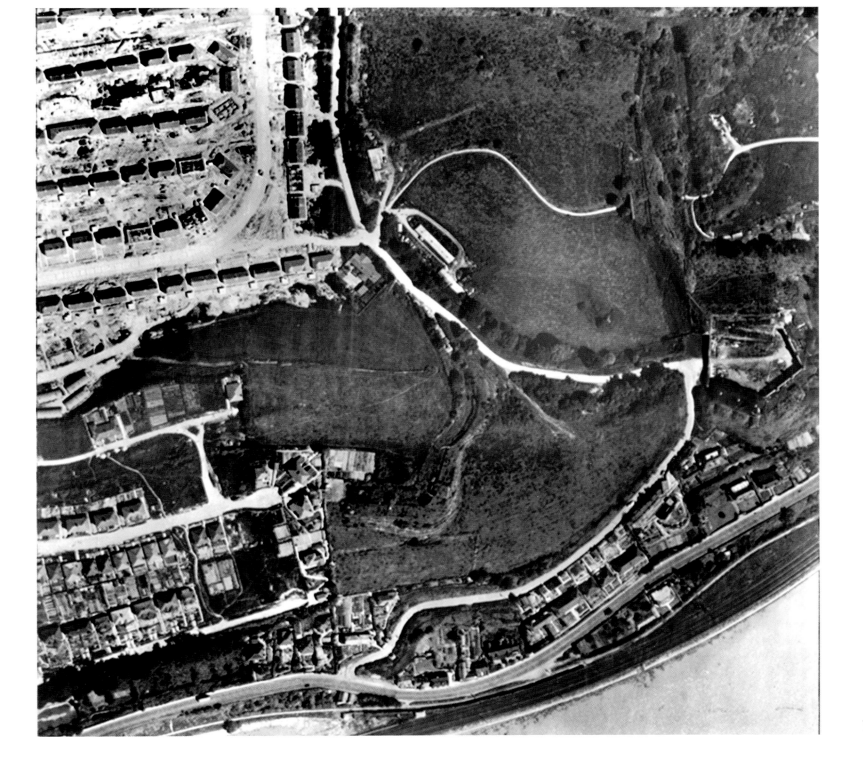

EMBANKMENT ROAD 1947

A number of changes leap out here, most notably the reclaimed land on the waterside of the Embankment that now goes by the name of Blagdon's Meadow and the extra wiggle at the western end of Lanhydrock Road after it crosses the Embankment.

It's also noticeable that a considerable quantity of allotments have been lost, at the northern end of Mirador Place (replaced by housing) and north of Mount Gould Park (now a luxuriant woodland).

Clearly however quite a few have been replaced by the Embankment Allotments, in that sliver of land between the Embankment and the railway track.

Viewed from this angle the paths that traverse Mount Gould Park present a very distinctive almost Celtic rune appearance and it's interesting to note that over 75 years later that layout is unchanged, as indeed is the layout of Beaumont Road and Dartmoor View just off it. Much of this estate, which dates from the two decades before the war, was laid out on Astor land and it was Waldorf Astor who granted the community, in perpetuity, the Astor Institute.

Opened by his wife, Lady Nancy Astor in April 1929, his idea was to provide a facility for the tenants of the Astor Trust Housing Estate, away from the public halls and recreation areas of the town.

'Here are the bones,' he said at the opening 'it is for the people to see that a soul is put into them.

'The gift,' he added, 'is not for the moment but for the future.'

In 1936 he funded the addition of a gymnasium, meeting rooms, hall and a kitchen and for many years it enjoyed a successful reputation. Over time however it's appeal was superseded by alternative entertainments and today the site is occupied by Mount Gould Hospital, Age UK and the Plym Neuro-Rehabilitation Unit.

LAIRA BRIDGE 1947

Here we see the lowest land crossings of the River Plym: Rendel's iron bridge of 1827 and the railway bridge from 1897. Today the latter survives but only as a pedestrian and cycle route – the train line to Turnchapel and Plymstock closed in 1961. The iron bridge came down around the same time as it was superseded that year by the new road bridge which was opened by Lord Chesham, Parliamentary Secretary to the Minister of Transport, on 1 June 1961, two months after the Tamar Bridge. Note the line of the new bridge picks up on the same side west of the river but the crossing point on the east side sits to the south of the Rendel structure and the original stonework still survives. Extensive quarrying either side of Pomphlett Creek, or Lake as it is described on some early maps, has created prime space for dockside development. Remarkably in both instances this remains almost exclusively industrial, not residential – perhaps in years to come?

Running down to meet the crossing from the north east is The Ride, which, in days gone by, the Earl of Morley would have used to access the bridge from his property at Saltram.

It's also worth noting that one of the earliest buildings to feature in these images is the pub that bears his name and which was erected to provide refreshment for the bridge builders as well as subsequent road users. Meanwhile, on the eastern bank, note how the former ship-breaking yard has been succeeded by a mini-marina site with pontoons for leisure craft.

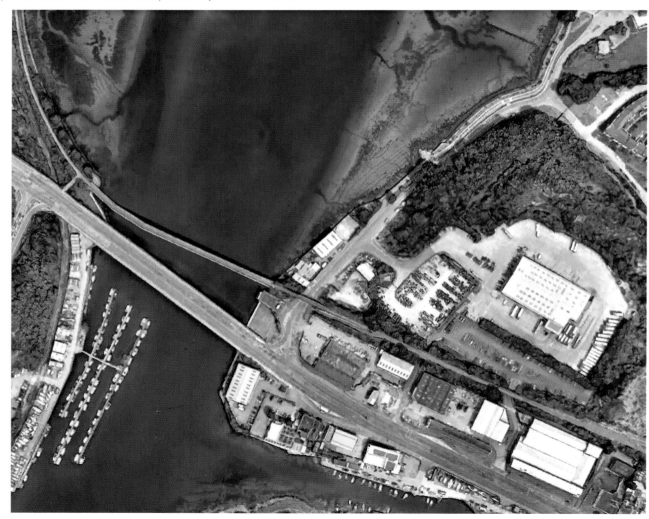

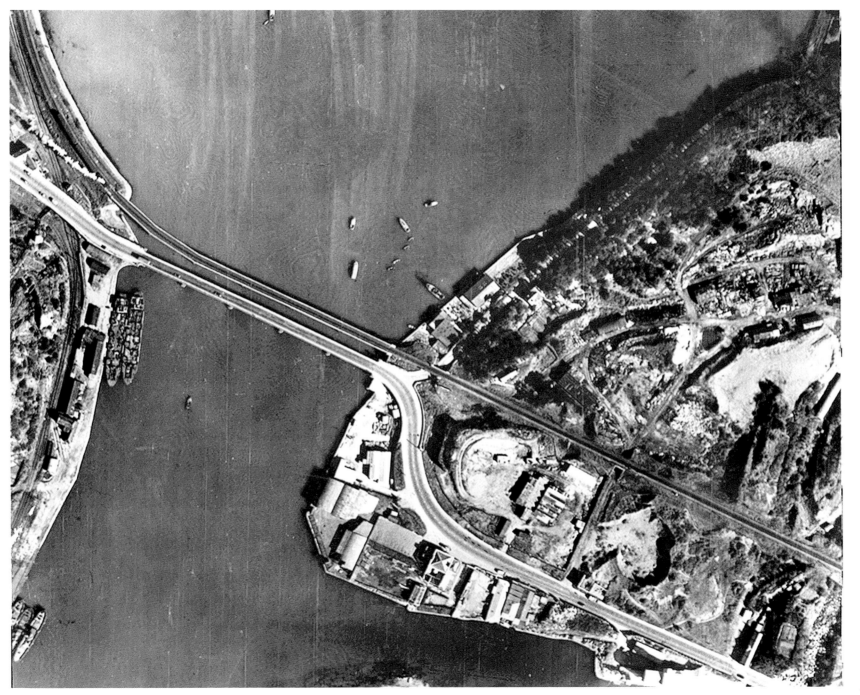

CATTEWATER c1950

The changes here over the last 200 years reflect so many different aspects of the way all of our lives have changed over that time. Back in 1823 there was only a ferry or flying bridge crossing the Plym at this point, but that was about to change as in 1822 the Earl of Morley, who lived at Saltram, commissioned a young engineer, James Meadows Rendel, to build one of Britain's earliest iron bridges, here, across the Laira. It was officially opened on 14 July 1827 by the Duchess of Clarence (afterwards Queen Adelaide).

At that time great strides had been taken to flatten the waterfront on either side of the Plym, not for the sake of creating waterside development potential but rather to quarry stonework to take out to the middle of the Sound and dump it there as part of that momentous undertaking to create Plymouth Breakwater. Clearly this created spaces that were easily serviced from the sea – few were thinking in terms of housing developments with riverside views in those days – and before the century was out a generating station had been constructed here to supply Plymouth with that most novel and game-changing of technological innovations – electricity. The main use at that time was for lighting and tramways. There were only 82 private consumers.

That first station opened in 1898, in 1932 an extension was added and in 1946 the Central Electricity Generating Board tasked Plymouth with the job of extending its facilities further. Our then picture shows Plymouth 'B' under construction.

Coal fired when it opened in 1953, it was converted to oil in 1959 when a second phase was completed.

It's now over 30 years since those familiar redbrick buildings with their imposing chimney stacks were swept from the waterfront and today, although industrial development dominates both sides of the river here, there are many changes to note: most notably the 1961 road bridge which superseded the iron bridge; the number of pleasure craft now moored here and the new housing that is appearing behind the quarry to the north of Billacombe Road.

PRINCE ROCK POWER STATION 1959

The Plym estuary, Pomphlett Creek and Laira Bridge make this an instantly recognisable image for those familiar with the area … but how very different it all looks today.

With its towering chimney dominating the view, phase one of what was always known as Plymouth 'B' Power Station, stands proud in the foreground. Largely superseded by a feed off the National Grid in the early eighties and demolished not long afterwards, Plymouth 'B' was new when this photograph was taken in the mid-late fifties. The smaller, Victorian, six-chimneyed, coal-fired Plymouth 'A' Station to the left kept going until the early seventies and was pulled down a decade or so before its newer neighbour.

Today a much more modest development occupies this site off Oakfield Terrace Road. Meanwhile another casualty in our Then image was the wonderful, early, iron bridge designed by Rendel in the 1820s and replaced by the current Laira Road Bridge in 1961. As well as more cars on the road, we have more boats on the water and today pontoons line this side of the Plym, while across the way there's the aggregate loading terminal and the Admiralty Breakwater blockworks where staff manufacture and deposit massive, cast concrete blocks on the Breakwater about 12 times a year in areas that need shoring up.

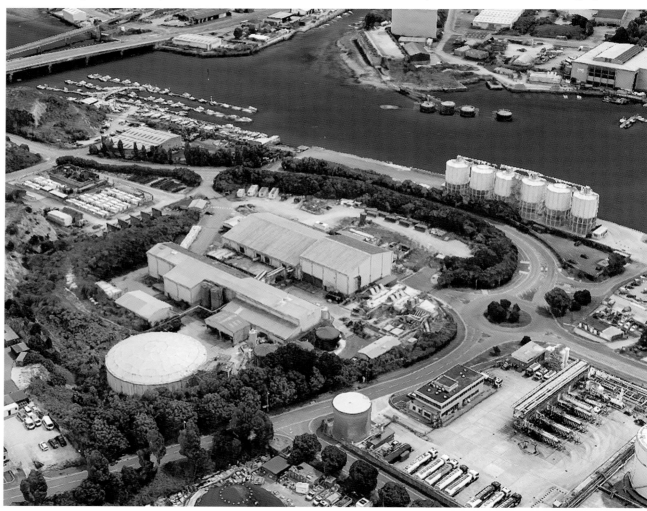

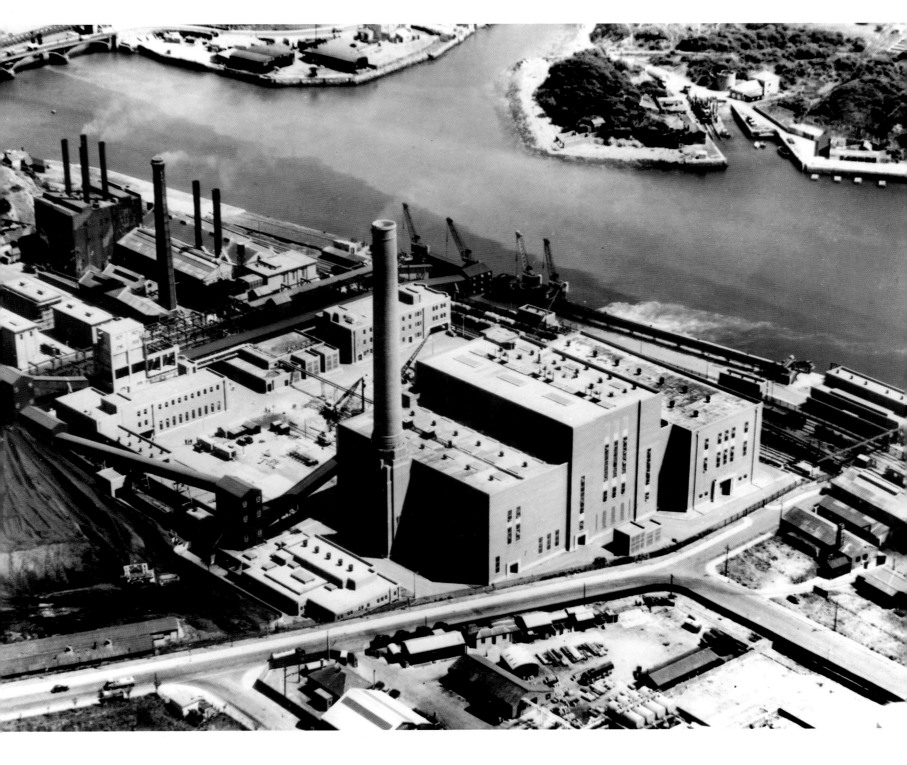

CATTEDOWN 1959

Here we are on one of the many flat sites around Plymouth waterfront created by quarrying. Much of the stonework excavated in the process went either into creating the great limestone buildings erected in the three towns in the nineteenth century (including many churches and schools, many of which are still standing today unlike many of their immediate post-war counterparts) or into constructing one of the greatest engineering endeavours of the day – the Plymouth Breakwater. There were designated Breakwater Works on either side of the Plym and easy to see here just where that quarrying stopped. Don't forget both Hooe and Hoe have the same etymology, they come from the term Haw as in high, and there were high ridges, all around the Hoe and Hooe as the Plym cut its way through the wide valley that led down from Dartmoor.

Meanwhile, who would ever have imagined that this massive redbrick power station was destined to have a lifespan of less than 40 years when it was completed in 1959.

With the rail links all but disappeared this is still very much an industrial waterside and looks destined to remain so for the foreseeable future, but it's not impossible to imagine a certain gentrification of the waterfront here one day, as the desire for waterfront views outweigh concerns about rising water levels.

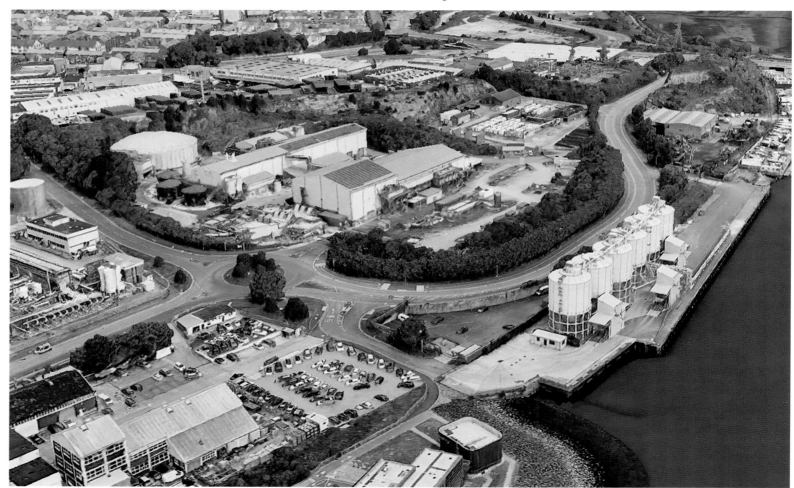

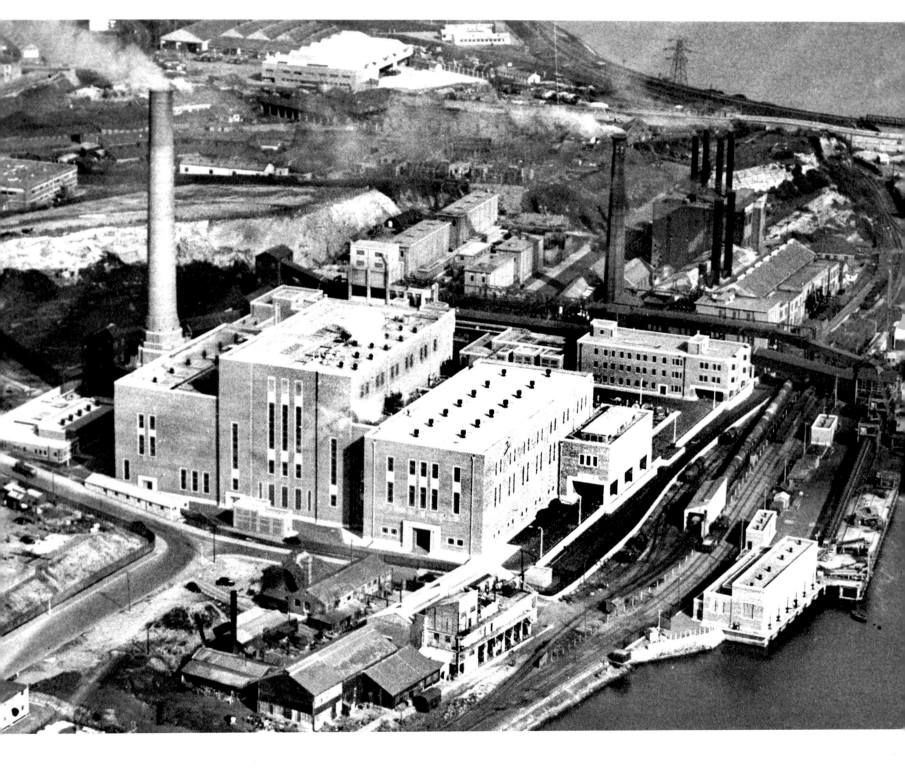

CATTEDOWN 1947

Caves uncovered by the intensive quarrying in this part of Cattedown suggest that the first known Plymothians probably lived in this neighbourhood thousands of years ago.

Certainly hundreds of years ago there was a small community living here, thanks in no small measure to the fact that the ancient ferry to and from Oreston plied its trade across to the Passage House Inn (closed but still standing) which sits on one of the oldest inn sites in the city – it's said to date back to the fifteenth century.

Later joined by a couple of other hostelries – the Three Crowns (long gone) and the Freemasons (which was pulled down in the late-1950s) – there was also a chapel and Sunday School.

As the whole eastern side of Sutton Pool and western bank of Cattewater became increasingly industrial so the smaller residential terraces of Cattedown village were replaced by large soulless structures, with the flat areas created by the quarrying proving ideal for large scale redevelopment.

Further level surfaces, reclaimed from the Cattewater, have added to the land available here. Cattewater Wharfs were followed decades later by buildings erected on what was described as being wasteland but which was in effect a mud bank with a stone topping, christened Neptune Park.

Here it was that in 2003 the Theatre Royal's award winning new rehearsal centre, TR2 was opened. This £8m complex stands in stark contrast to the industrial buildings around it and houses the theatre's carpenters, metal fabricators, prop makers, wardrobe team and scenic artists, as well as serving as home to their education programme and dance companies.

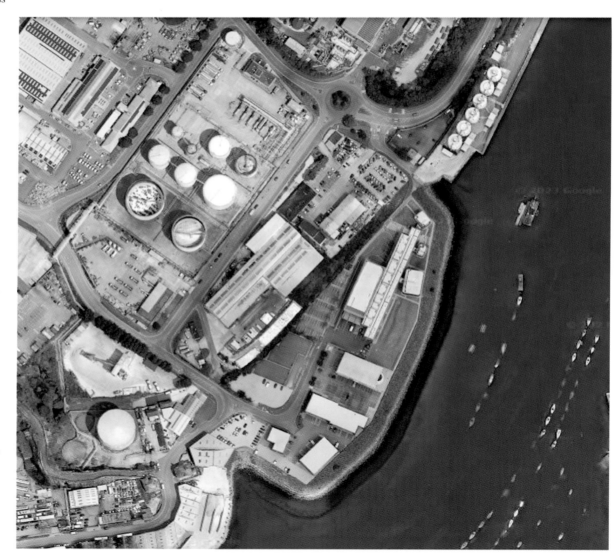

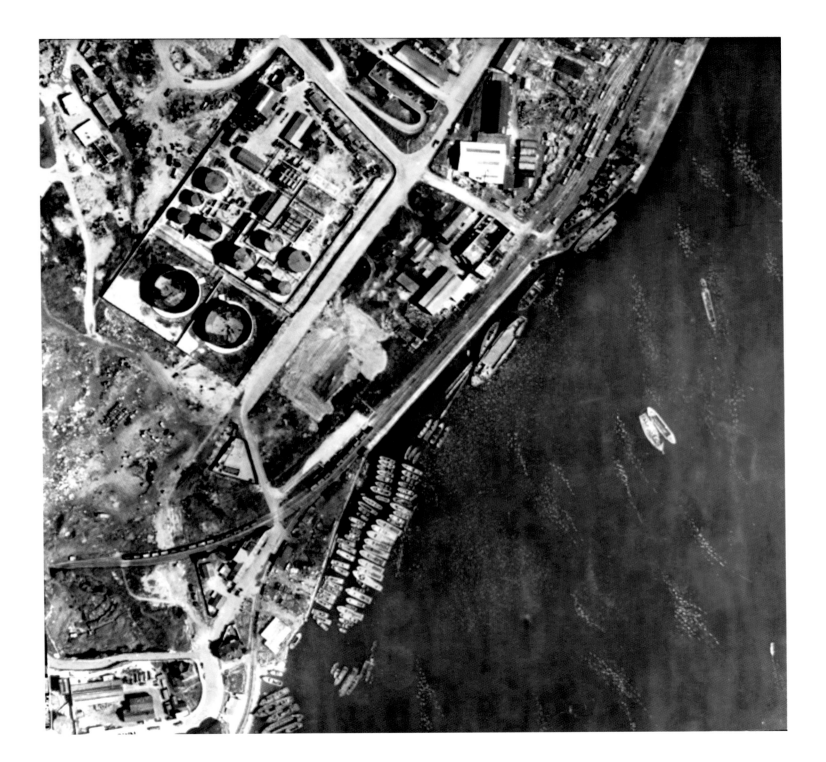

173

ORESTON, HOOE & TURNCHAPEL c1959

Much developed in recent years, the pastel coloured properties of The Old Wharf and the more recent Boston Close as they trail down and around the erstwhile Langshill Quarry now line the eastern side of the entrance to Hooe Lake. On the other side Barton Road and Causeway View fill the flat area that for many years lay at the bottom of Hooe Lake Quarry. Meanwhile the railway line into Turnchapel now makes for a fine walkway to here from Billacombe roundabout. The last passenger train left Turnchapel in September 1951, but the swing bridge was to remain in place for a few years, although it ceased to be used by trains soon after the aerial shot was captured. Our Then image gives us an insight into just how extensively the area was quarried in the course of providing stonework for domestic building locally and for the Breakwater in the middle of the Sound. Note also the private yachts off Turnchapel and the many changes at Cattedown.

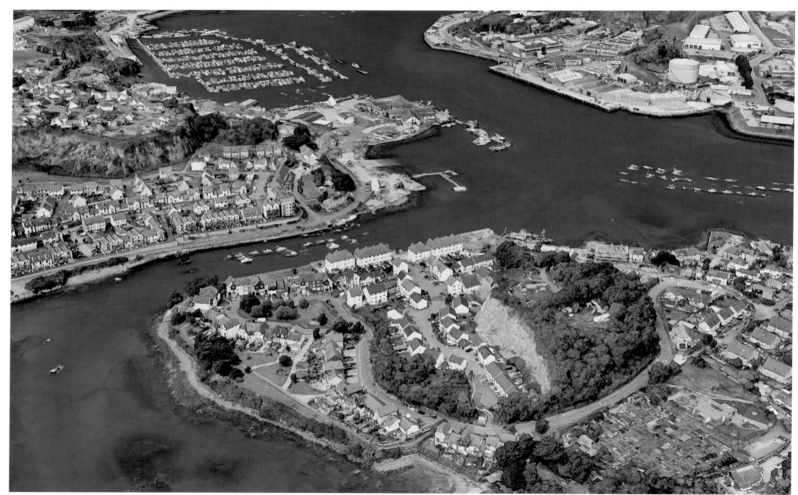

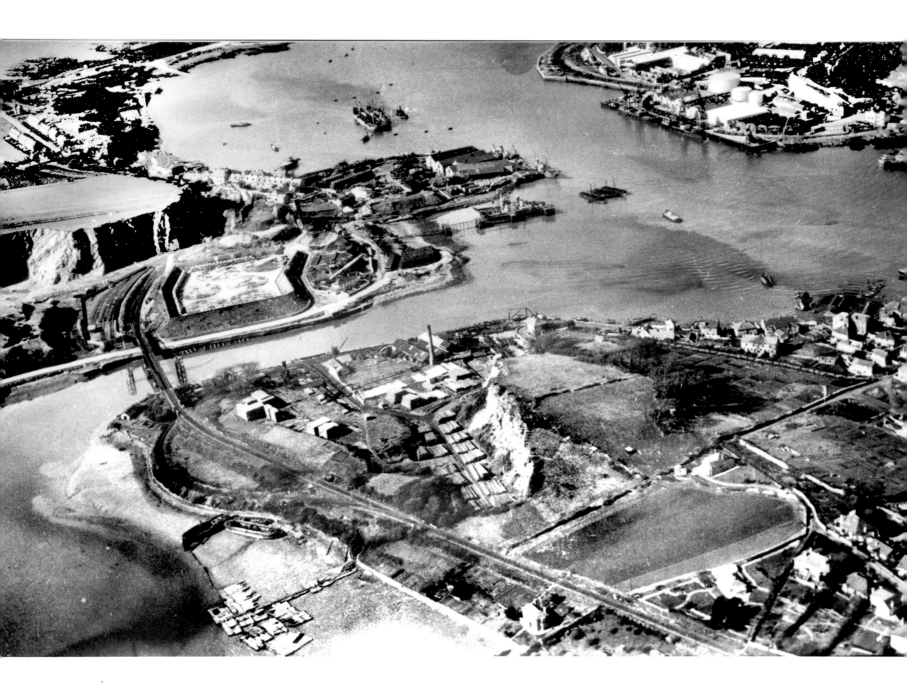

OTHER THEN & NOW TITLES FROM

Pen&inK
PUBLISHING

If you've enjoyed looking through this tome maybe you would enjoy our companion volume – *Plymouth Before the War From the Air Then & Now*. Packed with stunning images of the city before it was subject to some 60 air raids – many with absolutely devastating consequences – we see a city coming to terms with the motor car, moving pictures and electricity.

Or *The Story of the Plymouth Hoe, Baribcan & City Centre, Then & Now* featuring a selection of Then images that covers the era of local images from the 1860s to the 1960s with updates taken from exactly the same location and including detailed potted histories within the narative.

www.chrisrobinson.co.uk or email clare.robinson@blueyonder.co.uk